D1261745

HISTORIC PHOTOS OF
FORT WAYNE

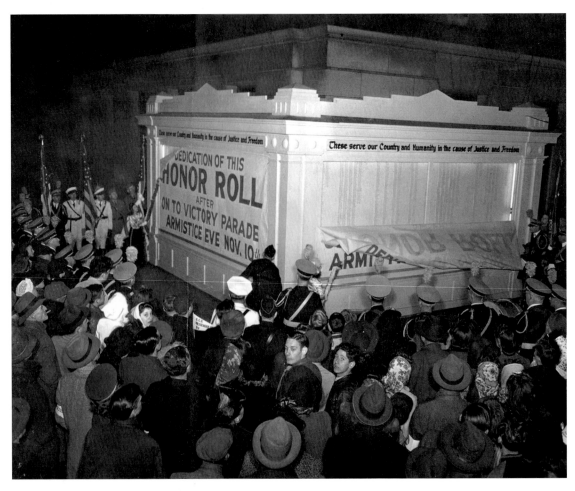

An emotional crowd gathers in the Allen County Courthouse in November 1942 to see the names of loved ones and friends as the Honor Roll of area servicemen and women is unveiled.

HISTORIC PHOTOS OF
FORT WAYNE

TEXT AND CAPTIONS BY SCOTT M. BUSHNELL

TURNER
PUBLISHING COMPANY
NASHVILLE, TENNESSEE PADUCAH, KENTUCKY

Turner Publishing Company
200 4th Avenue North • Suite 950 412 Broadway • P.O. Box 3101
Nashville, Tennessee 37219 Paducah, Kentucky 42002-3101
(615) 255-2665 (270) 443-0121

www.turnerpublishing.com

Historic Photos of Fort Wayne

Library of Congress Control Number: 2007923674

ISBN-13: 978-1-59652-377-7

Printed in the United States of America

07 08 09 10 11 12 13 14—0 9 8 7 6 5 4 3 2 1

CONTENTS

A group of Fort Wayne fire fighters pose alongside one of a dozen fire trucks they built between 1938 and 1942. They bought the chassis and engine from International Harvester and used their skills to fabricate and assemble everything from the seat to the rear bumper.

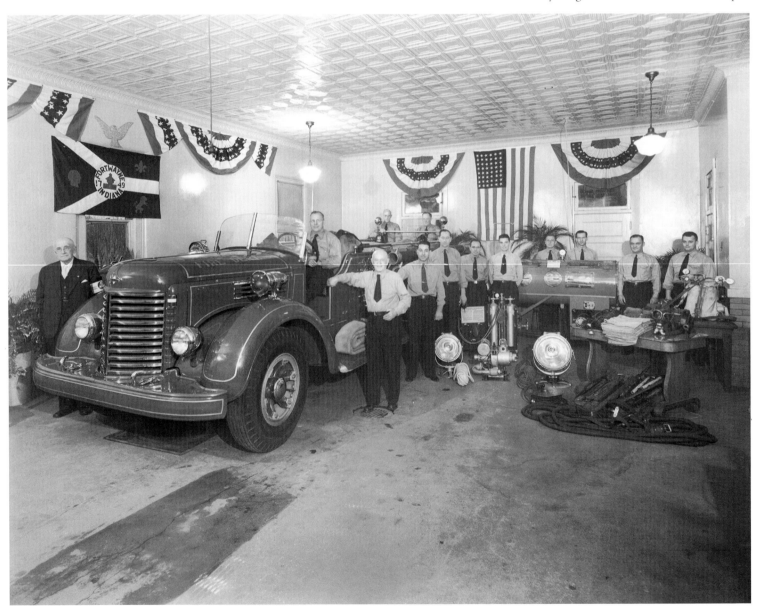

Acknowledgments

This volume, *Historic Photos of Fort Wayne,* is the result of the cooperation and efforts of many individuals and organizations. It is with great thanks that we acknowledge the valuable contribution of the Allen County Public Library, the Allen County–Fort Wayne Historical Society, the Embassy Theatre Foundation, and the Library of Congress for their generous support.

We would also like to thank the following individuals for valuable contributions and generous assistance in making this work possible: Curt Wichern and John Beatty of the Allen County Public Library; Walter Font, curator, and Randy Elliott, collections assistant, of the Allen County–Fort Wayne Historical Society; Tom Castaldi of the Wabash & Erie Canal Society; Sam Hyde and Tasha Bushnell of Hyde Brothers Books, Fort Wayne; Donald Weber of the Fort Wayne Firefighters' Museum; Steven Cox and David Latta of Turner Publishing; and especially Barbara W. Bushnell.

———————

The goal in publishing this work is to provide broader access to a set of extraordinary photographs. The aim is to inspire, provide perspective, and evoke insight that might assist officials and citizens, who together are responsible for determining Fort Wayne's future. In addition, the book seeks to preserve the past with respect and reverence.

With the exception of cropping images where needed and touching up imperfections that have accrued over time, no other changes have been made. The caliber and clarity of many photographs are limited by the technology of the day and the ability of the photographer at the time they were made.

We encourage readers to reflect as they explore Fort Wayne, stroll along its streets, or wander its neighborhoods. It is the publisher's hope that in making use of this work, longtime residents will learn something new and that new residents will gain a perspective on where Fort Wayne has been, so that each can contribute to its future.

—*Todd Bottorff, Publisher*

PREFACE

The area known as Fort Wayne, Indiana, was a thriving center of commerce for hundreds of years before European trappers, traders, and settlers "discovered" it. It was formed by two rivers—the St. Mary's from the south and the St. Joseph from the northeast—that seem to meander over great distances before coming together to become the Maumee River and its run to Lake Erie. These waterways enabled Native Americans to bring pelts, food, tools, and crafts to the convergence of the rivers from as far away as what would later become Wisconsin and western New York. Furthermore, a short portage led to the Wabash River, which could carry a canoe to the Ohio and Mississippi rivers. To the Miami peoples who controlled what they called "Kekionga," the area where the Maumee formed was a glorious gateway.

There are three themes that resound throughout Fort Wayne's history. Commerce and transportation are two of them. Although the earliest settlers were attracted by the area's great groves of hardwood trees and arable land to grow crops, subsequent generations saw the promise of greater prosperity through the building of a canal to provide access for the Midwest to the Great Lakes and the Atlantic seaboard. In an engineering feat of almost heroic proportions, the Wabash & Erie Canal was carved through Ohio and Indiana, with the first boats traveling between Fort Wayne and Huntington in 1835. The boatloads of commodities and workers in the next few years swelled Fort Wayne from a town to a small city by 1840.

The building of the canal through swamp and wilderness exemplifies the third theme in Fort Wayne's history: the persistence of engineers, inventors, and businessmen to recognize opportunities and bring new products to the marketplace. The canal was replaced by the railroads, which built roundhouses, locomotive shops, and repair facilities as well as freight yards and depots. The city's economic growth, particularly in heavy manufacturing, was sustained by the railroads for six decades. In the 1920s, Fort Wayne convinced International Harvester to build its new truck plant here, creating thousands of manufacturing and support-industry jobs.

Fort Wayne's inventiveness wasn't limited to transportation. Men and women with vision played key roles in the

community and industry: whether it was Henry Paul and John Peters manufacturing the first contained washing machine; or Theodore Thieme daring to bring a state-of-the-art knitting mill—machinery and manpower—from Germany to Fort Wayne; or Samuel Foster recognizing the opportunity in designing a blouse for women that became the fashionable style of the Gibson Girl; or Philo Farnsworth pioneering the development of television. Success wasn't the product of leadership alone; the highly skilled workers of the area also attracted a number of industries that grew up in Fort Wayne, particularly the magnet wire industry and related products that form the basis for modern electrical technology.

The economic downturn in heavy manufacturing had an effect on Fort Wayne in the later half of the twentieth century. The demise of the railroads was a heavy blow and the north-south interstate highway that swept through the city did not create the immediate economic growth that rail-based commerce had a century before. The inability of manufacturing to adapt their older facilities to new production methods put Fort Wayne in with the rest of the so-called Rust Belt in the Midwest. The steady, at times alarming, loss of manufacturing firms deprived the city not only of high-paying jobs, but also of some of its pride. Retail activity in the downtown area—whose history is a central portion of this book—moved to the city-like malls on the perimeter of Fort Wayne.

Today, both the private and public sectors of the area are devoted to fostering new avenues to economic growth. Elements of Fort Wayne's heritage can be found in several new paths being followed by entrepreneurs. Universities and venture capital firms are investing in start-up firms in the health-care field that will benefit the nation's aging population. The transportation industry is experiencing growth in inter-modal transportation with truck trailers mounted on rail cars. And the rivers are being reclaimed environmentally as residents value them for their beauty, not just their economic efficacy. It will be interesting to see how Fort Wayne of the early twenty-first century is portrayed a century from now in whatever form image-and-text works of the future take.

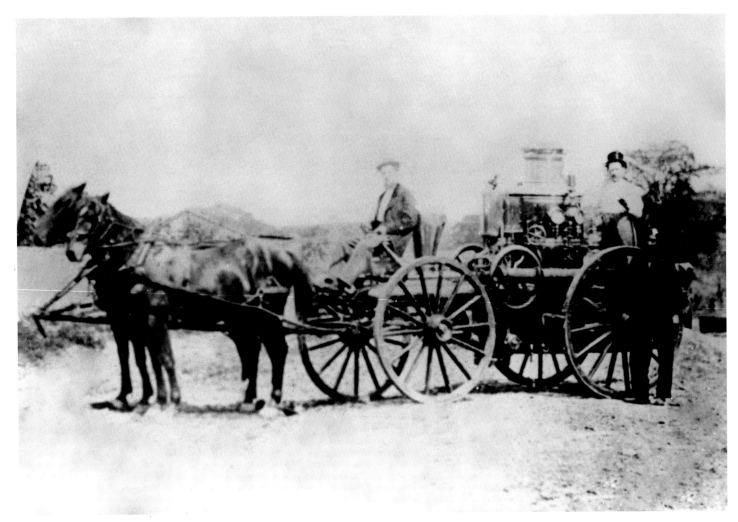

Three firemen from the Vigilant Engine and Hose Company pose with the steam-powered Frank Randall Pumping Engine in the 1860s. Named after the mayor of that time, the engine was a marked improvement over the hand pumpers and would remain in service for decades.

ON THE RIGHT TRACK

(1860–1889)

When the Civil War began, Fort Wayne was a small county seat with 10,388 residents. Citizens were not fully in favor of the effort to quell the secession of the Confederate states, as was clearly evident in Abraham Lincoln's losing the popular vote in Fort Wayne in both 1860 and 1864. More than 4,100 men from the city and surrounding Allen County, however, went off to war in the Union Army. When the fighting was done in 1865, 489 of them had lost their lives.

Fort Wayne grew during the war, recording a 71 percent increase in population by 1870. The city prospered greatly, too. The first steam engine had arrived by canal boat in the 1850s and from this inauspicious beginning Fort Wayne became a leading railroad center. The Pittsburg (as it was spelled then), Fort Wayne, and Chicago Railroad built the city's first passenger station in 1855 and later added a roundhouse and shops for the building and repair of locomotives and cars. Six more railroads would serve Fort Wayne in the decade ahead, and in 1880 the Nickel Plate Railroad bought the canal right-of-way for its new line. As a result of this growth, ancillary businesses blossomed: the city became the world's largest supplier of railroad wheels and axles, and Kunkle Valve patented safety valves for steam engines, as two examples.

The railroads made Fort Wayne attractive to more than just industry. It was the first stop outside Chicago for many theatrical touring companies and therefore a convenient place to perform. The most famous stage personality of the period, Lillie Langtry, performed here in January 1883. Fort Wayne was one of the original members of the National Association of Base Ball Players (the forerunner of the National League), in part, because of its locale. By 1880, the city's population had grown to 26,880.

Fort Wayne saw itself as a progressive city during this period. It began offering horse-drawn streetcars in 1872 and later expanded the service for the growing community. Municipally provided services like water and sewer became available. The Jenney Electric Company showed that artificial lighting was possible. Fort Wayne was fully prepared for what became known as the Gilded Age.

Dams, reservoirs, and aqueducts were all required for the operation of the Wabash and Erie Canal. This 75-foot-wide dam on the St. Joseph River created a reservoir that supplied a small feeder canal whose water lifted the boats through the Summit City. It also provided good fishing and some challenging experiences in small boats after the canal's heyday was past.

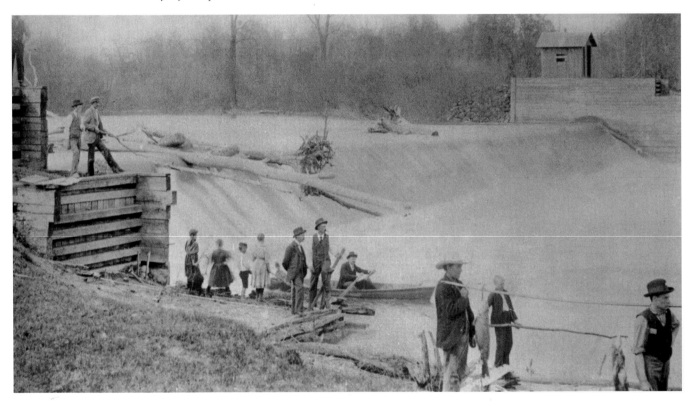

As early as the 1850s, Fort Wayne was nicknamed "a city of churches." This white frame church was the first in the city, built in 1837 on Berry Street between Lafayette and Barr for the Presbyterian faithful. It later housed the congregation that formed the Trinity English Lutheran Church, who preserved the church bell for its new home.

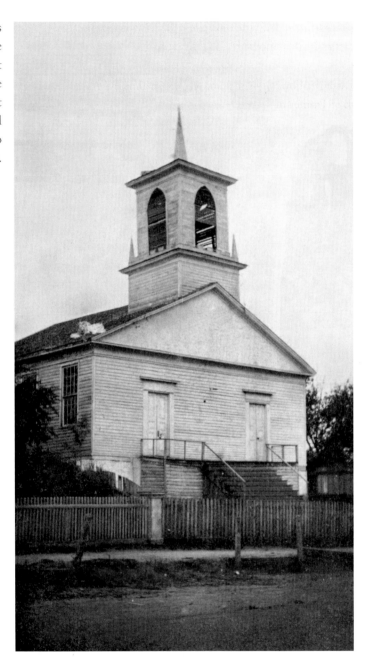

A well-equipped and trained fire department was a requirement in nineteenth-century cities where fire often meant calamity. This photograph of Fort Wayne's only engine house in 1882 shows a sizable group of firemen as well as a steamer and a hose-and-ladder wagon. The firehouse was located on the northeast corner of Court and Berry streets.

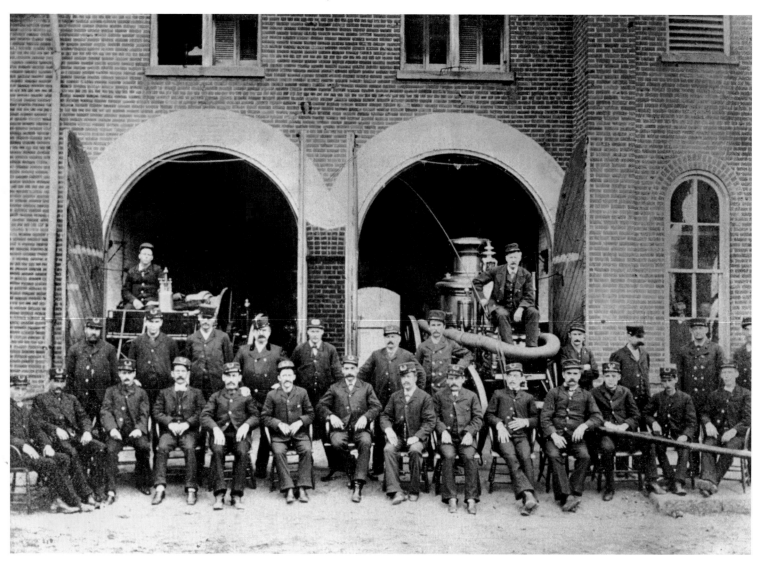

It was said that the late nineteenth century prompted an unofficial competition to see who could build a church with the tallest spire. Few could compete with St. Paul's Evangelical Lutheran Church, shown here in its Gothic splendor shortly after its 1889 dedication.

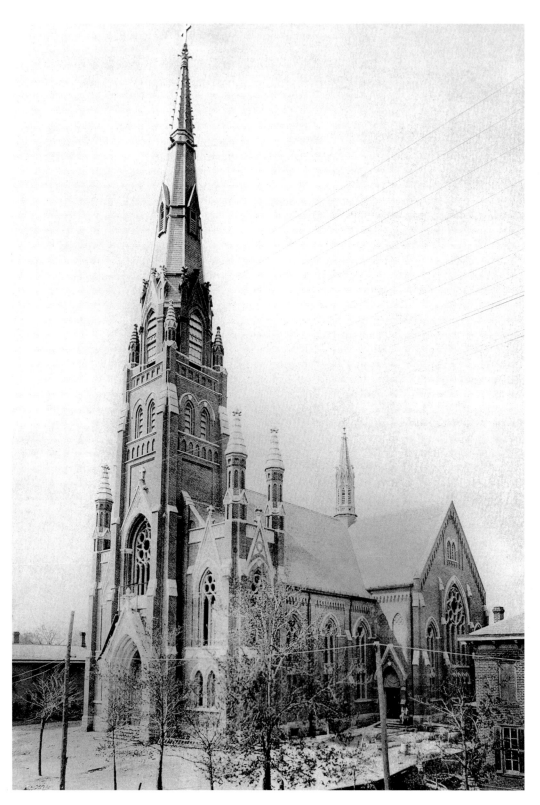

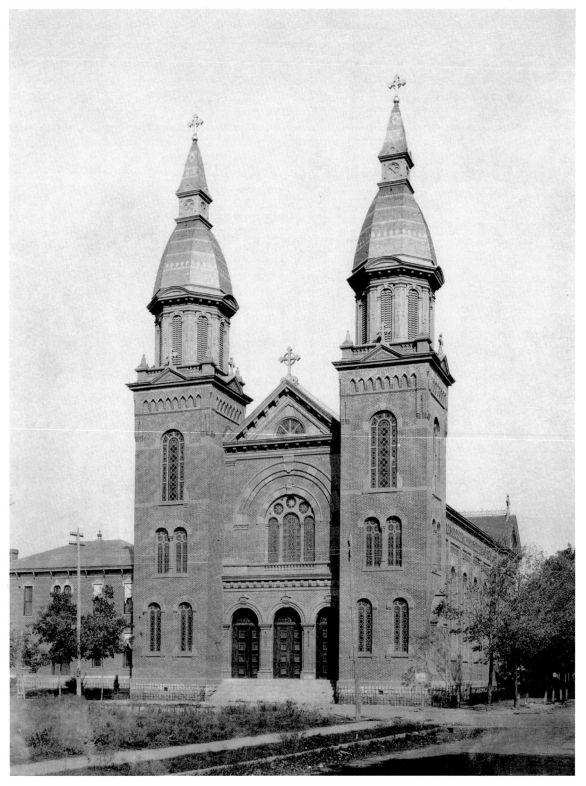

A panoramic view of Fort Wayne in the final decade of the 1800s undoubtedly revealed a skyline of spires. Few were so remarkably recognizable as the twin steeples of St. Paul's Catholic Church.

Columbia Street was the center of commerce for Fort Wayne from the earliest days of the Wabash & Erie Canal. Named for Dana Columbia, a canal boat and hotel owner, the street was also known as "the Landing" for settlers, businessmen, and scalawags. As can be seen, Columbia Street was still focused on the agricultural market half a century after its founding.

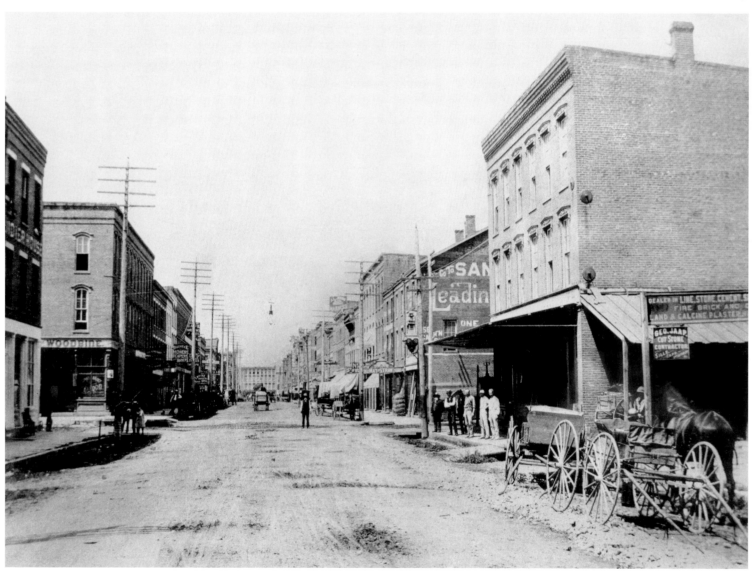

The Randall Hotel is still among the most recognizable buildings in downtown Fort Wayne. Located on Harrison Street where Columbia Street ends, the building was a three-story granary and tannery when it was built in 1856. Remodeled and expanded, it became "the best $2 hotel in Indiana," attracting patrons like Buffalo Bill Cody.

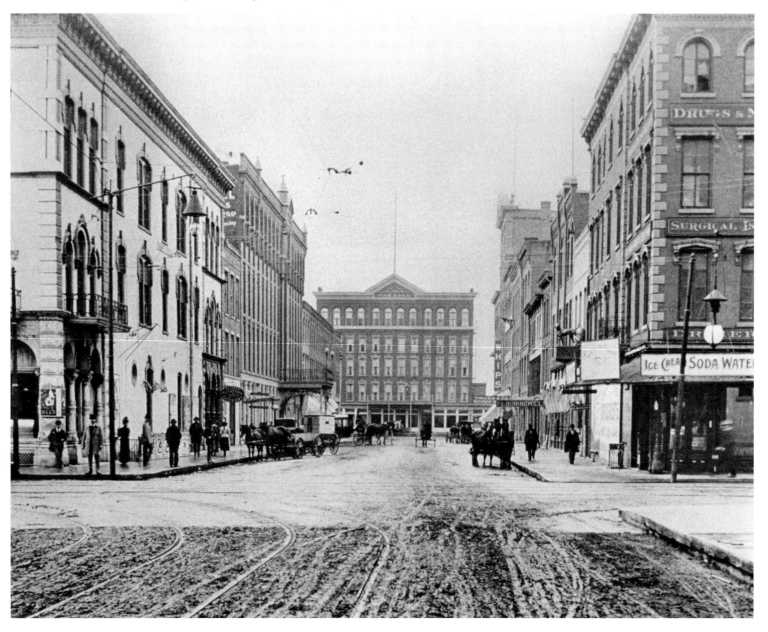

The Reformed Church Orphans Home—officially known as Reformirtes Waifenhaus by the two German Reformed Church parishes that sponsored it—was built in 1894 on Lake Avenue to care for unwanted children. During the Great Depression, it took in not only orphans, but also children whose families could not care for them.

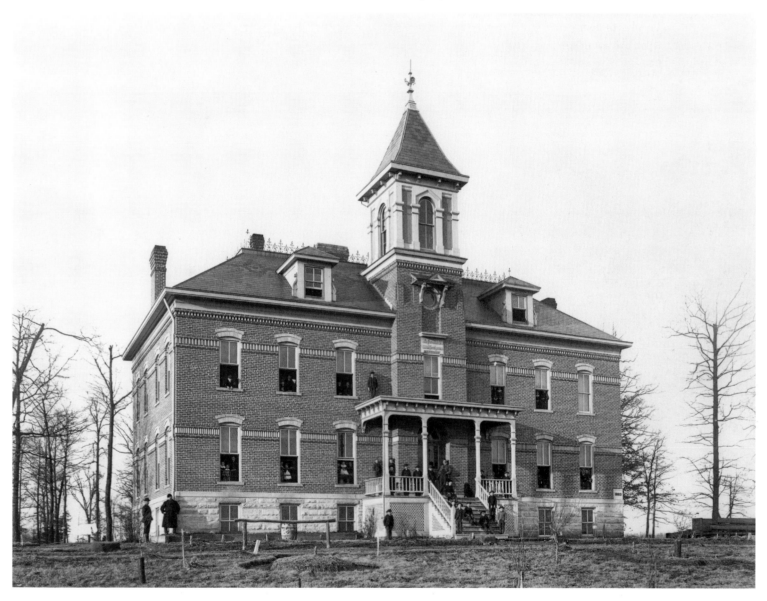

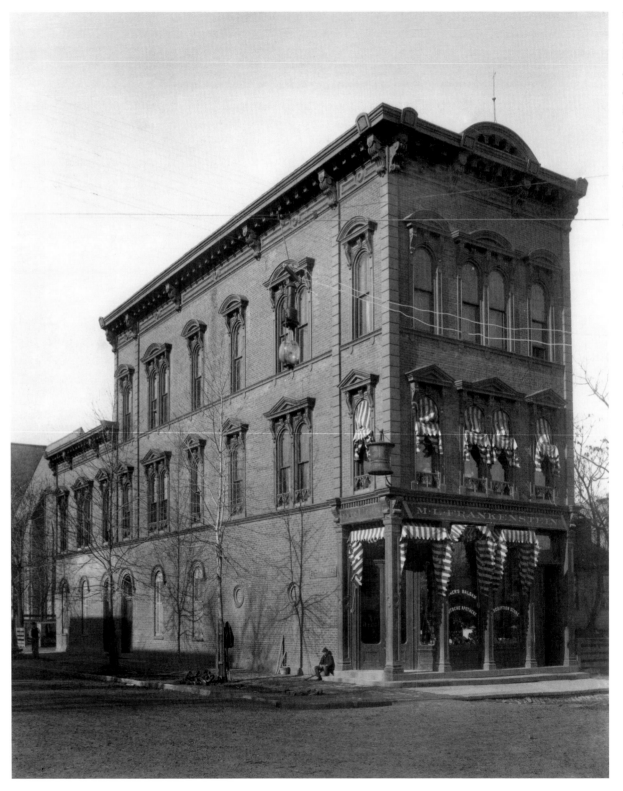

With its pilasters and pediment, Max L. Frankenstein's building on the northwest corner of Barr and Washington Street in the 1880s was a classic example of Victorian Renaissance architecture that was dominant in the Midwest. Frankenstein operated this store into the 1890s.

Calhoun Street was the "face" of Fort Wayne for nearly a century. Its streetscape of stores, shops, restaurants, saloons, and professional businesses was continually changing, reflecting the community's taste. In this view facing south on Calhoun from Columbia Street, the Hofbrau Café with its very European decor on the left contrasts with the more modern Clemens Quick Lunch and the Meyer Brothers Drug Store on the right.

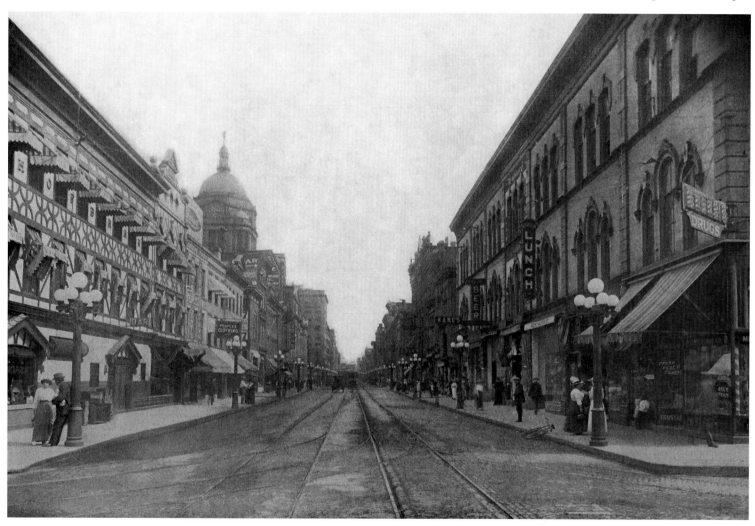

Built in 1863, the Aveline House quickly became known as one of the region's finest hotels. Facing the courthouse at Berry and Calhoun, it served well-to-do travelers, political candidates, and even local businessmen who wanted a prestigious address. Shown here in 1889 before a fifth story was added, the Aveline was the scene of a tragic fire in 1908.

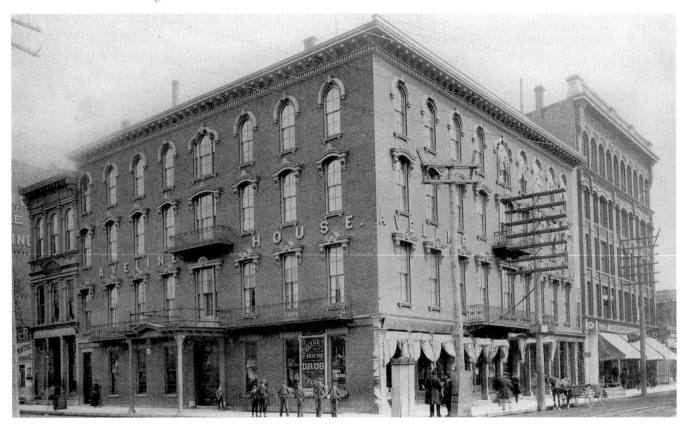

Location is everything in the retail business. Gideon Seavey was a lawyer who bought a Columbia Street hardware business in 1883 and moved it to West Main Street on the edge of downtown. His "up-to-date" hardware store proved successful and it continued as a family operation for many years.

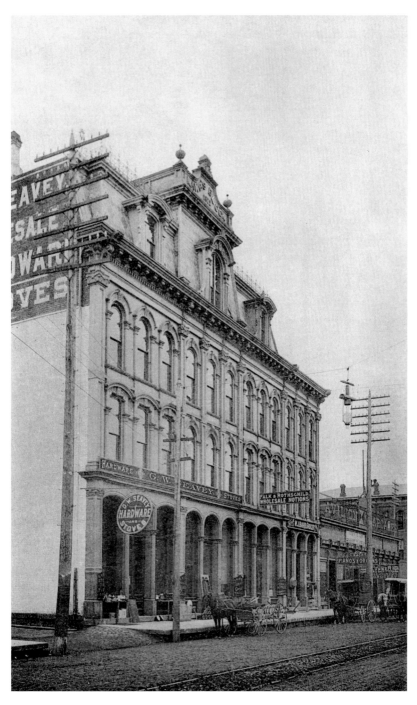

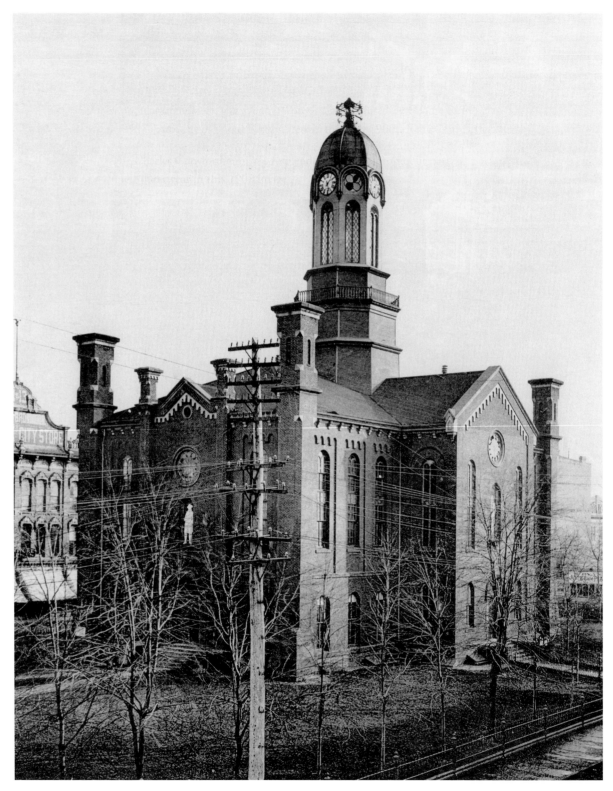

The Allen County Courthouse was feeling its age in 1889 when this photograph was taken. When it was dedicated in 1861, this—the third courthouse in the city's history—was said to be "designed to last a century." Less than 40 years later, its lack of modern amenities, such as workable plumbing, led city fathers to plan a new courthouse.

Frederick Eckart operated a meat market and pork packer near the center of the city before moving it to this location at West Main and Harrison streets.

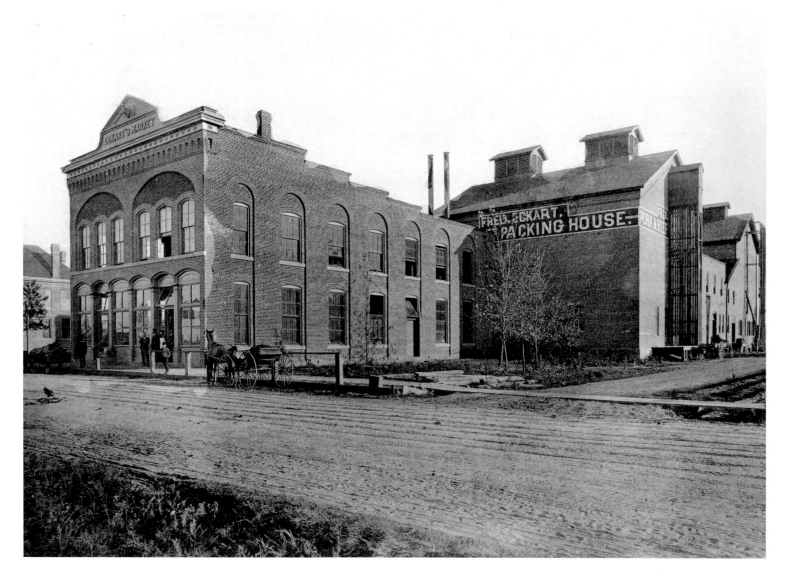

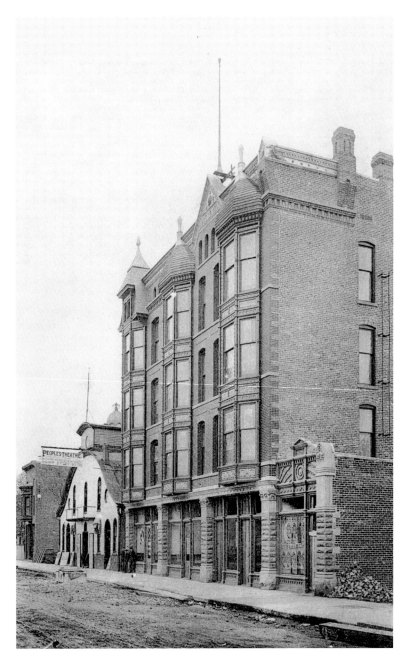

The small, dome-like building peering from behind a formidable, four-story neighbor on Berry Street was the Princess Rink, where the "new" recreation of roller-skating was enjoyed. Larger inside than it appeared from the street, the Princess was also a site for mass rallies, as in 1896 when vice-presidential candidate Theodore Roosevelt campaigned in Fort Wayne.

There was hardly a neighborhood in late-nineteenth-century Fort Wayne that did not have a cigar-maker. The Golden Rod Cigar Factory was one of about 40 such firms whose storefronts offered passersby an opportunity to watch the cigars being made by hand.

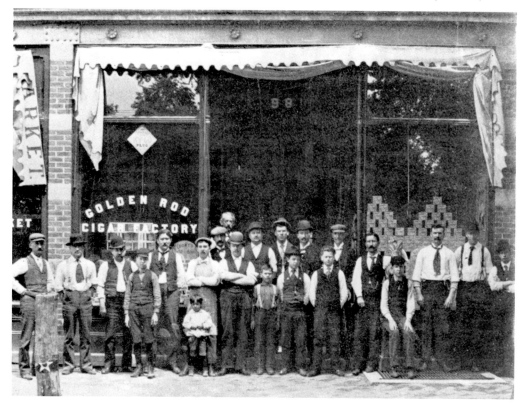

18

By 1882, the Nickel Plate Railroad had built its trackbed over the old Wabash & Erie Canal. Portions of this longest of canals remained open water, however, and the old towpath was convenient for cart and wagon travel.

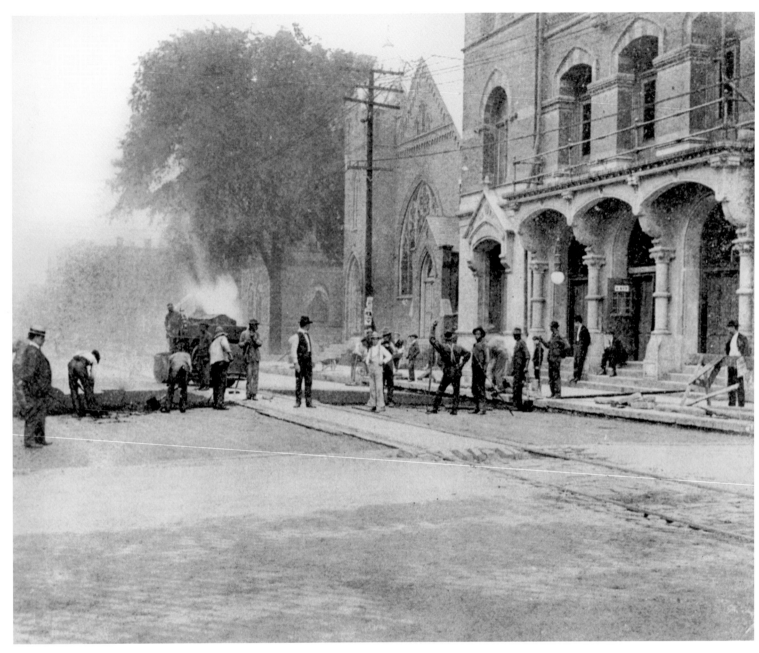

Dirt streets had been replaced with paving blocks in the 1880s in Fort Wayne. Then in 1889 the Barber Asphalt Company developed a method of spreading "Trinidad pitch asphalt" on the main thoroughfares. This activity occurred in front of the old Temple Theatre.

PREVALENT PROSPERITY

(1890–1915)

Fort Wayne was described by the *Chicago Tribune* in the 1890s as "a most German town," reflecting that about 80 percent of the county's foreign-born population were immigrants from nations and states where German was the predominant language. This was a period when the German influence reached its peak and significant contributions were made in all sectors of the city. Mayors, manufacturers, and merchants of German descent led the city into the twentieth century. Singers, soldiers, and saloonkeepers were prominent people. Two of the most widely read newspapers were the German-language *Freie-Presse* and the *Staats-Zeitung*. Classified advertisements for clerks in the downtown stores stated that non-German speakers need not apply.

This was a time of celebration of, and confidence in, the continued progress of Fort Wayne. The city put on its finest attire to celebrate its first century after General Anthony Wayne defeated the Miami and other tribes to establish the American fort in 1794. There seemed to be no end in sight for the community's progress. The impetus behind the city's growth and change in this period was the establishment of the Fort Wayne Electric Works, which eventually merged with General Electric Company. The Works brought not only lighting into homes and power into factories, but also better transportation through trolleys. A wave of substantial construction—City Hall, the county courthouse, many churches, downtown buildings, and factories—swept through Fort Wayne, whose population grew from 45,000 in 1900 to almost 64,000 in 1910.

The growth also showed the city's vulnerability to the whims of nature. While the rivers presented great opportunity, they also brought great flooding. The destructive 1913 flood etched itself into the collective memory of Fort Wayne, although little was done to protect at-risk homes and businesses.

The beginning of World War I changed the nature of Fort Wayne society. Anti-German sentiment caused businesses to rename themselves: the German-American Bank, for example, became Lincoln National Bank. And the prospect of a nationwide ban on the sale of alcohol seemed more likely. The political climate changed dramatically as the Democratic Party's dominance of the electorate collapsed and Fort Wayne became a Republican stronghold.

Henry Schone and Frank Veith apparently did things right. When they established their undertaking and embalming business at 53 Berry Street in the 1890s, they purchased a pair of matched white horses to pull the hearse. Schone remained a respected name as it continued to operate its funeral home business into the 1950s.

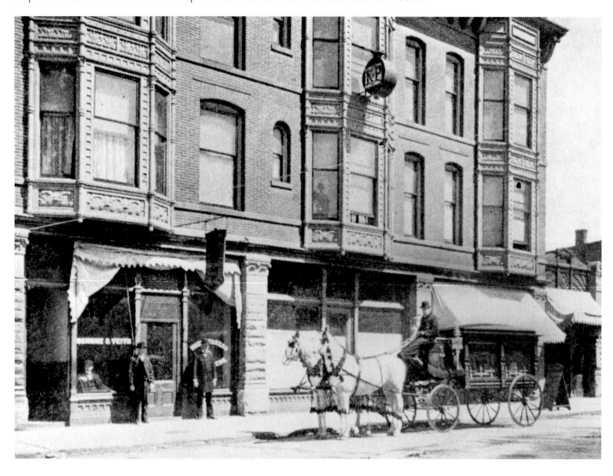

Calhoun Street in the early 1890s offered a variety of stores, from Kuttner's on the left where suits were made to order, to Skelton, Watt and Wilt on the right, a wholesale grocer whose windows featured stylish shades. This view faces north from Jefferson Street.

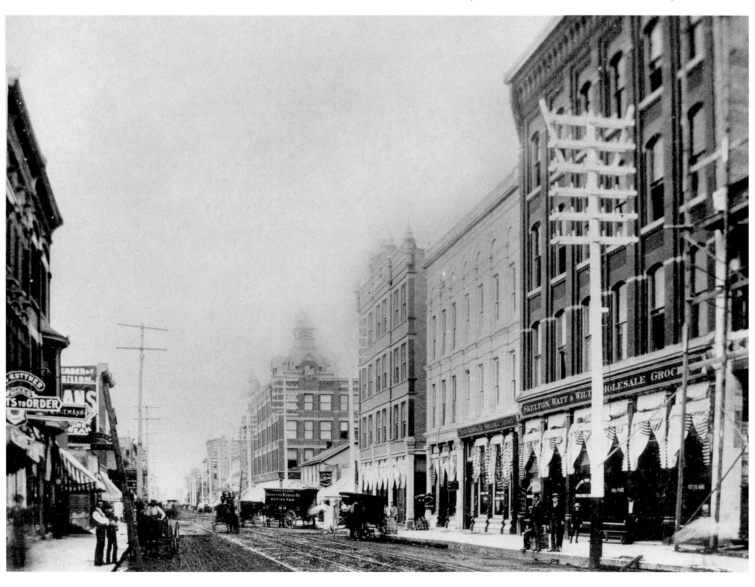

Calhoun got busier as one walked closer to the center of the community. This view in the early 1890s is from Wayne Street, facing north, toward more commercial activity. The five-story building at right is the Bass Block, and beyond it are the Aveline House and the trees in the courthouse yard.

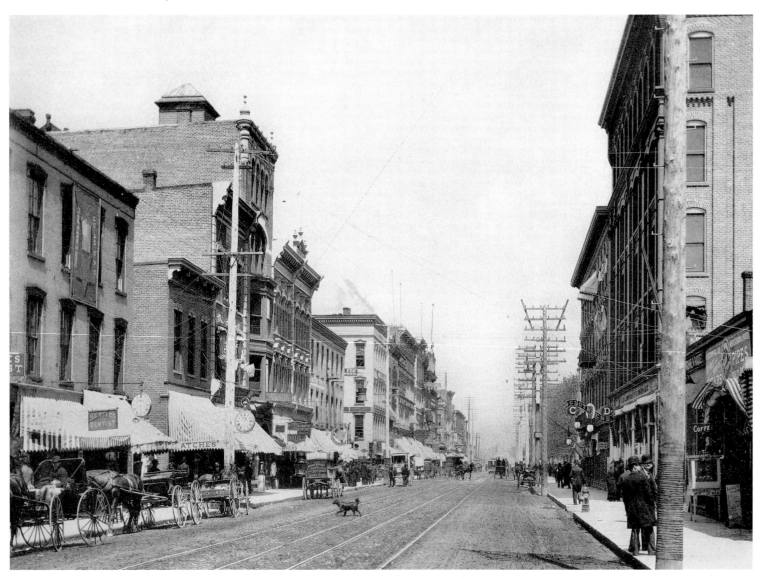

This photograph of Calhoun Street is from Main Street, facing north, and shows the successful retail clothing businesses on the left and an electric-powered trolley approaching. The Eckart & McCullochs block—as large buildings were called in those days—is on the left.

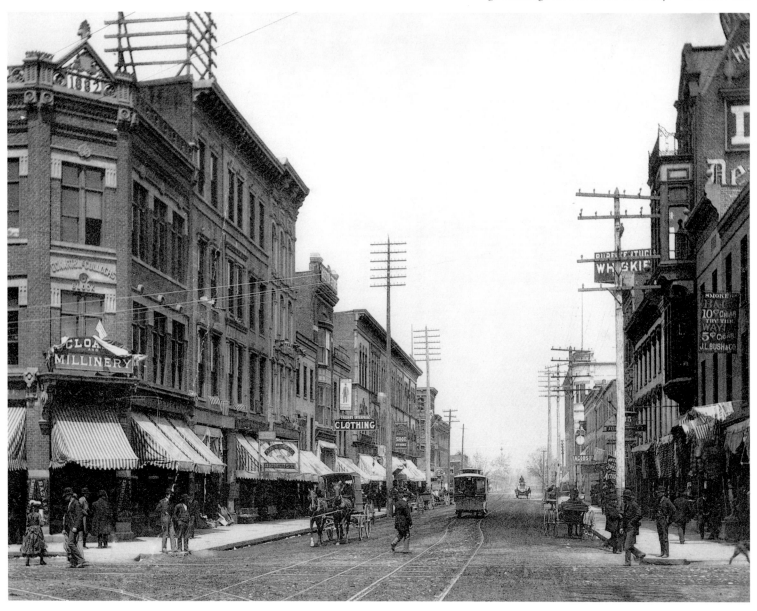

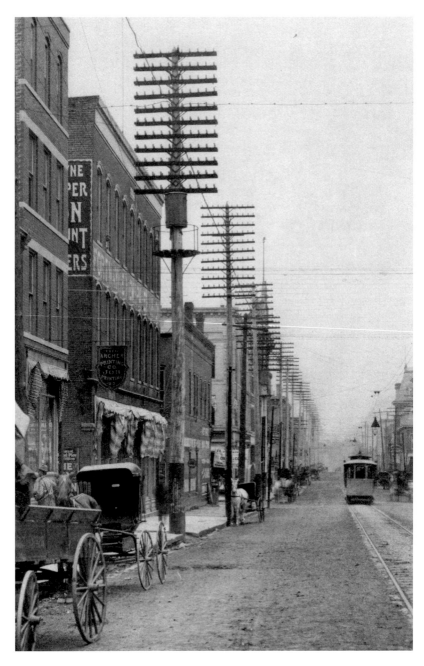

Clinton Street as shown in this 1892 photograph seems far calmer than Calhoun Street. Electric-powered streetcars made their first run in Fort Wayne in July 1892.

This was the second home of the Plymouth Congregational Church, at Harrison Street and Jefferson Boulevard. It was dedicated in 1892 and served the congregation until 1924.

Located on Cass Street near the depot for the Lake Shore and Michigan Southern Railroad, this hotel was advertised as having "a first class bar and lunch room." One has to wonder how well its patrons could sleep, given its proximity to the tracks that can be seen in the lower right-hand portion of the photograph.

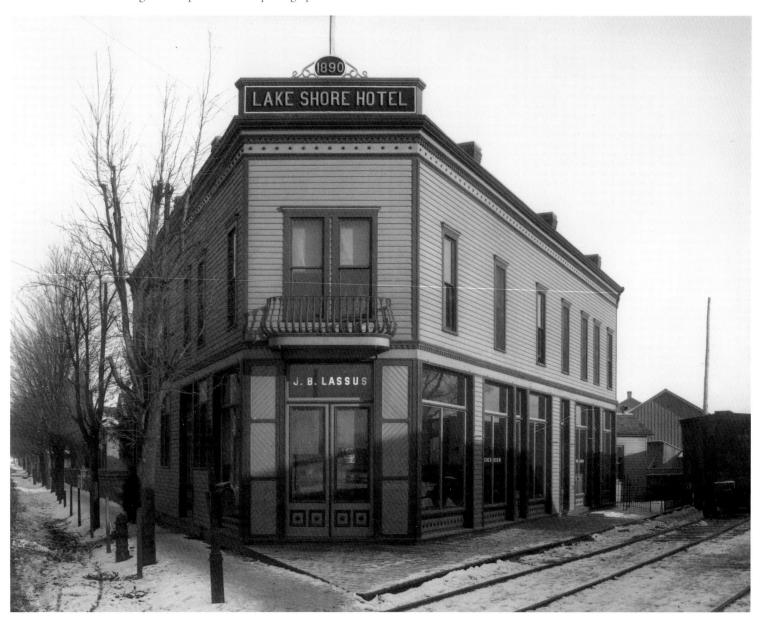

Dedicated in 1893 shortly before this photograph was taken, City Hall at Berry and Barr streets housed the Fort Wayne Police Department in addition to the offices of the mayor and the clerk as well as the municipal court. The police used this horse-drawn wagon to transport men and women to the jail that was in the City Hall basement.

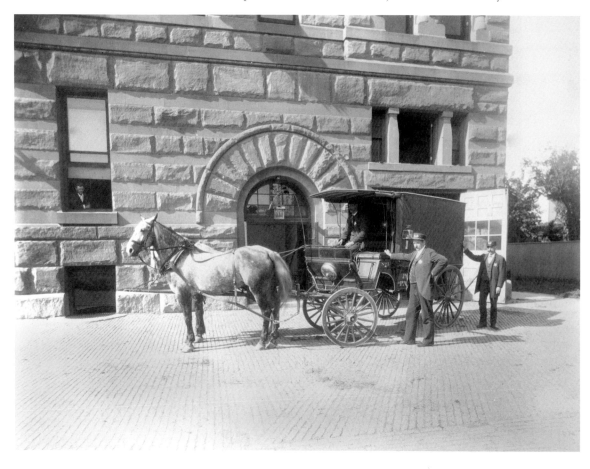

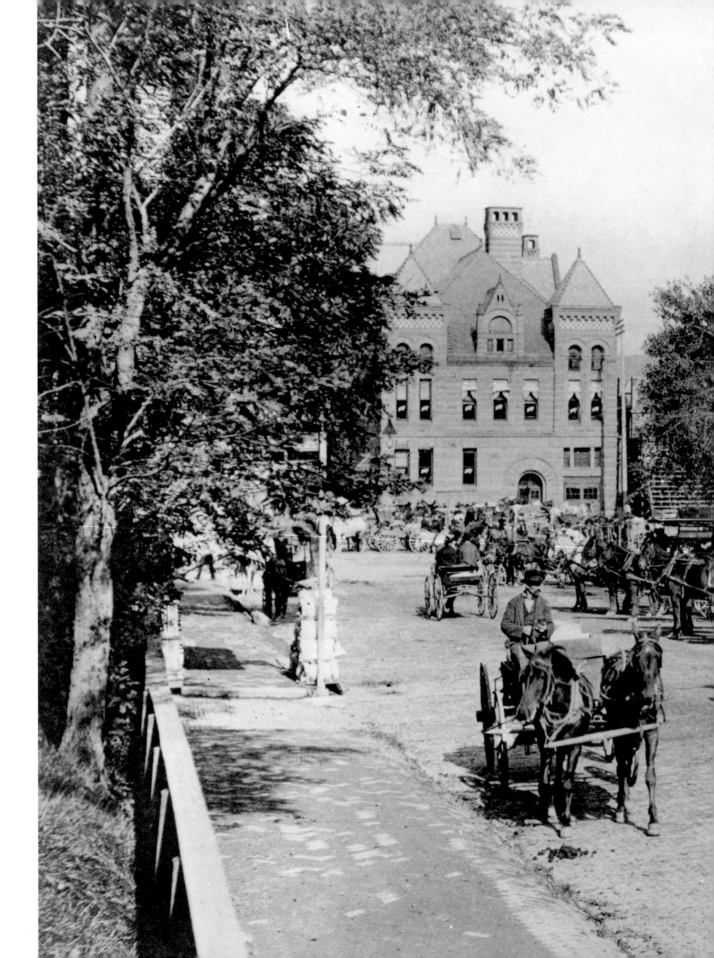

The Barr Street Market assumed its pivotal role in the daily life of Fort Wayne when it was created in the 1840s by Samuel Hanna to provide residents of the then-young community with access to fresh produce. In this 1893 photograph, the market is alive with horses and wagons.

Every photograph tells a story and there certainly must be one about why these two conductors from the Fort Wayne Electric Railway Company have a donkey standing with them. Perhaps the donkey was saved by the "cowcatcher" on the front of the trolley. Or perhaps he just didn't pay the fare.

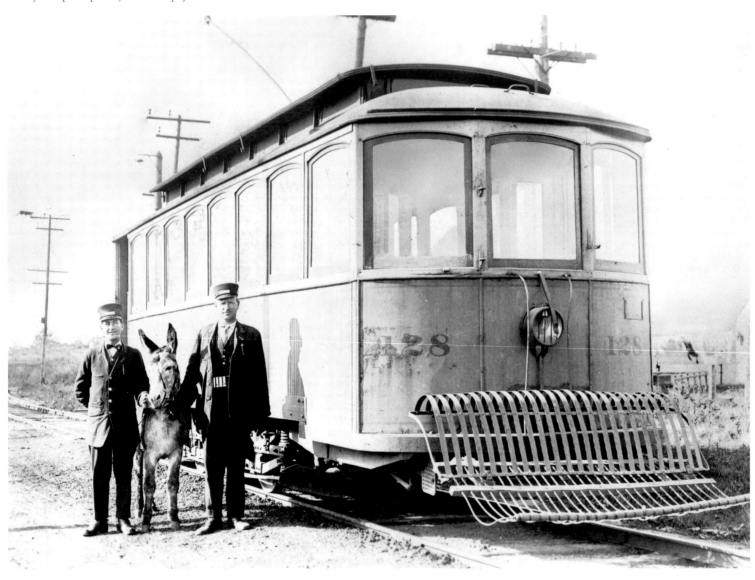

The employees of Mayflower Mills were photographed at the rear of their building on Columbia Street in 1895. The bookkeepers and secretary are identifiable by their dresses; the teamsters by their stance near their horses; the mill workers by the amount of flour on their clothes; and the foreman by the jaunty angle of his hat. The fellow looking down from the roof is an unknown quantity.

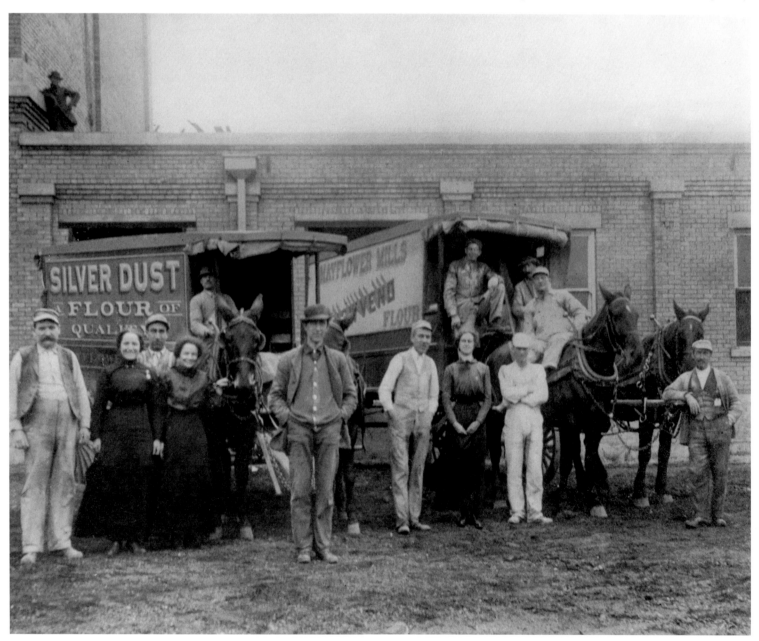

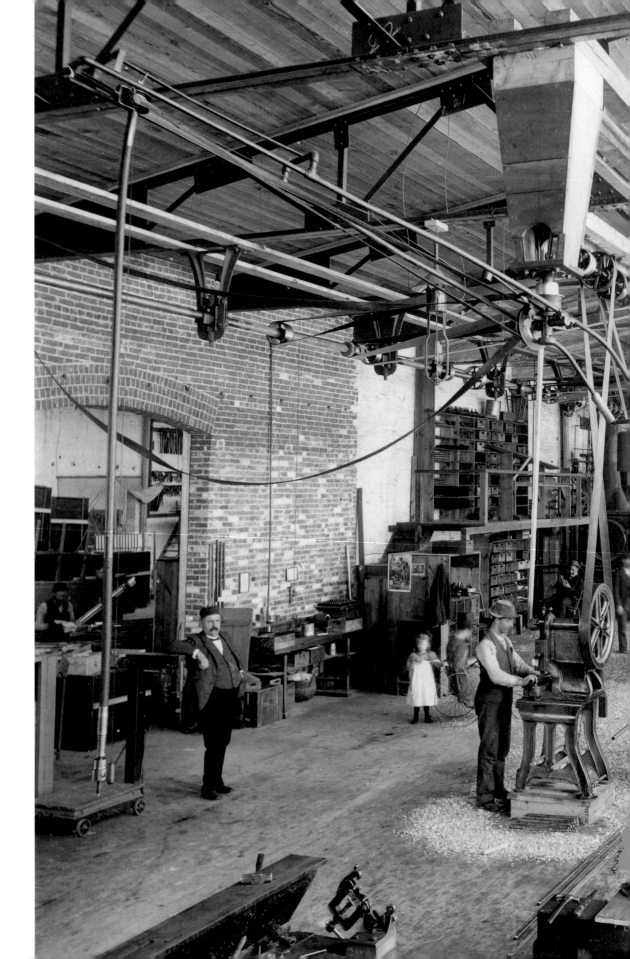

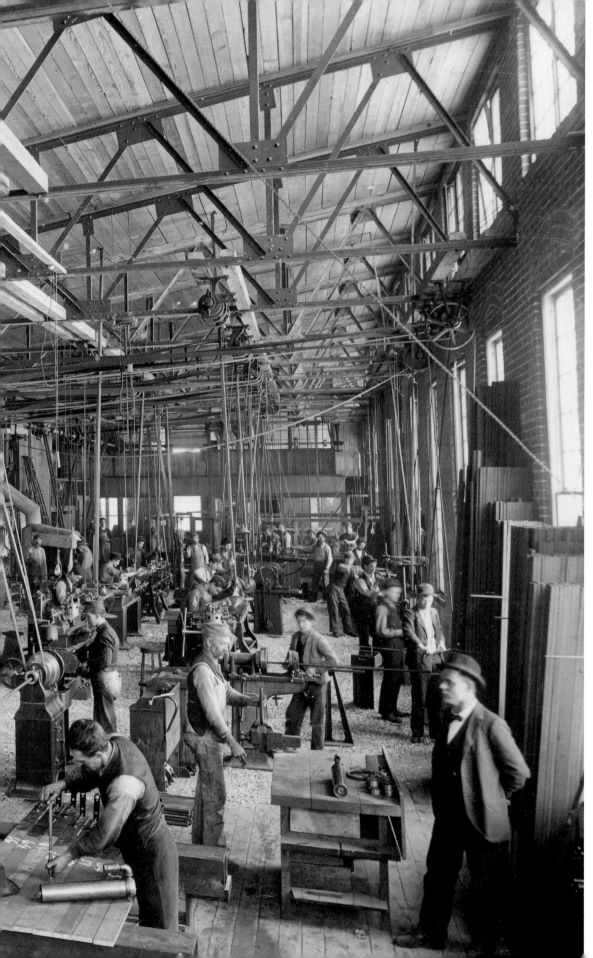

Sylvanus F. Bowser was an inventor, industrialist, and philanthropist who revolutionized the oil and gas industry by inventing the self-measuring pump. He is standing at left in this 1890s photograph of his factory on East Creighton Avenue, watching over production. Note the woman in the wheelchair and the little girl tending to her to Bowser's left.

The 100th anniversary of the city's founding by General Anthony Wayne should have been observed in 1894. When the city declined to fund the celebration, Perry Randall raised the money for the celebration, which was held in October 1895. One hallmark was eight grand arches—including this one, at Lewis and Calhoun streets, on which a worker is putting the final touches.

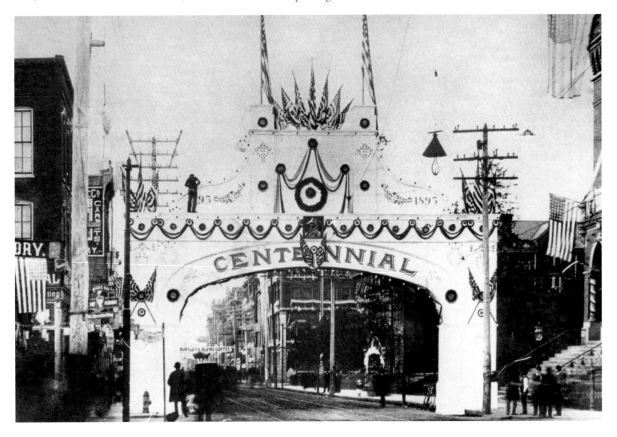

Fort Wayne's centennial celebration was filled with parades, exhibits, and dances. The crowd outside the old Pennsylvania Railroad station seems to be waiting for the next round of activities.

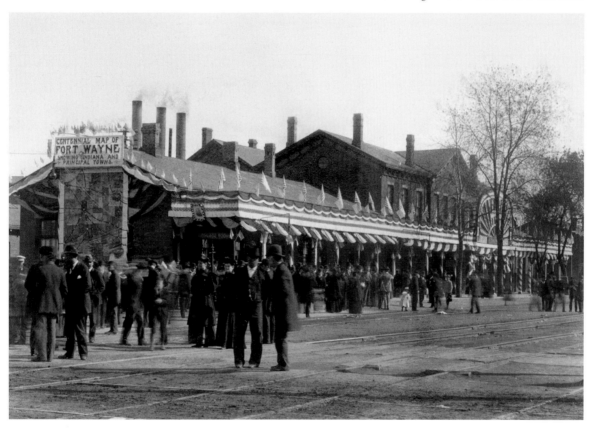

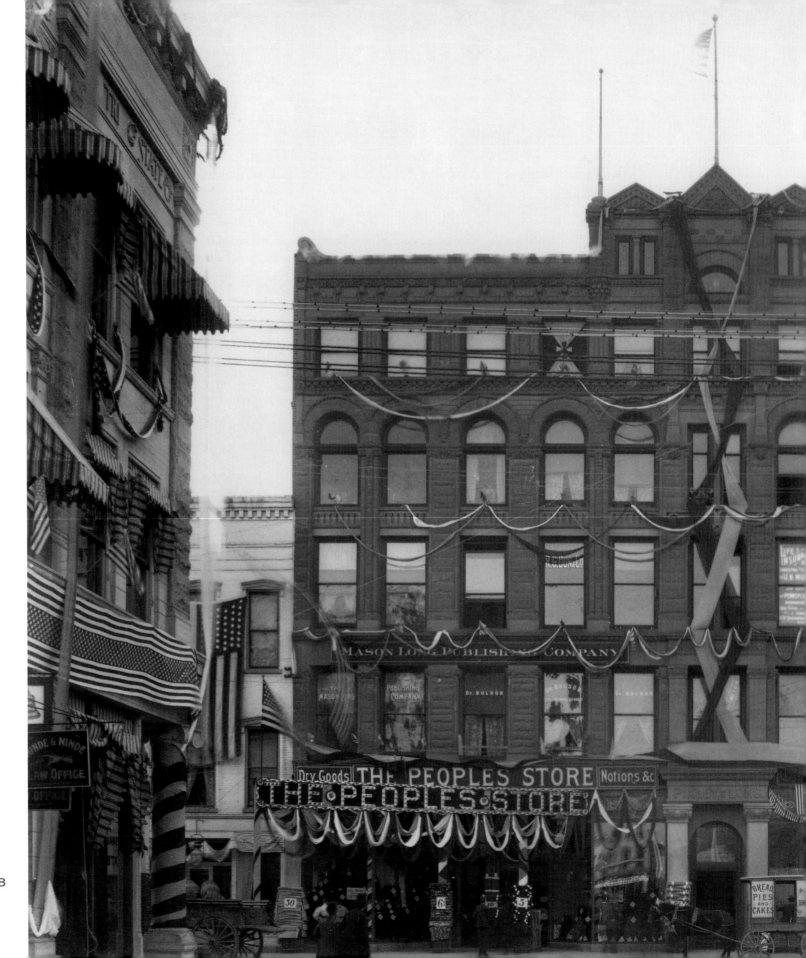

Even the city's larger structures were decorated for the 1895 celebration, including the Pixley-Long building at 116-118 Berry Street. The building housed more than the popular People's Store. Upstairs were the offices of architects Wing and Mahurin, temperance publisher Mason Long, attorneys Ninde and Ninde, and real estate developer Louis Curdes. All played pivotal roles in Fort Wayne's history.

A lone trolley exits the Fort Wayne Electric Works plant that is decorated for the city centennial in 1895. The generating plant had its genesis in the Jenney Electric Light Co., which produced electric arc lights, in 1881. It evolved into an electricity producer from the Broadway site shown here in 1885. After a series of financial difficulties, it was merged with General Electric in 1911.

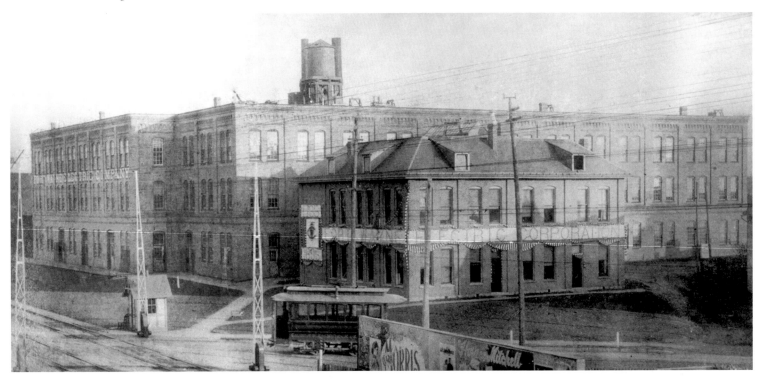

The demand for greater trolley service grew in the mid 1890s. The crew stringing wire to Robison Park in the spring of 1896 took time out to pose for a photographer. The car being pulled by a mule was transformed into an unusual mobile tower to expedite construction.

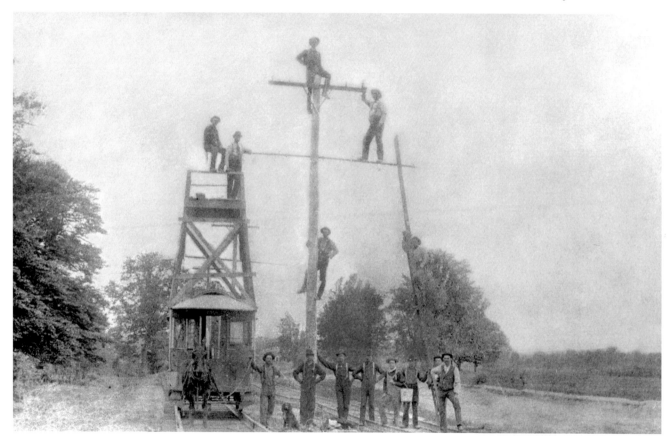

It took a skilled teamster to navigate busy Columbia Street and pick up a wagonload at
Viberg & Co. in the 1890s. George H. Viberg had been Allen County sheriff for five
years before buying this store, which operated until 1926.

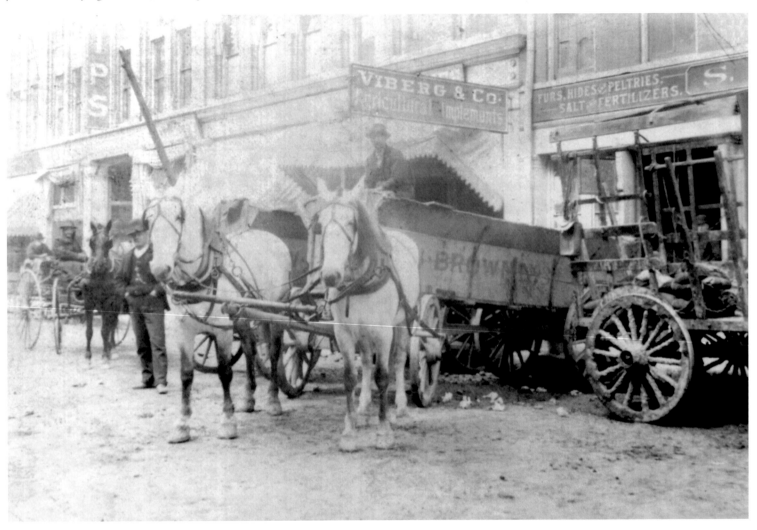

The new brick Wayne Street Methodist Episcopal Church was built in 1871 at Wayne and Broadway. It was remodeled and enlarged 25 years later.

The growing prosperity and culture of Fort Wayne can be seen in this 1898 photograph looking north on Calhoun Street from Washington. Not only are the streets paved, but there are competing piano stores on opposite corners. Farther down the left side of Calhoun, there are offices of dentists, insurance salesmen, and architects.

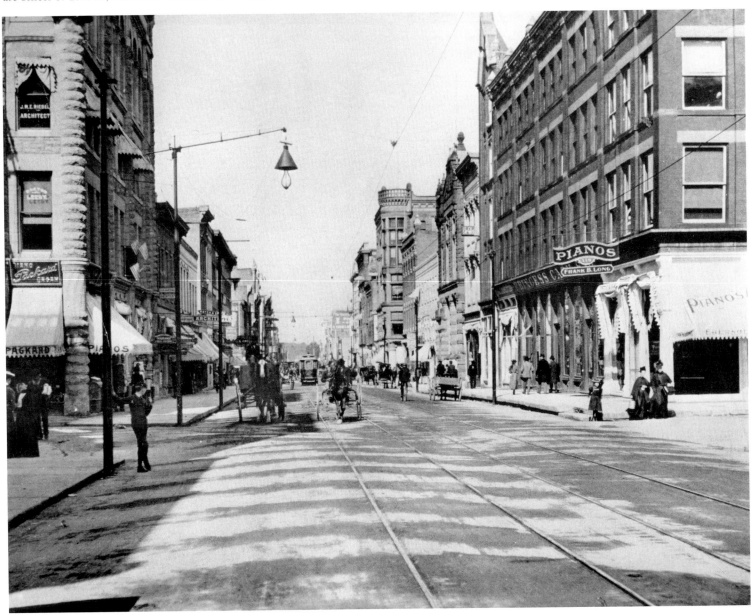

Fort Wayne's Lakeside School was two years old when the new school building was photographed in 1898.

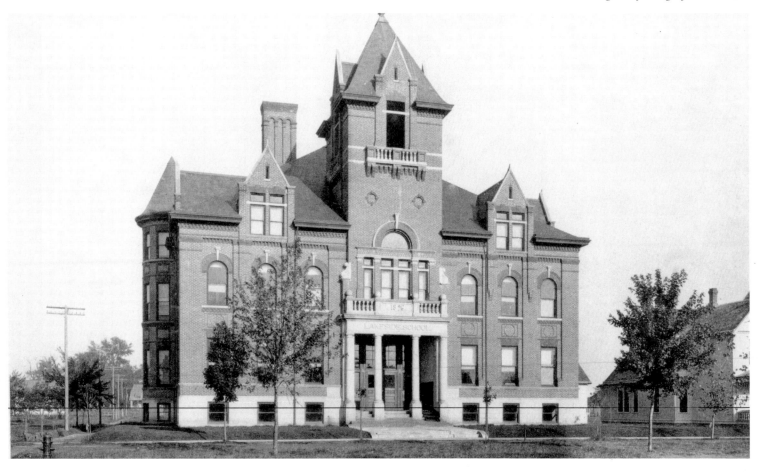

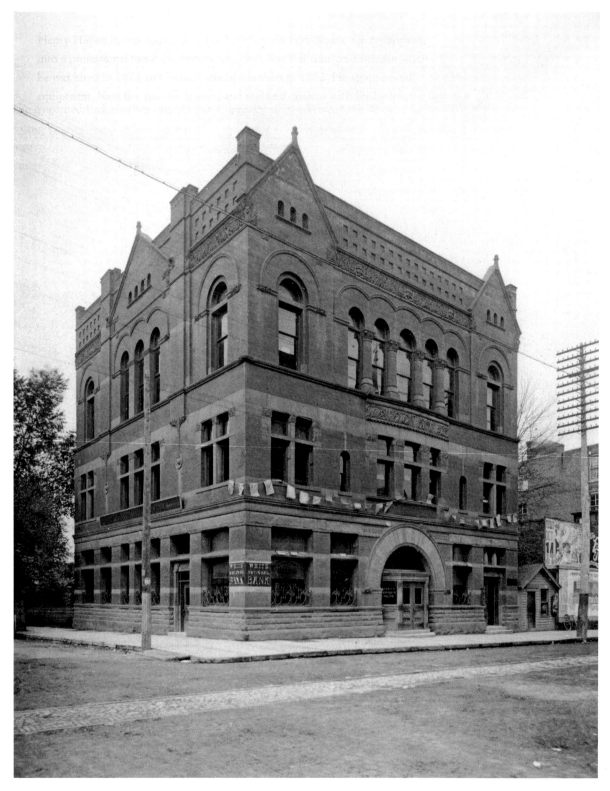

The White National Bank was formed in 1892 by businessman and former Congressman John B. White. It survived the turmoil of the financial panic of 1893, but was consolidated with the older First National Bank in 1905.

Fort Wayne was in step with the national cycling craze in the 1890s. These young men are posing in Swinney Park with the top of the park pavilion visible in the background.

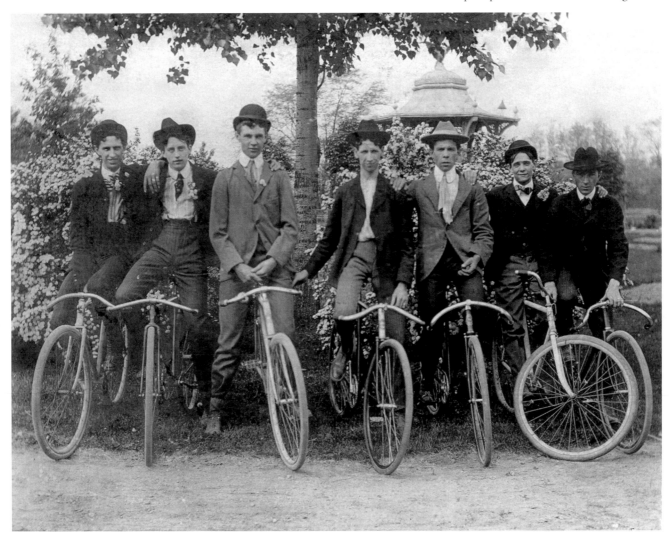

The parlor recreation of singing along with a pianist began to be supplanted in the Gilded Age with that of formal listening. Three young men seem hypnotized as they listen intently to a recording played on a Victor Talking Machine Co. Gramophone in July 1900.

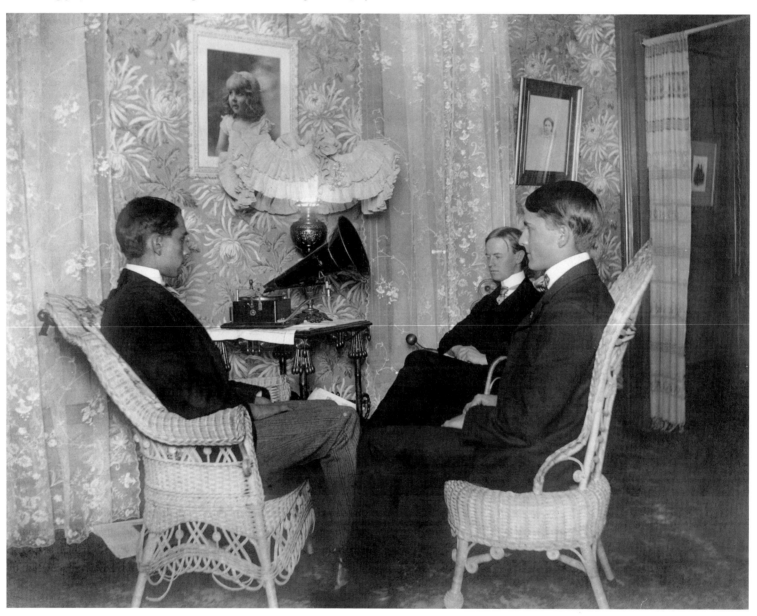

Hugh McCulloch built this grand home along the St. Mary's River in 1843. But he spent much of his later life in Washington after being named the nation's first comptroller of the currency by President Abraham Lincoln and serving as secretary of the treasury in three administrations. The pillars on the front were not part of the original construction. The house became the home of the Fort Wayne College of Medicine in 1892.

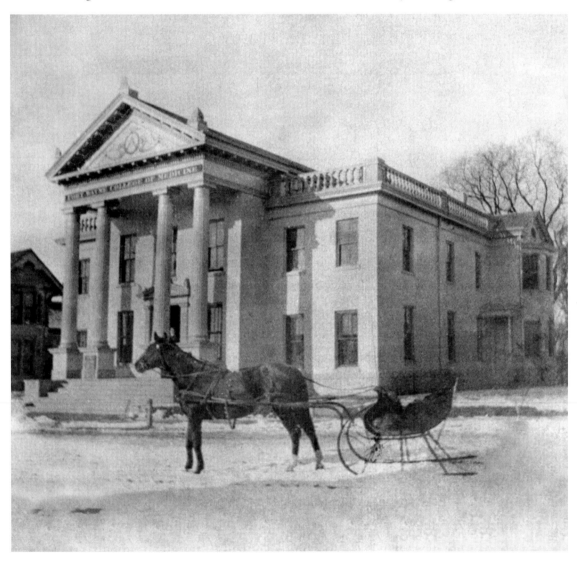

One of the most popular brands of cigar was the "Pony," manufactured by George R. Reiter, who is shown here in his store at Barr and Berry streets in the early 1900s. Reiter is at far-left, with his wife Mary Ann Payne beside him. The empty chair and strategically placed spittoon indicate they expected the photographer to sit down and talk for a spell.

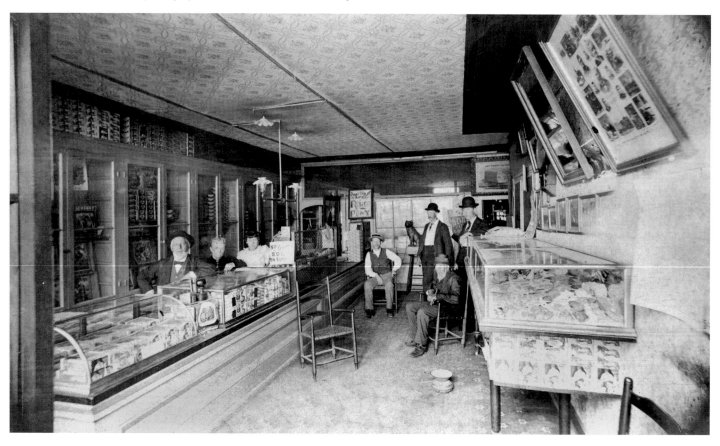

A December 3, 1903, fire, fanned by strong winds, left St. Paul's Evangelical Church in ruins. The church was rebuilt by April 1905.

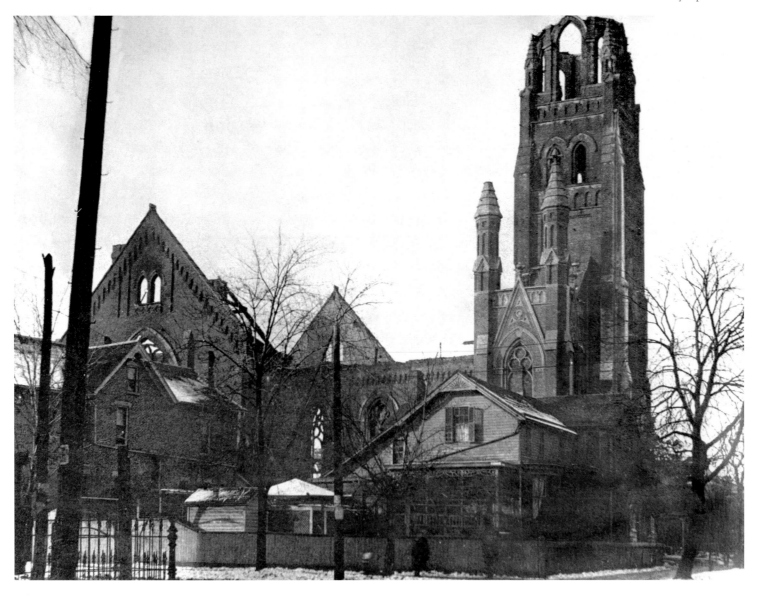

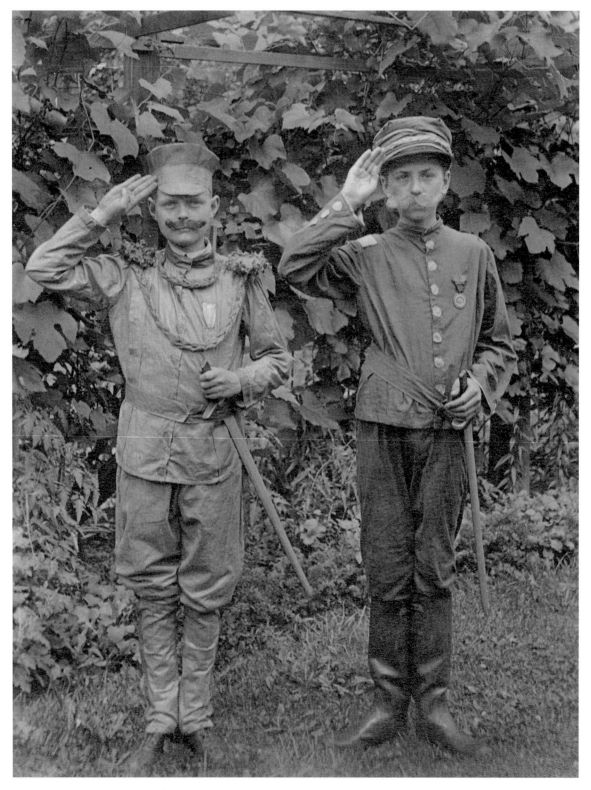

There was significant cultural pride among the German-speaking immigrants who helped Fort Wayne prosper in the nineteenth century. Singing societies, athletic competitions, and literary and political groups flourished within the immigrant community. In the decades before World War I, even young boys fancied themselves soldiering in their ancestors' armies.

Fort Wayne built its finest ballpark close to the St. Mary's River and flooding was a problem. The 1913 flood is better known, yet this is what the March 1904 flood did to League Park. The Fort Wayne Railroaders fielded a team in the Central League in 1904, but it moved to Canton, Ohio, in mid-season.

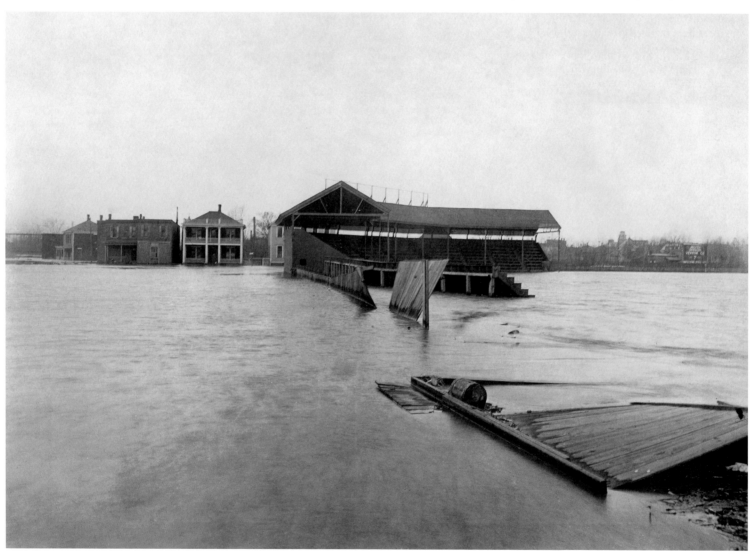

Built in 1895 at Calhoun and Wayne streets, the International Order of Odd Fellows building featured a distinctive and dominating design. The Fort Wayne Commercial Club, the forerunner of the Chamber of Commerce, was located here as well as one of the city's fine jewelers, August Bruder. The intersection's arc light and its gas-fueled or kerosene-fueled lamp on the corner are both visible in this 1905 image.

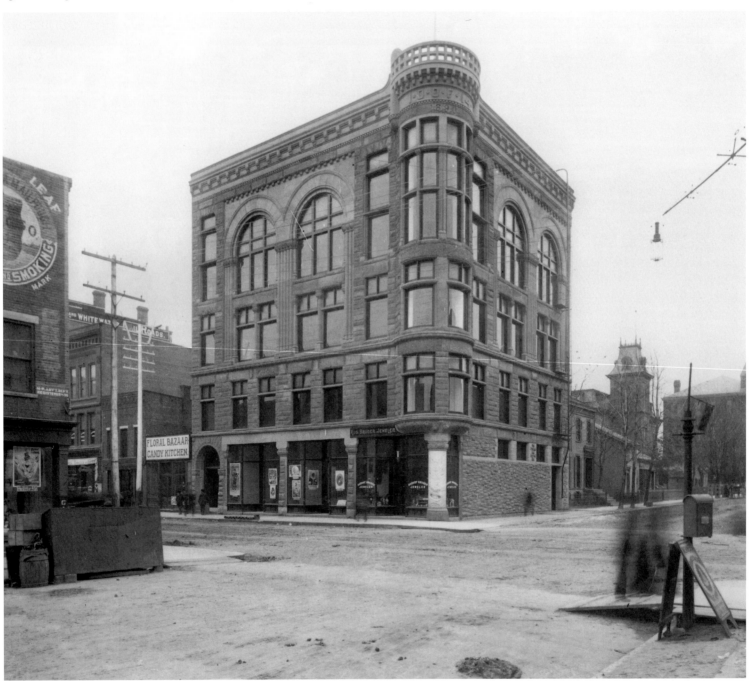

The Federal Building and Post Office was located at Berry and Clinton streets. Completed in 1899, the building resembled the Fort Wayne City Hall in size and design. It was demolished in 1938.

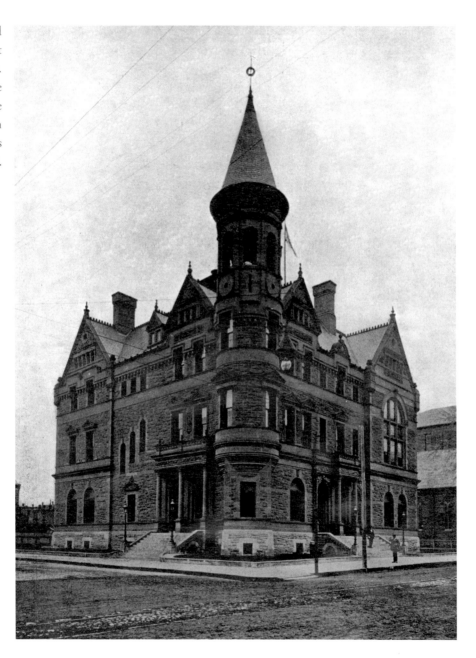

Although their hats may not be identical, the burden distributed among the mail carriers was consistent. This is a normal workload for Fort Wayne postmen at a time when 54 mail trains stopped daily and four deliveries a day were required to downtown addresses.

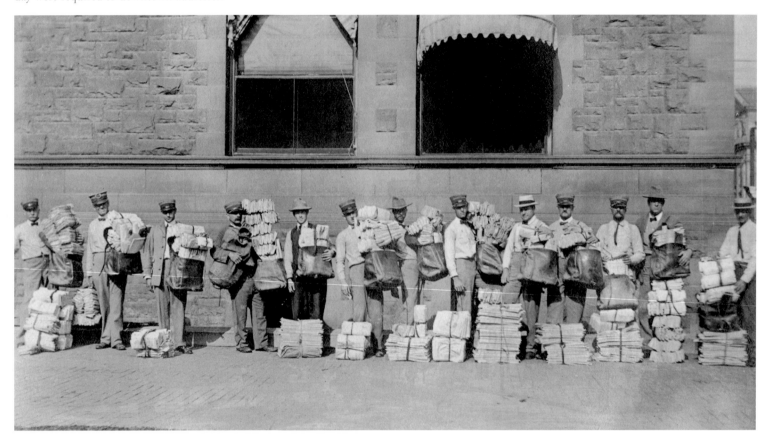

The crowd in front of the Allen County Courthouse is ready for a parade in 1903. The experienced policeman at left seems to be gauging how well the other officer knows how to handle the manually operated stop sign.

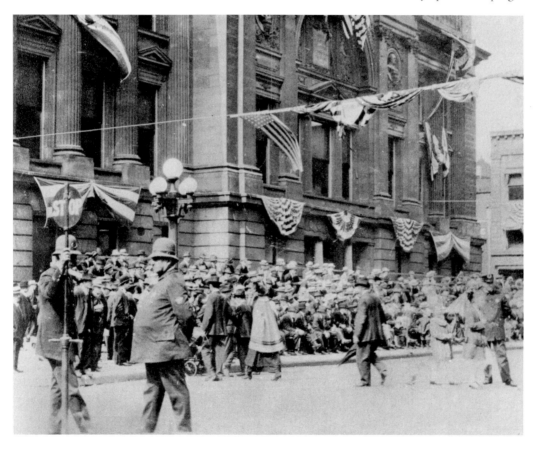

The 28th annual Grand Army of the Republic encampment brought thousands of people to Fort Wayne to see the Union Army veterans on parade in May 1907. The grand arch in front of the Elektron Building on Berry Street carried the images of three Civil War hometown heroes: Sion Bass, Henry Lawton, and Charles Zollinger.

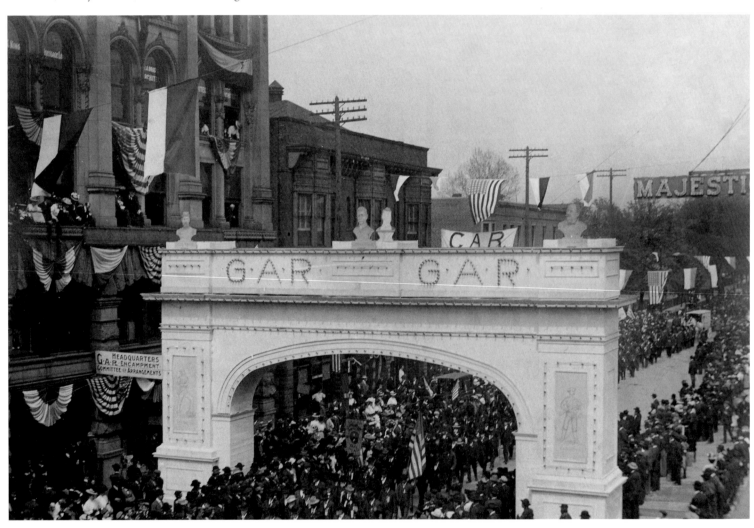

The GAR reunion also gave younger troops an opportunity to march in parade and salute the Civil War veterans during the three-day encampment. Here the 157th Infantry—which was called to active duty during the Spanish-American War, but never sent overseas—steps smartly along.

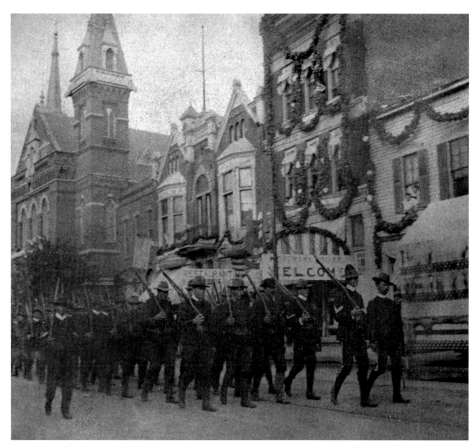

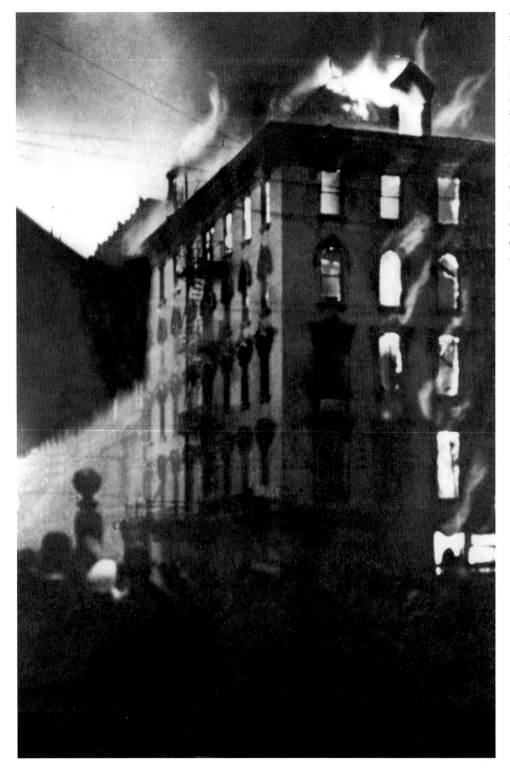

The worst fire in the city's history swept through the grand Aveline Hotel in the early morning hours of May 3, 1908, killing 12 people. The blaze was described as a veritable inferno. It took 20 minutes for the horse-drawn ladder truck to reach the scene, well after some of the victims had cried out in vain from the upper-floor windows. The city's grief continued through several days of recovering and identifying the victims.

On the day after the Aveline Hotel fire, small crowds gathered to view the charred remains as workmen sifted through the rubble for victims. Great piles of debris covered the street. Luggage, clothing, and jewelry were uncovered and taken to the courthouse for identification. While the fire raged through the Aveline, it apparently did little damage to the more modern Pixley-Long building.

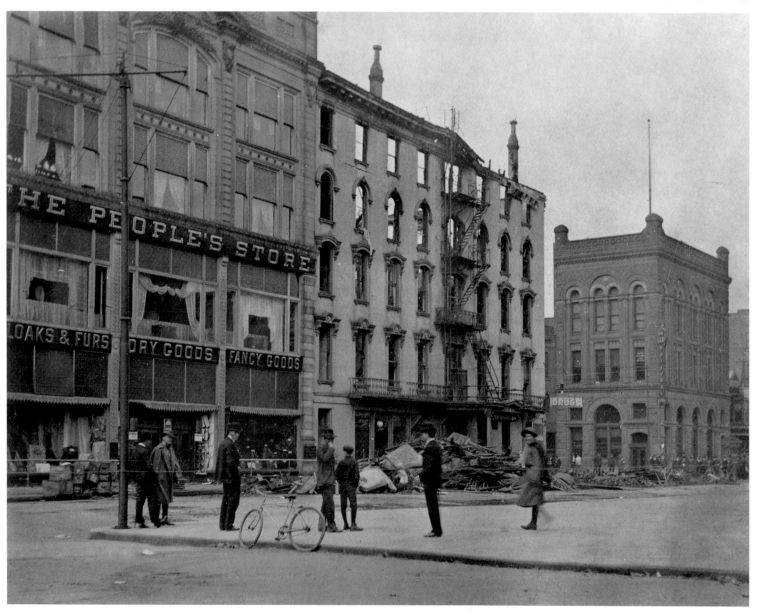

The Charles Crawford family is resplendent in their automobile and
finest outerwear in this 1908 image.

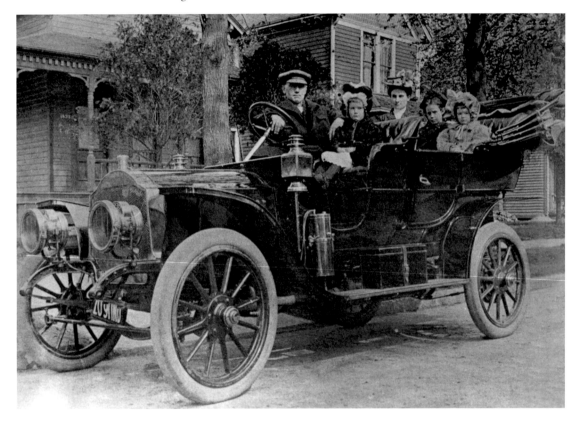

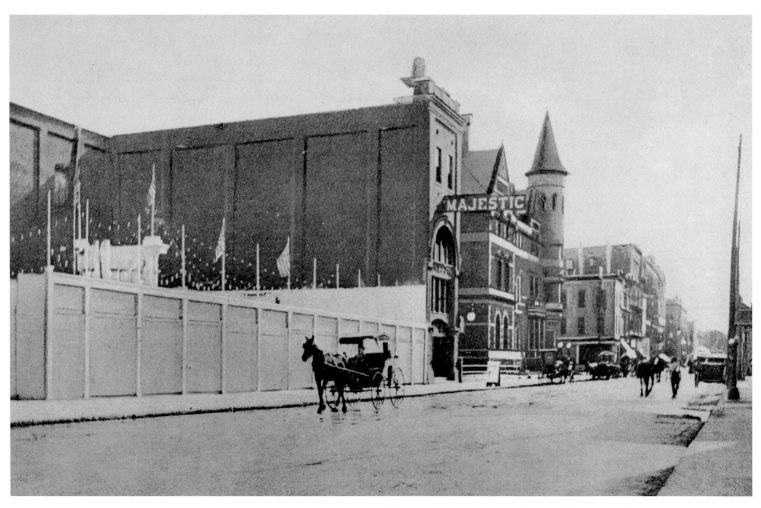

The 1,800-seat, exquisitely decorated Majestic Theatre opened in October 1904, only to be destroyed in a fire two months later, the result of a carelessly tossed cigarette. It reopened in the spring of 1905 and attracted the top traveling shows for the next 22 years. The Majestic was surpassed by the new Shrine Temple Theater in 1927, but served the theater-going public until it was razed in 1957.

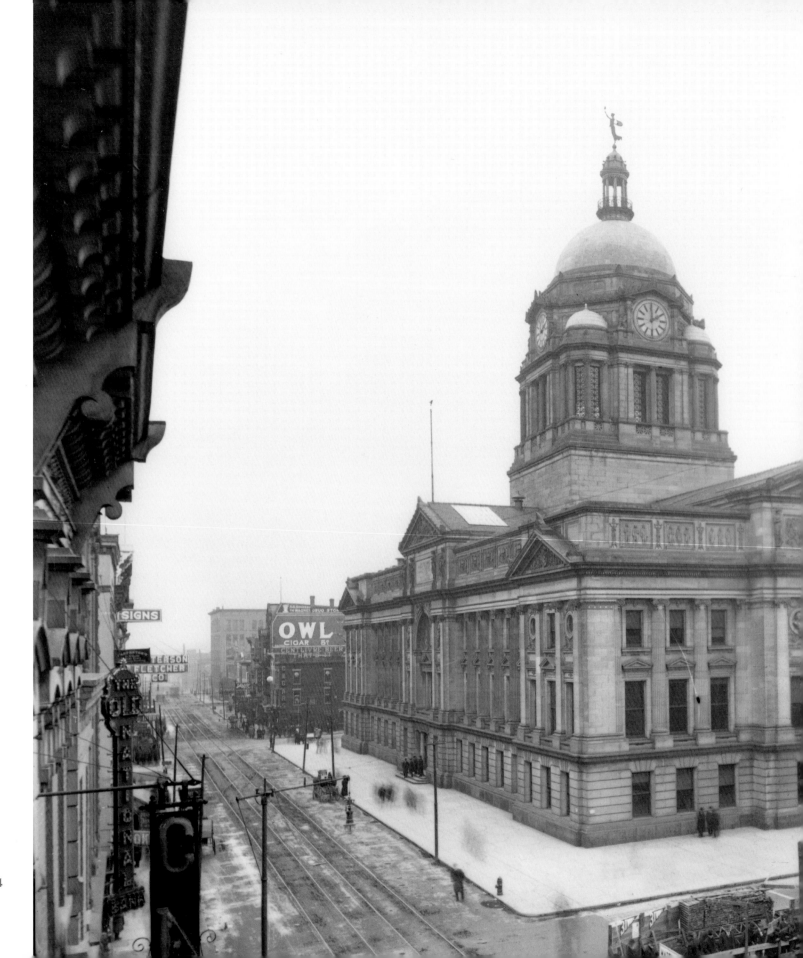

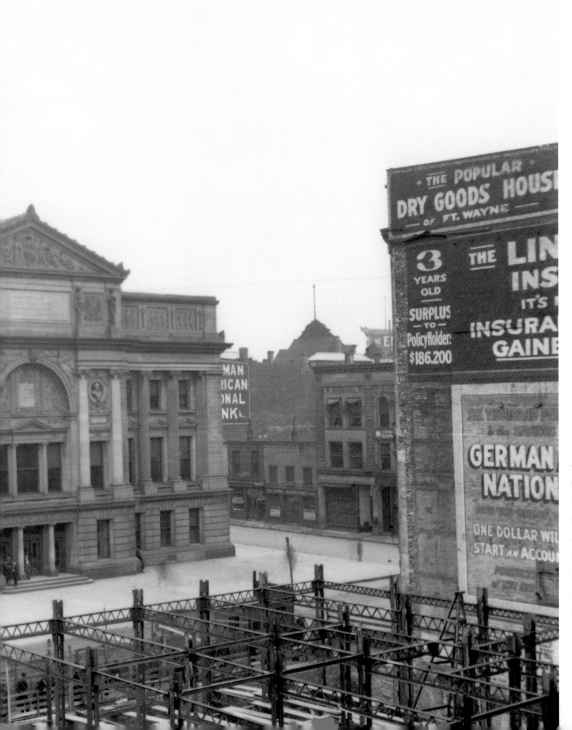

A copy of Brentwood Tolan's architectural drawings for the Allen County Courthouse resides in the Louvre, where it is valued as an example of early-twentieth-century U.S. architecture. Dedicated in 1902, the courthouse is a national treasure with its exterior sculpture and interior murals. When this photograph was taken in 1909, it dominated the city skyline. In the foreground, a new building finally rises from the ashes of the Aveline Hotel.

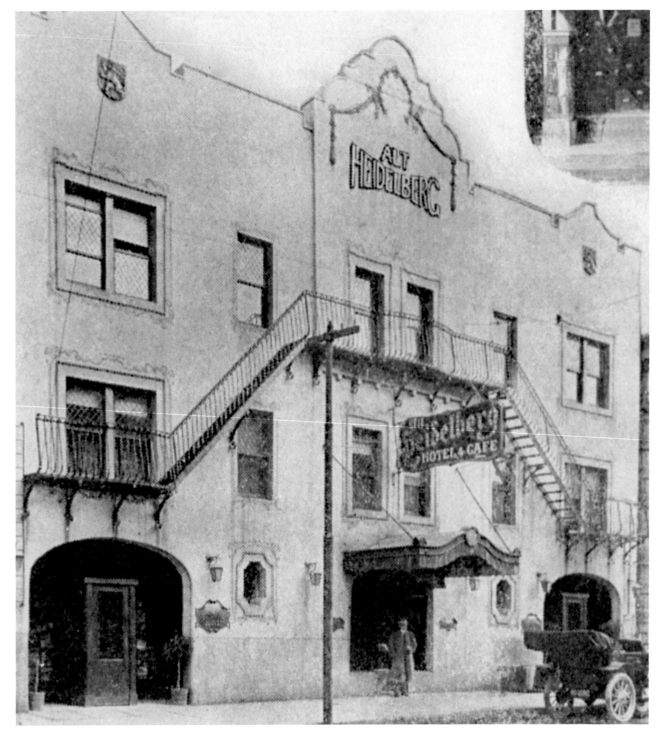

The Alt Heidelberg (or Old Heidelberg) Hotel and Cafe was appropriately described in 1910 as being Fort Wayne's "very European hotel."

The Barr Street Market continued to grow, and in 1910 stone pavilions were added to give farmers and produce buyers some protection from the rain and wind. The arch to the left spans Wayne Street and was decorated for different celebrations.

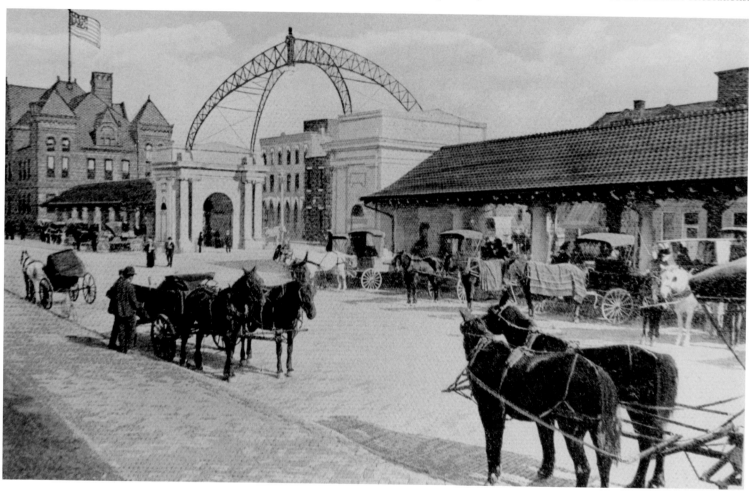

When St. Mary's Church was completed in 1858 to serve the German-immigrant Catholic population, it could claim the tallest steeple in the city. However, the Franco-Irish Catholic congregation completed the larger Cathedral of the Immaculate Conception two years later. St. Mary's was destroyed by fire in September 1993 after it was struck by lightning. A much different design was used for its replacement.

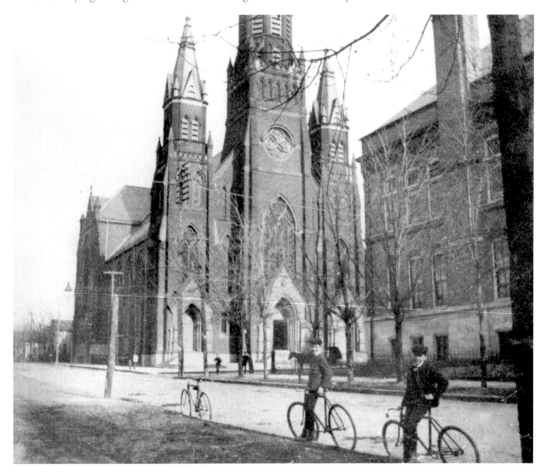

Cathedral Square included, from left, St. Augustine's Academy, the Cathedral, and Library Hall. St. Augustine's was built in 1846 and became a girls high school in 1884. Library Hall had been built as a parish hall and library for the Cathedral parish, and its first floor became Central Catholic, a school for boys. Both of these schools were closed in 1938 with the opening of a new Central Catholic.

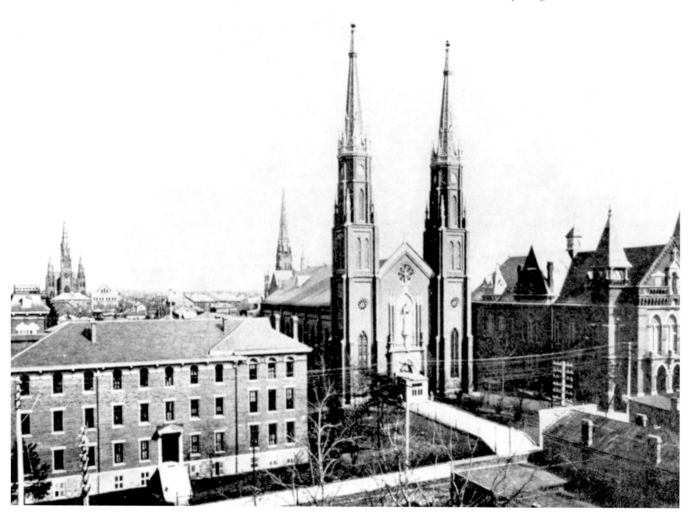

This was the second home of the Trinity English Lutheran Church at Wayne and Clinton streets. It was dedicated in 1884.

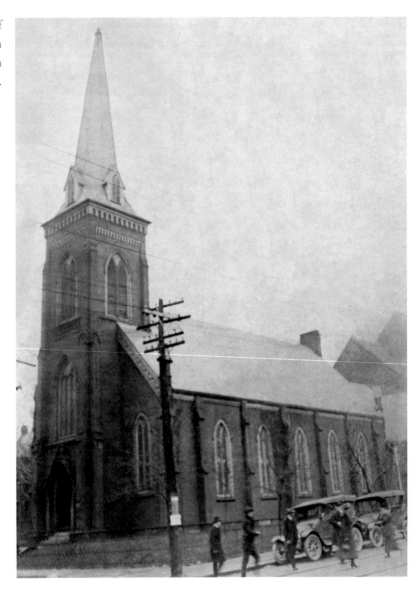

The two-story building to the right of the baggage platform is the Pennsylvania Railroad Station that served Fort Wayne prior to 1914. This is the station where Abraham Lincoln changed trains in the early morning hours of February 23, 1860, en route to New York City for his famous speech at Cooper Union.

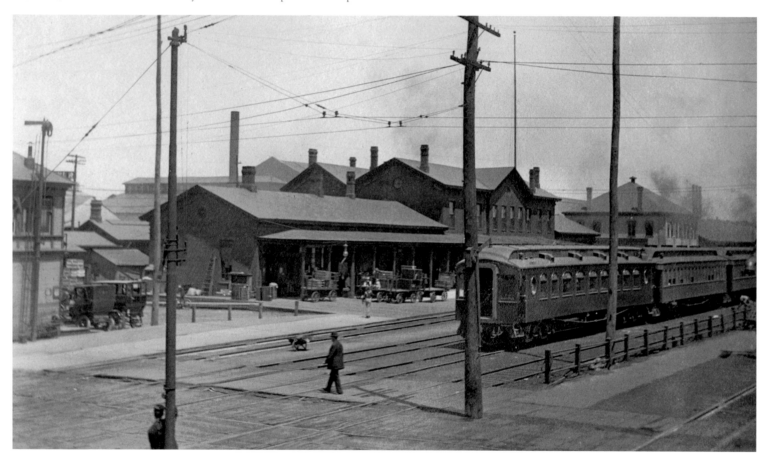

Smoke billows from the Mayflower Mills building on Columbia Street between Harrison and Calhoun on May 21, 1911. Although it appears the police have roped off the area, shoppers at Fisher Brothers Paper can be seen at left, seemingly unconcerned by the fire.

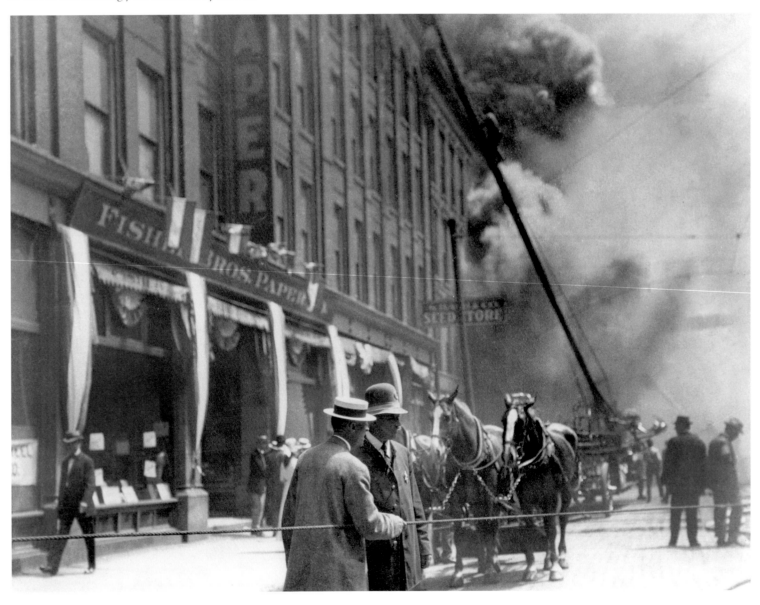

The worst train wreck within Fort Wayne city limits occurred on August 13, 1911, when a speeding Pennsylvania Railroad passenger train crashed into a freight train in Swinney Park. Three railroad men were killed and 35 passengers and crew were injured. The crash, which resulted from the passenger train trying to make up lost time, attracted hundreds to the scene.

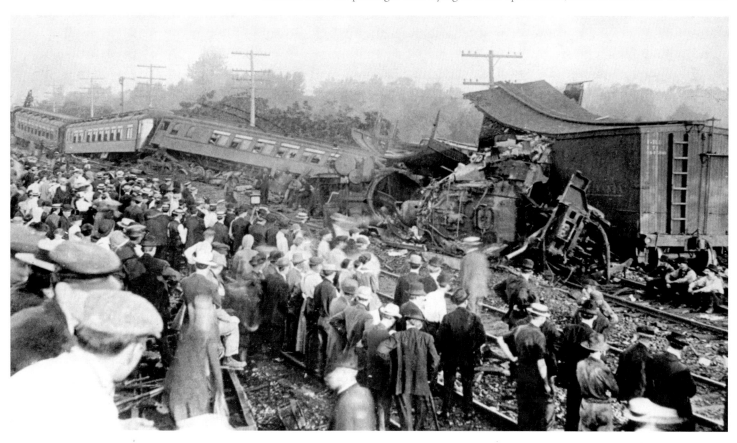

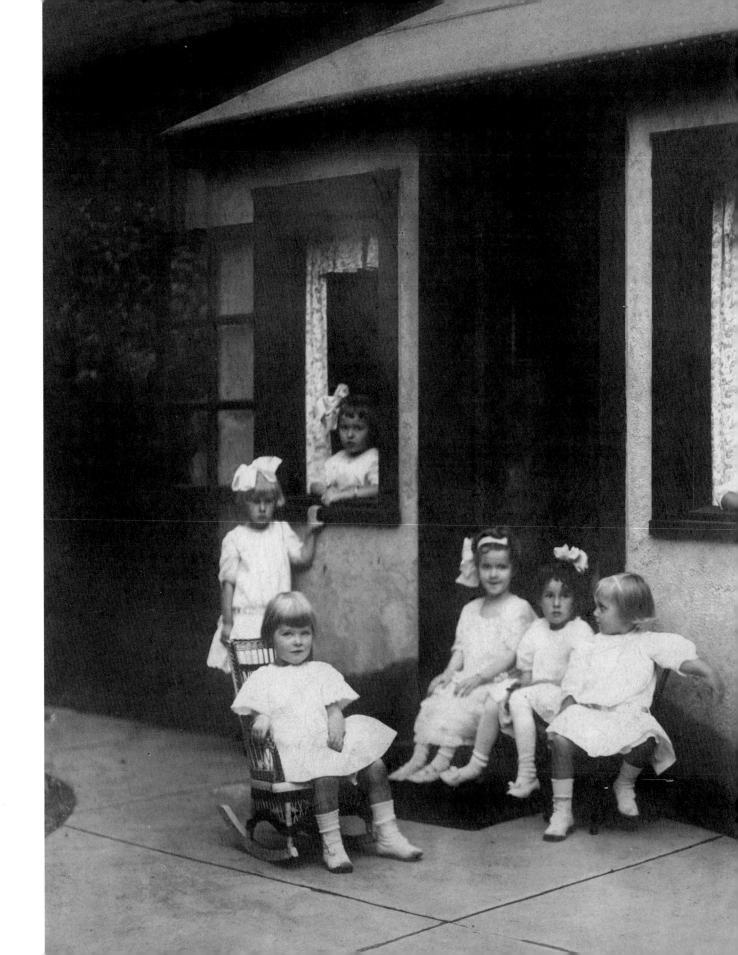

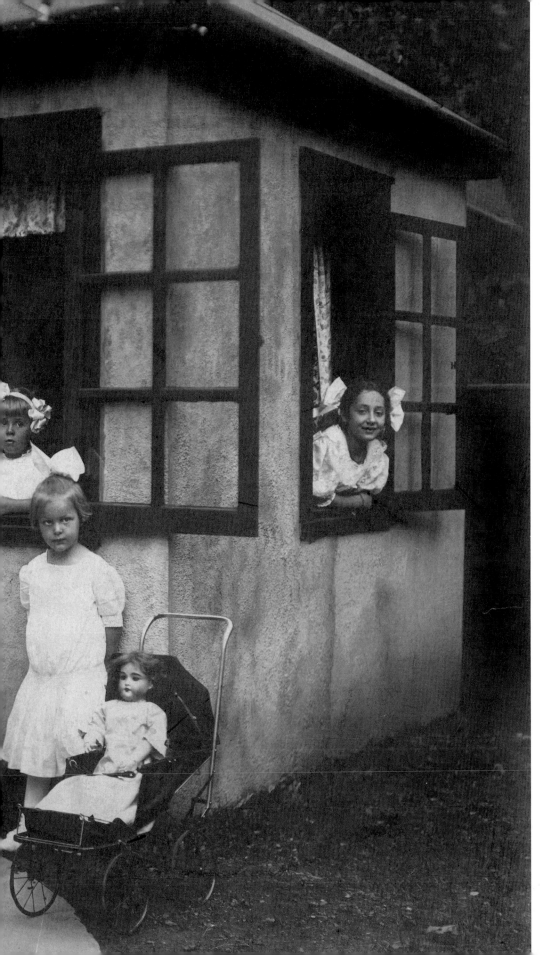

Miss Betty McCulloch, seated in the rocking chair, celebrated her birthday on September 5, 1911, with a special party at her "cottage" at 376 E. Berry St. Among her friends in attendance was Jane Alice Peters, sixth child from the left, seated on the stoop. Miss Peters would be hailed two decades later as one of Hollywood's greatest actresses, Carole Lombard.

Mayor William Hosey championed the elevation of the railroad beds through the city when he took office in 1909, arguing that the trains snarled traffic and impeded growth. While he succeeded in fashioning a plan for the Pennsylvania and Wabash railroads to raise their trackbeds—as shown here in 1911 near the Weber Hotel at 1601 S. Calhoun Street—the city would not realize a midtown elevation until the 1950s.

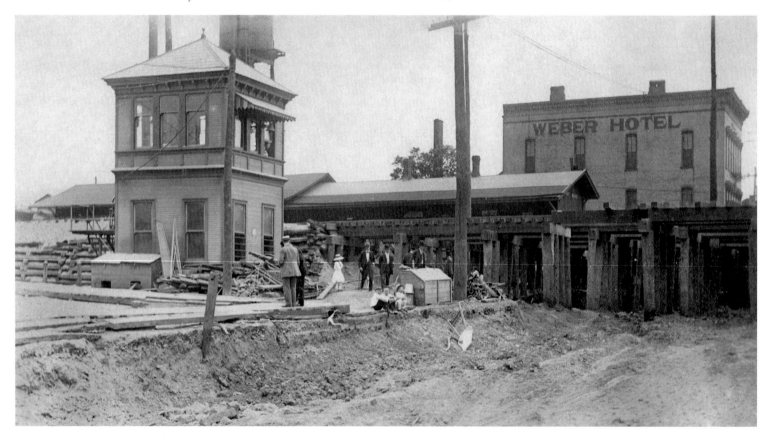

Depending on one's perspective, the Wigwam Saloon was on the right—or wrong—side of the tracks. It served Fort Wayne's Centlivre Special beer, which undoubtedly met the approval of those who frequented the tavern right next to the railroad tracks.

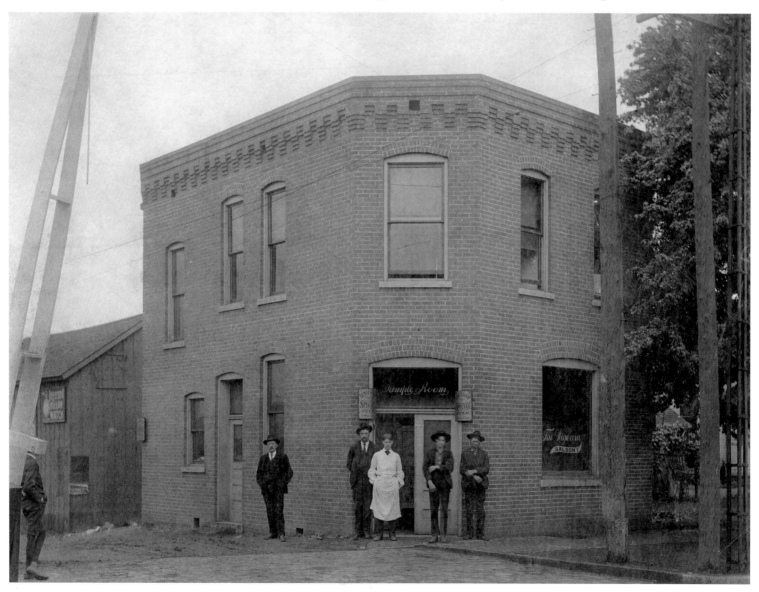

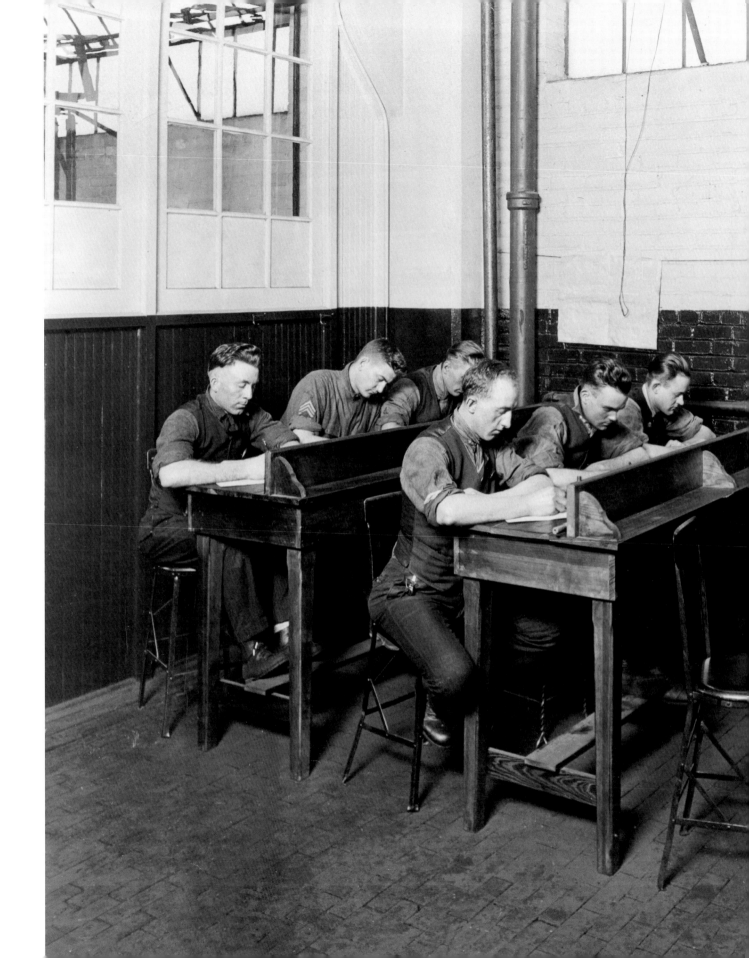

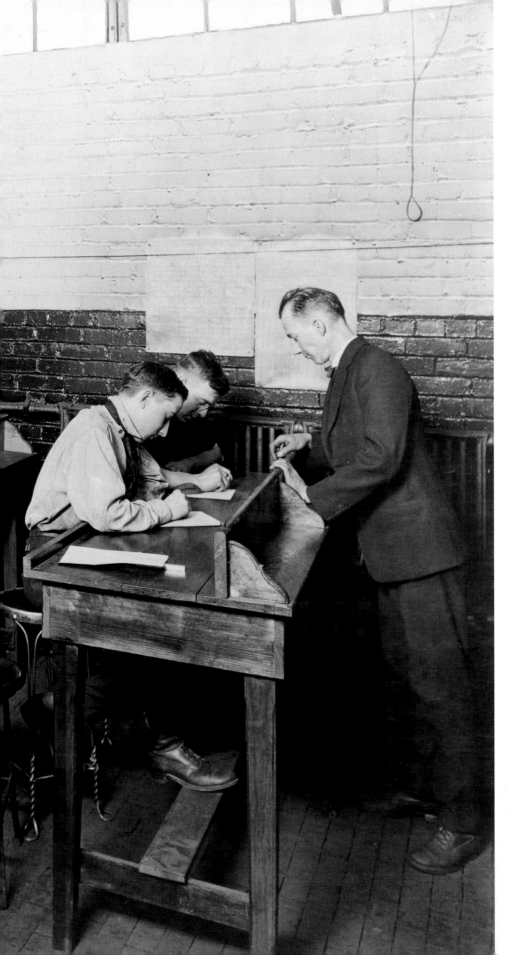

The General Electric plant in Fort Wayne was ahead of its time with an on-the-job training program for employees. A course included blueprint reading, mathematics, and other subjects related to the employees' tasks in the shop.

The massive flood in March 1913 devastated much of the Midwest, leaving neighborhoods and even whole communities isolated. The daily newspaper was often the sole source of news, which is why the *Journal-Gazette* sent its horse-drawn delivery wagons through axle-deep water to get its extra editions into the hands of its readers during the crisis.

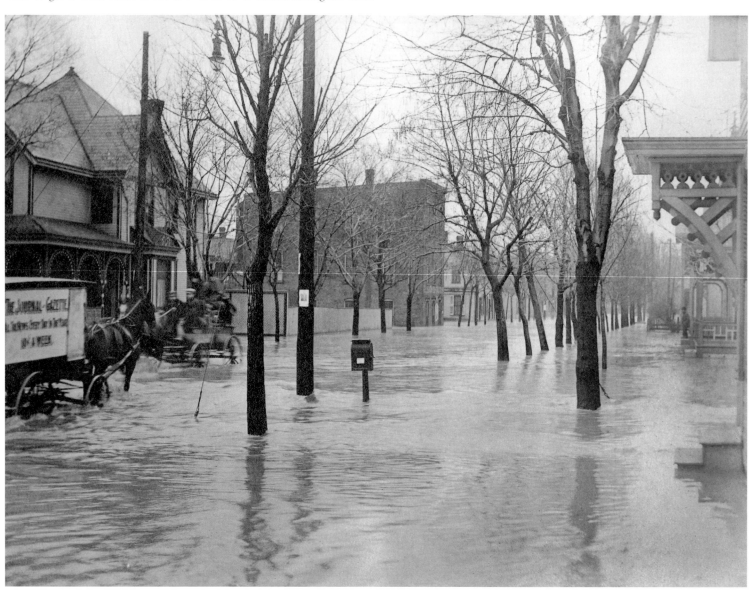

Art Smith captured the hearts and imaginations of people around the world in 1915 with his daredevil feats in the air. The self-taught aviator from Fort Wayne thrilled crowds with loop-to-loops and nighttime skywriting using phosphorous candles. He even won the hearts of some romantics by eloping with his sweetheart, Aimee, in his biplane.

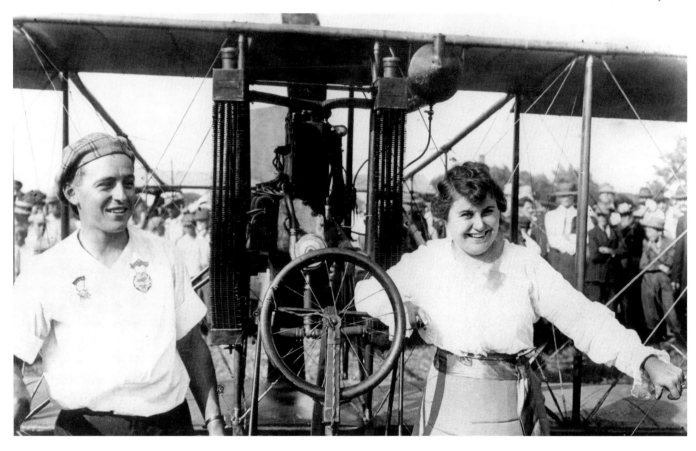

Henry Hilbrecht was instrumental in building the Fort Wayne fire department into a professional force. He became the city's first full-time paid fireman when he was hired in 1873 and its first official fire chief in 1882. He scrapped old equipment, built five new firehouses, and replaced cisterns with fire hydrants.

Although Fort Wayne has a proud history in Organized Baseball, its industrial or semi-professional leagues provided some of the most affordable, exciting entertainment. The men pictured here not only played for the Rolling Mill team, they also held down strenuous jobs at the mill.

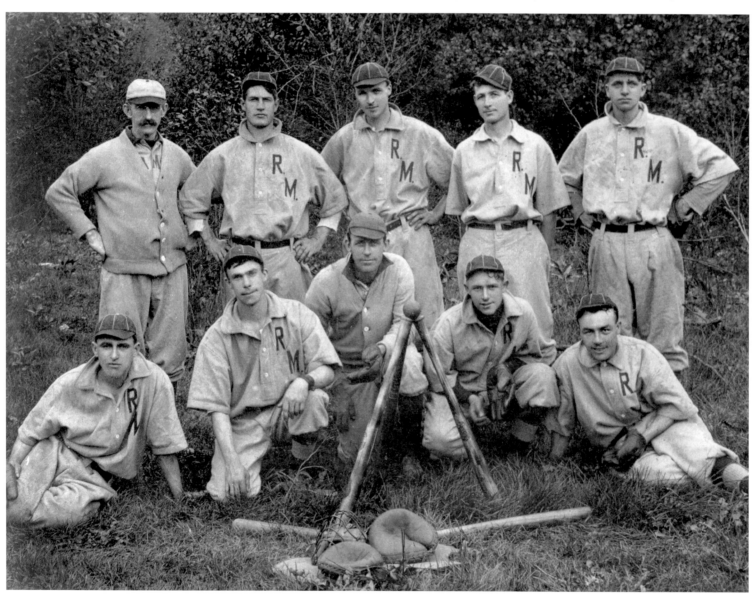

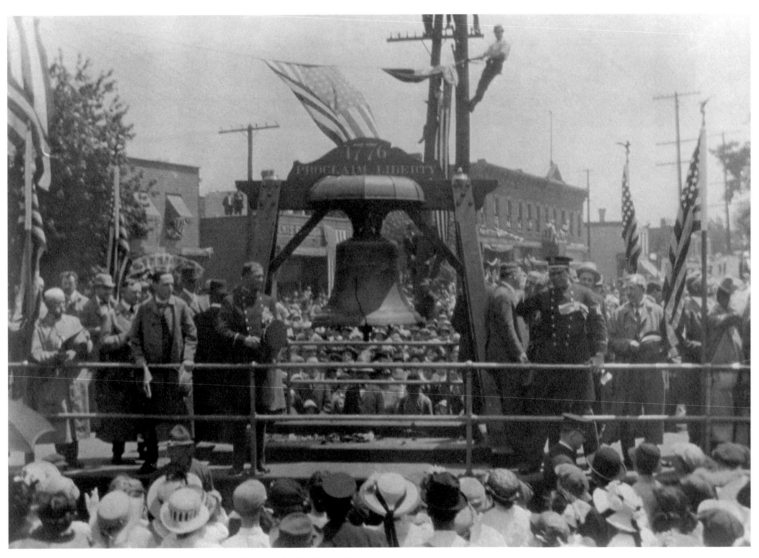

The nation's symbol of independence traveled from Philadelphia to San Francisco in 1915, and one of its stops was in Fort Wayne on July 6. The event was held at the new Pennsylvania Railroad station, where more than 50,000 people viewed the Liberty Bell.

GROWTH AND GRIT

(1916–1940)

One of the primary qualities of Fort Wayne in difficult times is its patriotism. With the outbreak of World War I, Indiana's second-largest city in population saw a remarkable surge in enlistments, in volunteer efforts in support of the war, in industrial production of armaments, and in home-based efforts to have a self-sufficient food supply.

The city used the same all-out effort to fight the influenza epidemic after the war. Business leaders, health officials, and volunteer organizations willingly took extreme measures—such as disinfecting buildings daily, canceling public meetings, and banning Christmas festivities—to fight the epidemic. The result was that Fort Wayne had fewer deaths than other communities.

Economic growth continued in the 1920s, particularly with the city securing the International Harvester truck manufacturing plant in 1923. The plant would become the largest employer, far more than the Pennsylvania Railroad shops that had been the backbone of the city workforce for many years. International Harvester, in turn, would spawn scores of smaller companies that served the truck plant's needs. It was during this period that Fort Wayne's future growth would be secured by the establishment of the magnet wire industry and the significant expansion of gasoline pump technology.

Fort Wayne's confidence led it to fight off the Great Depression, too. The city fathers were unwilling to accept federal relief and for two years raised money in the community to help the needy. Workers, for example, agreed to set aside one hour's pay every two weeks in many companies. There was a belief that if citizens would only spend ten cents more a day, the nation could escape its economic doldrums. When a "hooverville" began to grow in the area near the St. Mary's River, it became apparent that Fort Wayne was sharing the misfortunes of the rest of the nation. One measure of the impact was that this was the period of the city's slowest growth: The 1930 population had grown only by about 4,000 people when the 1940 census reported the city had 118,000 residents.

The Lincoln log cabin built in 1916 in Foster Park was visited by thousands of schoolchildren and history buffs over the years. The Lincoln National Life Insurance Co. underwrote the cabin in response to a growing interest in Abraham Lincoln and U.S. history. But the replica's accuracy is dubious since there wasn't any remnant of Lincoln's boyhood cabins in Kentucky or Indiana at the time. The structure still stands, but tastes have changed and it is now used for storage.

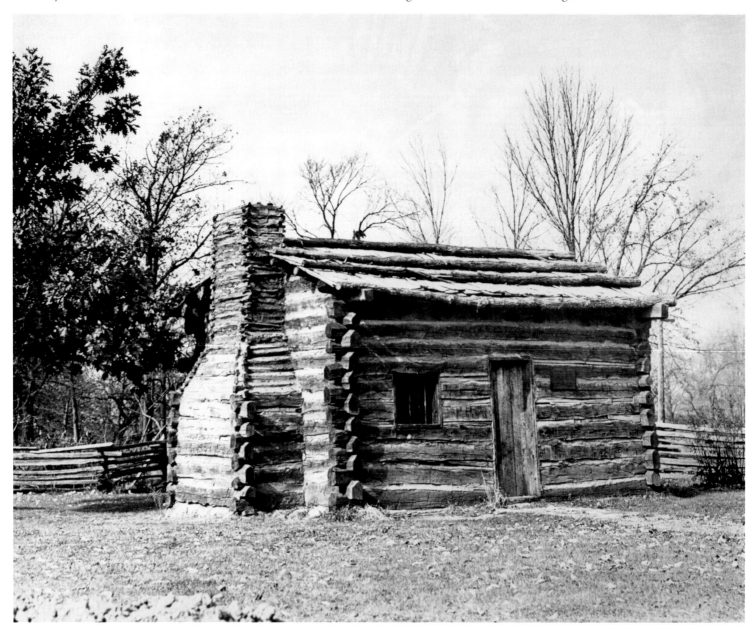

The Indiana Horticultural Society placed a marker at Swinney Park in 1916 to memorialize the work of John Chapman, better known as Johnny Appleseed. Chapman spent the last 10 years of his life tending to thousands of trees he had planted east of Fort Wayne along the Maumee River. Chapman died in 1845 and the society's marker is believed to be near where he was buried.

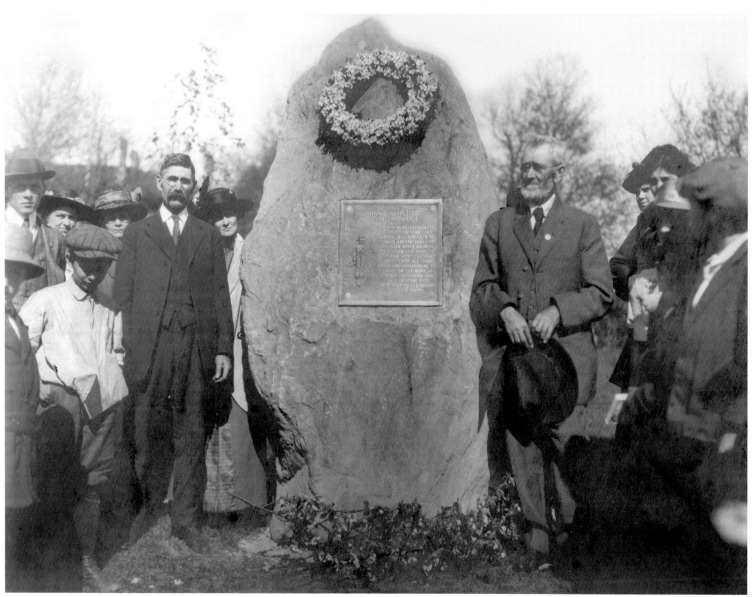

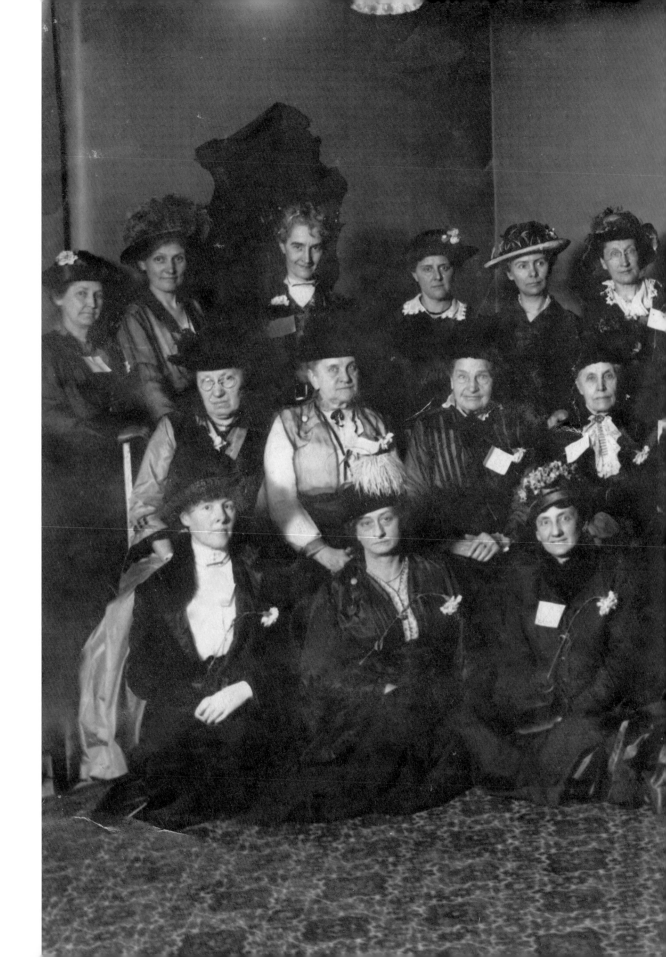

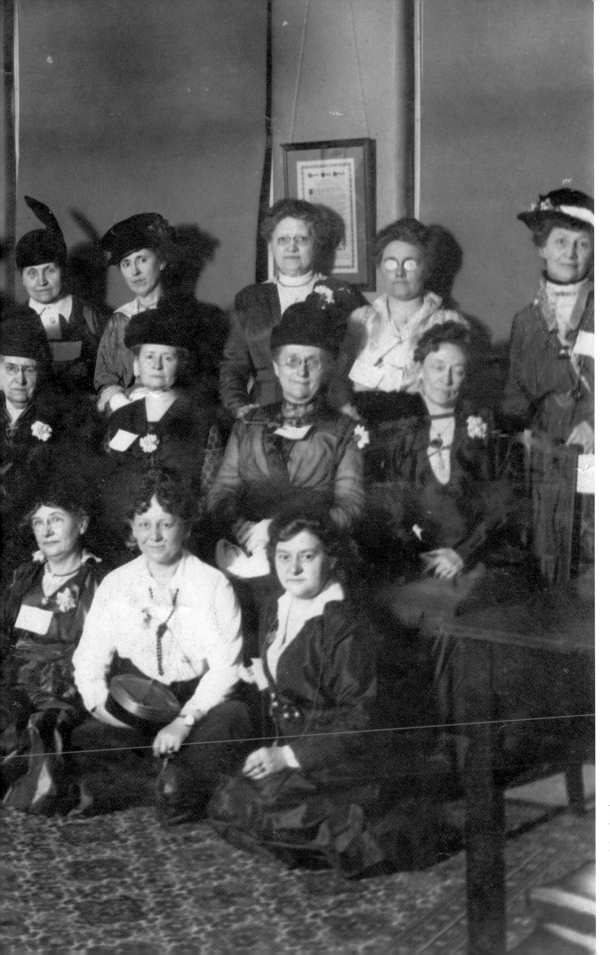

The founders of the YWCA in Fort Wayne were honored with a "Pioneer Days" celebration in 1916.

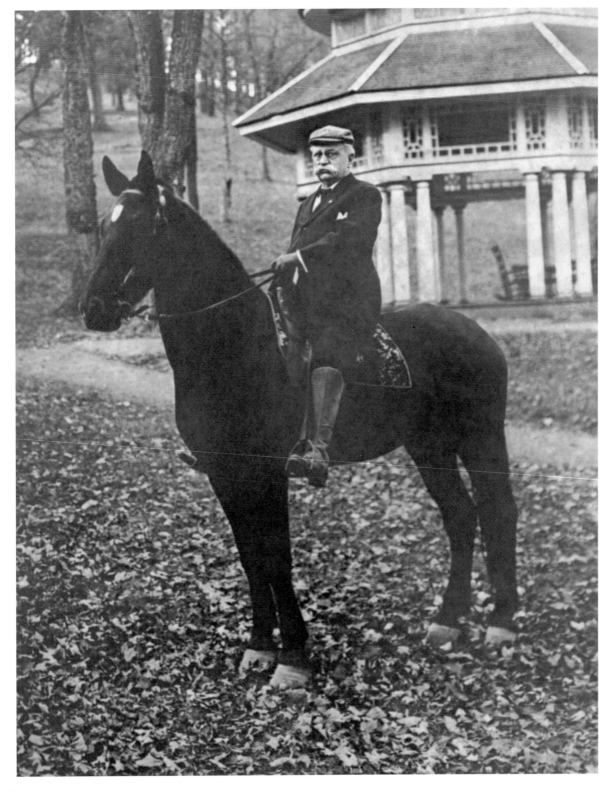

E. C. Rurode was one of Fort Wayne's leading retailers in the late nineteenth and early twentieth centuries with his New York Store on Calhoun Street across from the courthouse. In his youth he was one of the founding members of the first professional baseball team in the city and throughout his life a bit of a dandy, as this photograph suggests.

An idea that was ahead of its time, the Fort Wayne & Northern Indiana Traction Company's experiment in 1917 with "autobuses," was unsuccessful because of the vehicles' unreliability. Within two decades, though, buses would be replacing streetcars.

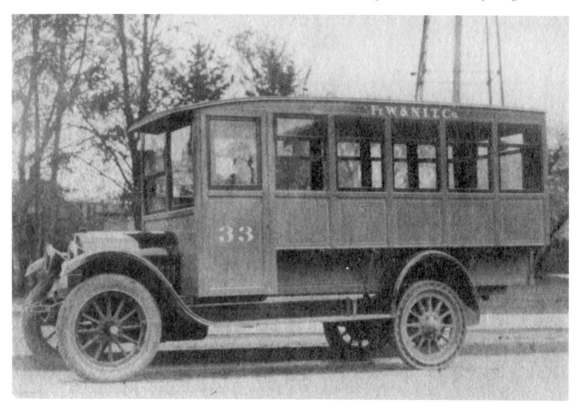

The funeral procession for Assistant Fire Chief George W. Jasper in March 1917 included a delegation of Fort Wayne police marching in the rain.

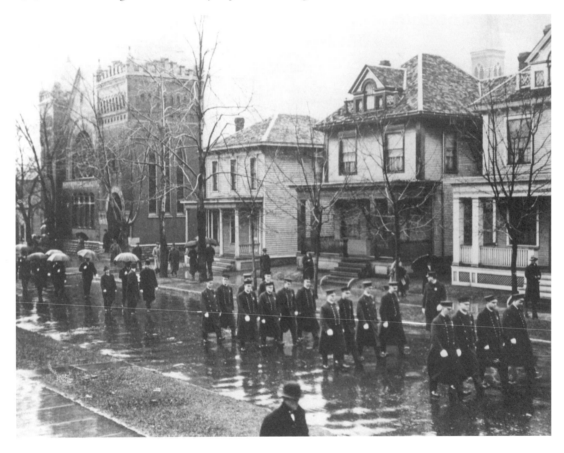

World War I brought a number of changes to people's daily lives, including rationing. In this photograph, an Indiana deputy monitors the offloading of barrels of sugar from a boxcar to waiting delivery trucks.

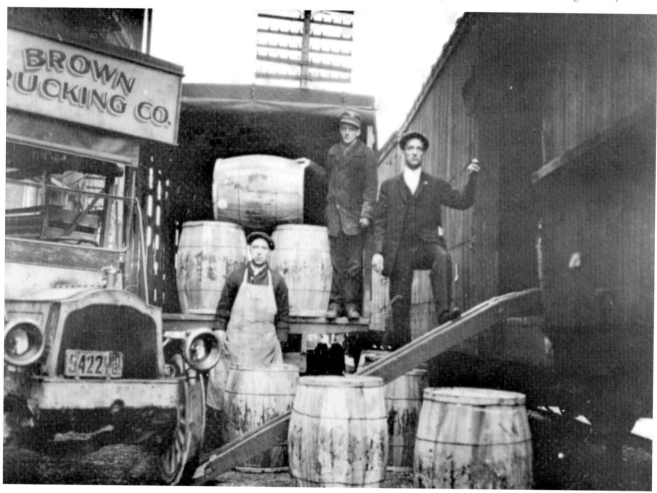

The renowned Packard Piano and Organ Company changed its tune in World War I, carefully crafting airplane propellers for the army in its Fort Wayne plant. The answer to the sign hung from the ceiling (asking "Who's the Boss?") seems clear when one looks at the foreman overseeing the workers.

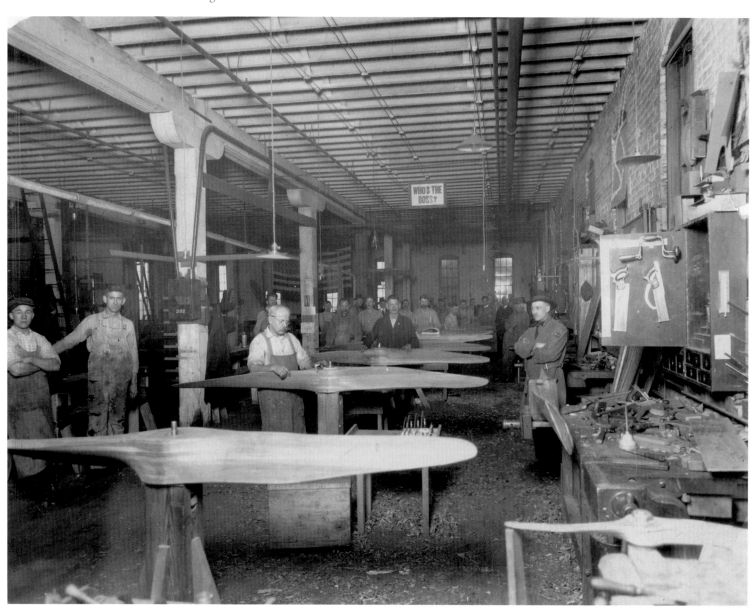

By 1918 there was a shortage of food supplies because of the war, and shoppers had to use a 50-50 rule when buying scarce commodities such as sugar and flour. Under the government plan, for example, one could buy five pounds of sugar only if he or she were also buying five pounds of a substitute for sugar.

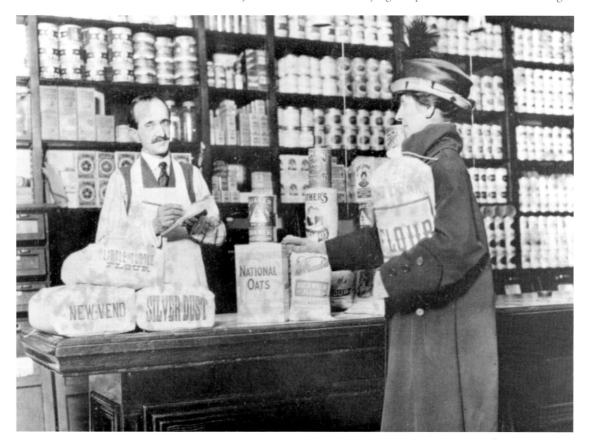

Red Cross fund-raising activities in Fort Wayne during World War I
included selling roses at the 1918 Liberty Gardens Fair.

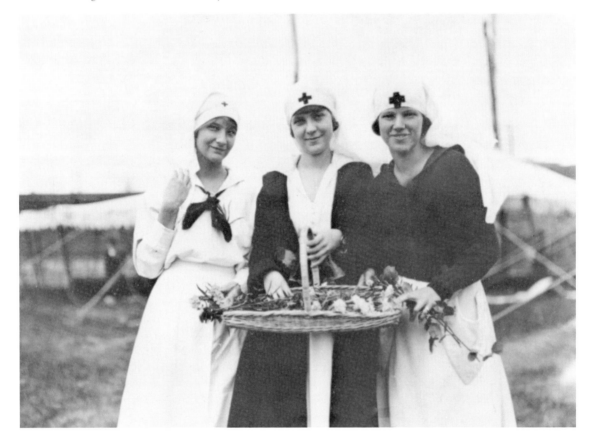

Every part of American society was asked to do its share in World War I. Here the Lincoln School Canning Club shows its contribution to the war effort in 1918.

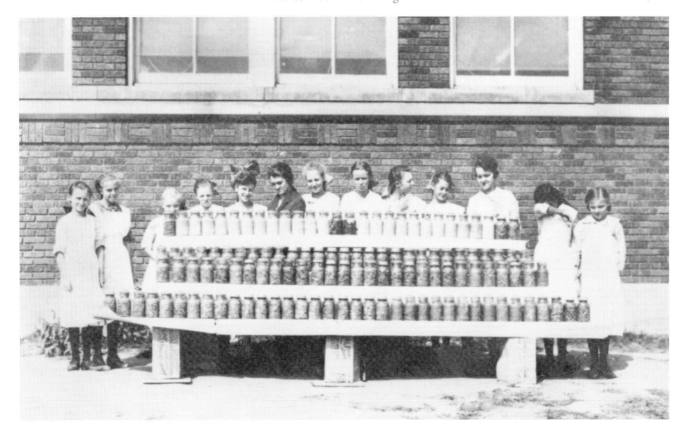

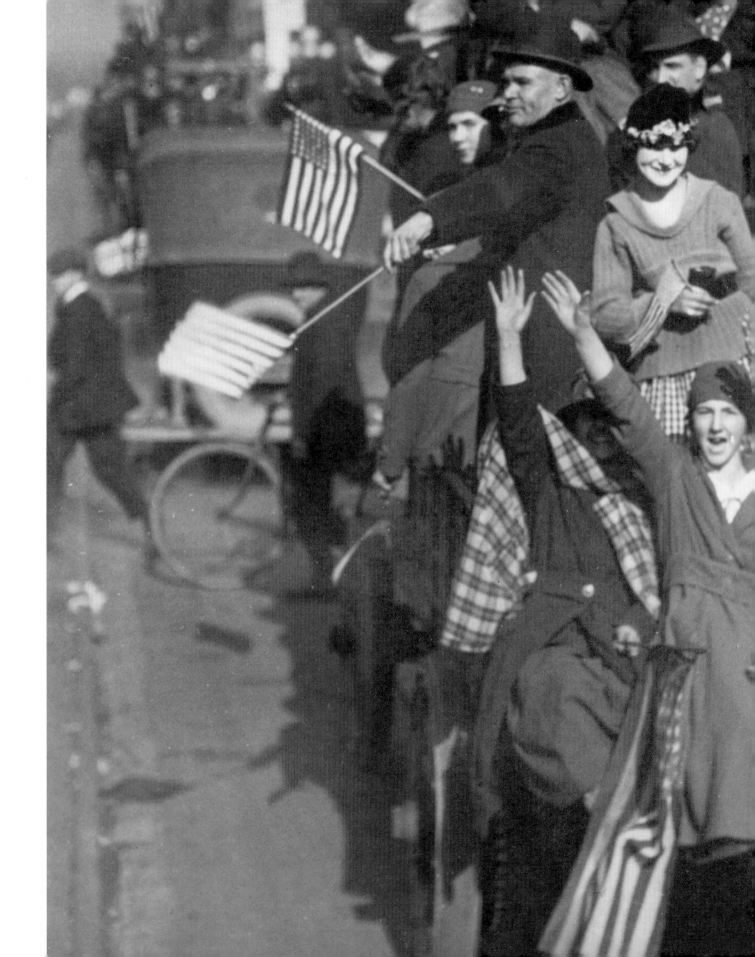

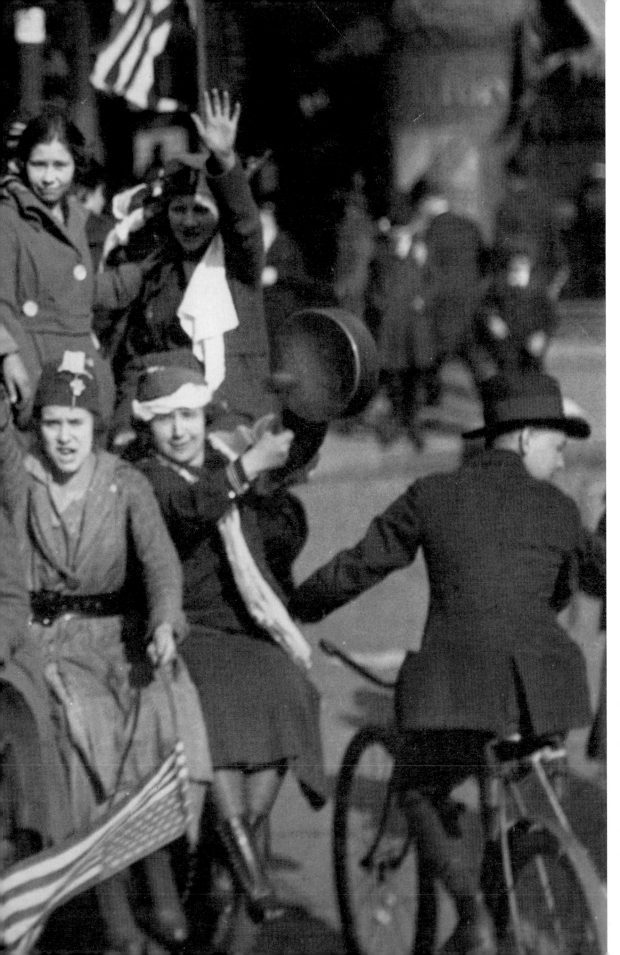

Fort Wayne responded the same as every other American city when the armistice was declared on November 11, 1918—with spontaneous bell-ringing, parades, and cheering. Some found unusual ways to make noise, like the woman on the rear of the vehicle banging the inside of her cooking pot with a hammer.

The Allen County and Fort Wayne Memorial to World War I was dedicated in 1920. With a doughboy on one side and a sailor on the other, the monument in Memorial Park lists those who died in the war.

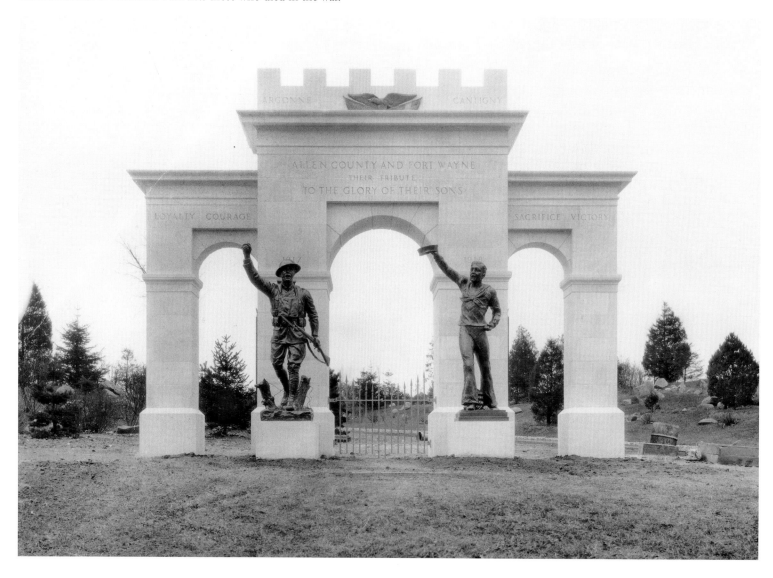

The return to prosperous times after World War I led to greater demands on public services. The back-breaking work of tearing up and repaving Calhoun Street south of Main Street was captured in this June 30, 1929, image.

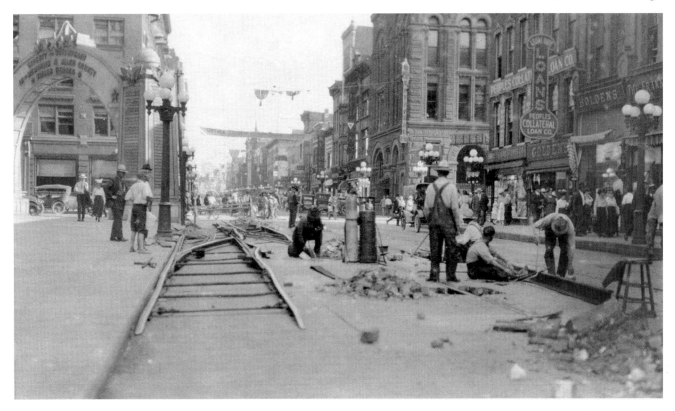

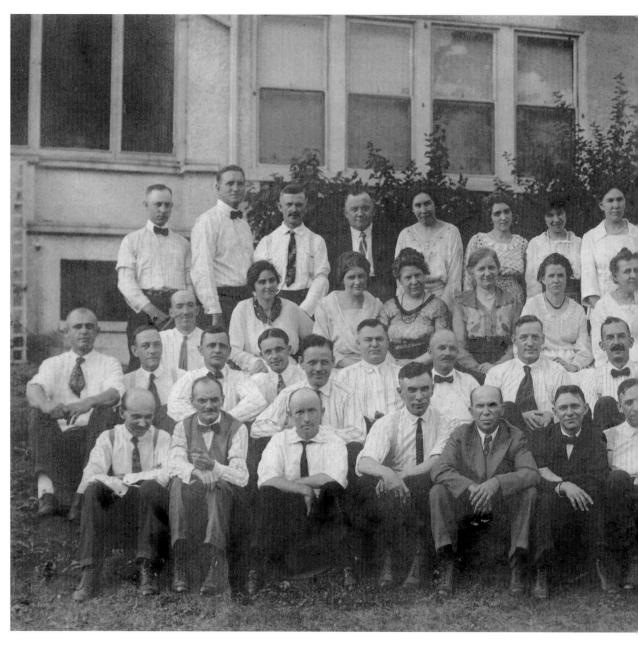

Theodore Thieme, at center in the front row with the white suit and dark tie, founded Wayne Knitting Mills in 1891. Thieme was a generous industrialist, trying to provide what he felt was right for his workers. Among his efforts was this annual outing at his home for longtime employees.

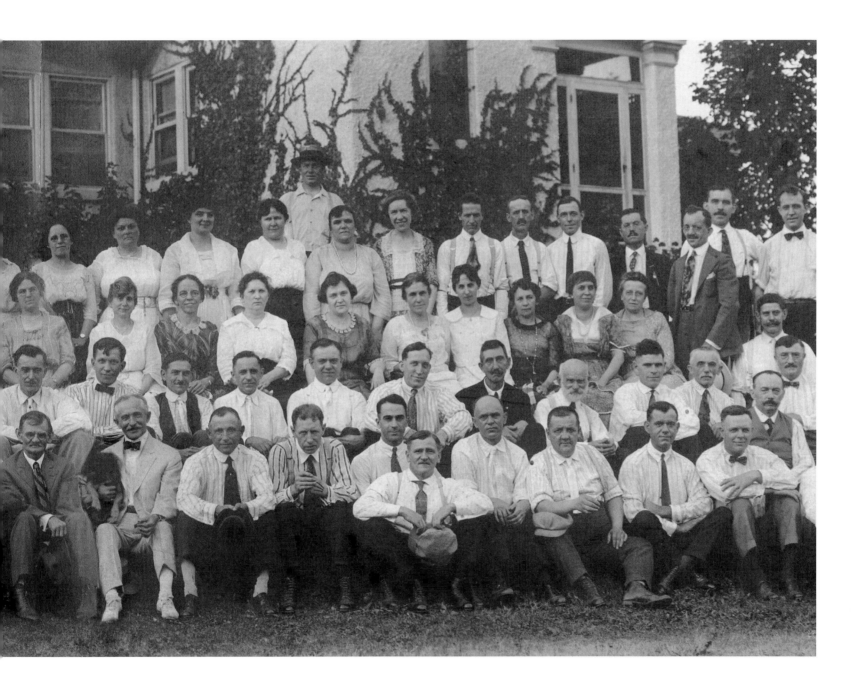

Fort Wayne continued to be a railroad hub into the early twentieth century. Few connections were as easy as when passengers could cross from the Wabash Railway depot, on the right, to the Pennsylvania Railroad station, at left in the distance.

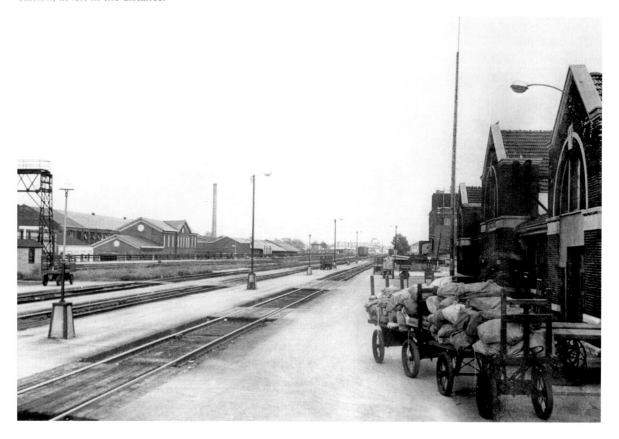

The Wayne Hotel was the first 100-room hotel in the city when it was built on Columbia Street in 1887. Still prospering in the 1920s, the hotel was located on the site of the original Dana Columbia house. It continued to operate until a February 1975 fire led to its demolition.

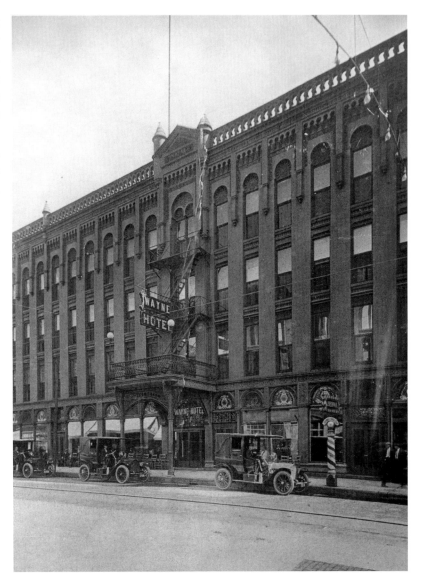

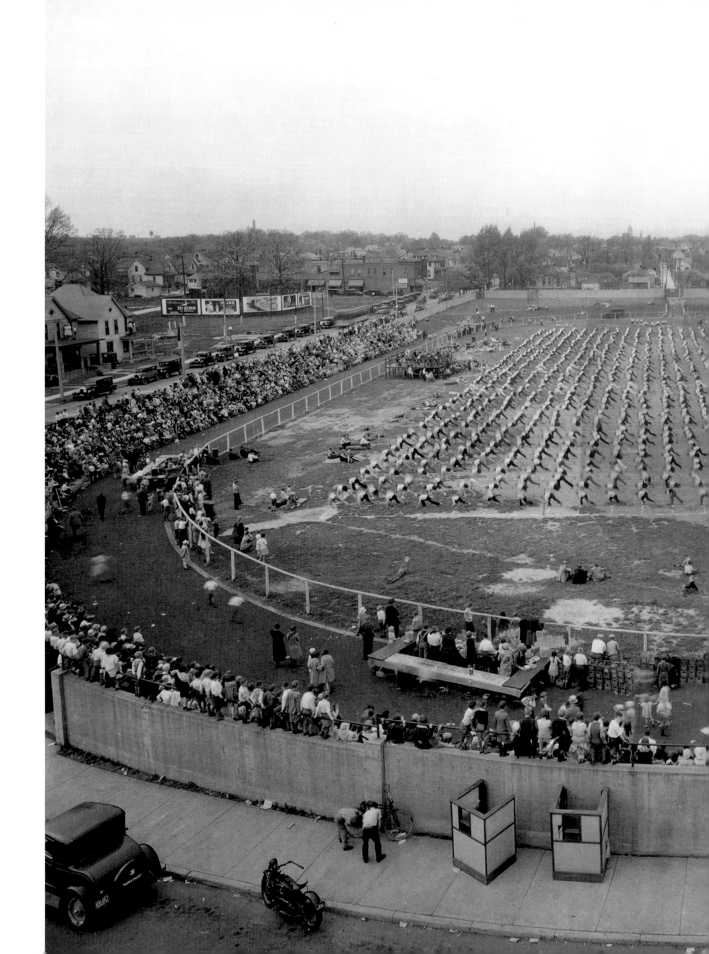

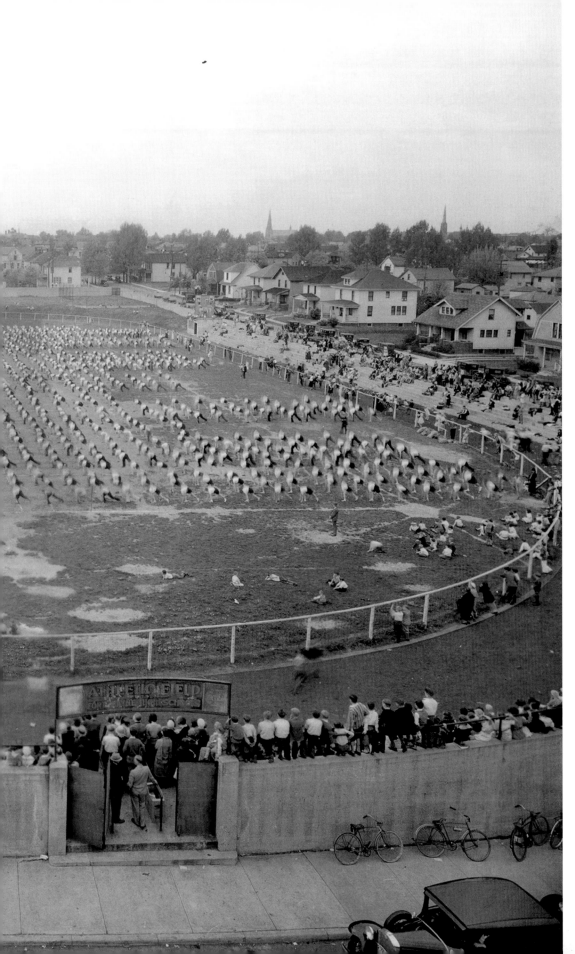

A sea of students at South Side High School enjoys field day in the 1920s. The school was built in 1922.

North Side High School was completed on State Boulevard in 1927 near the St. Joseph River. It was one of the city's first $1 million projects.

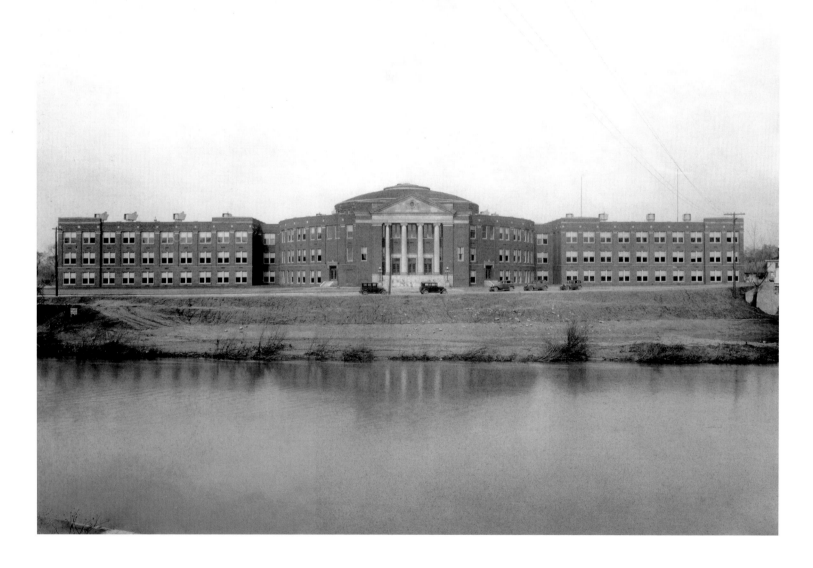

This vehicle was among the first of more than a million trucks produced at the International Harvester plant. Fort Wayne's success at outbidding 26 other cities for the truck manufacturer was one of its greatest successes in the twentieth century.

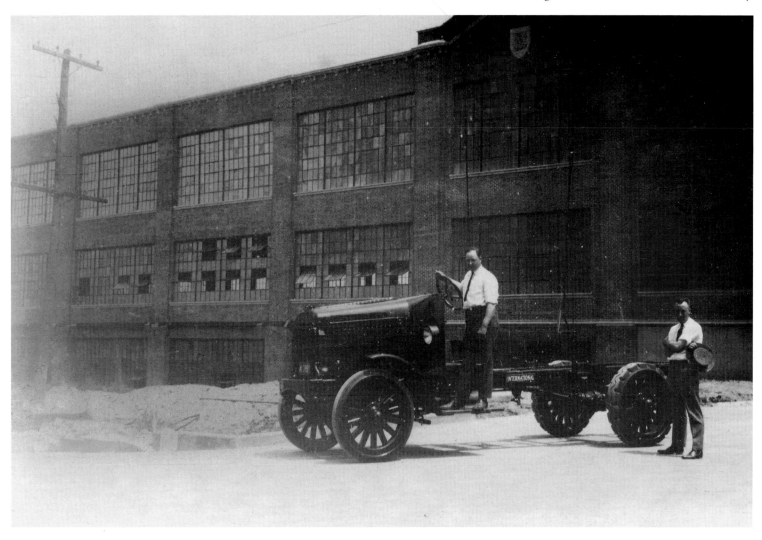

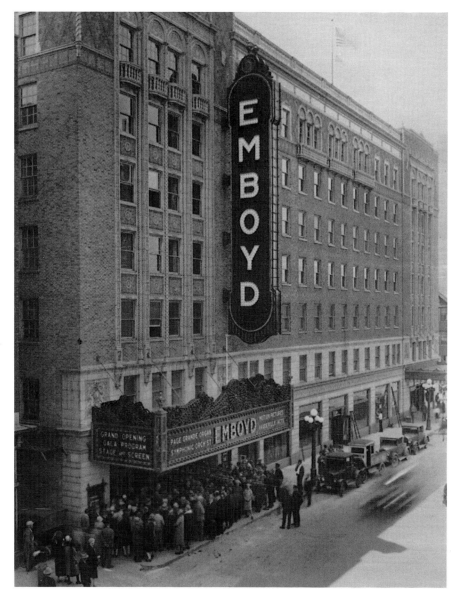

It is opening night in May 1928 for the Emboyd, a movie palace and vaudeville house on Jefferson Boulevard. Over the years the Emboyd featured stars of stage and screen, including Bob Hope whose first emcee job was there. In 1952 its name was changed to the Embassy. Twenty years later, a handful of community volunteers saved it from demolition and it stands today as the last of the majestic theaters in Fort Wayne.

The Public Library began an outreach program to poorer children in 1927 with a "book wagon," bringing reading material to kids on summer vacation. This visit occurred near the Rolling Mill School, which served the area around the Fort Wayne Iron and Steel plant off Taylor Street.

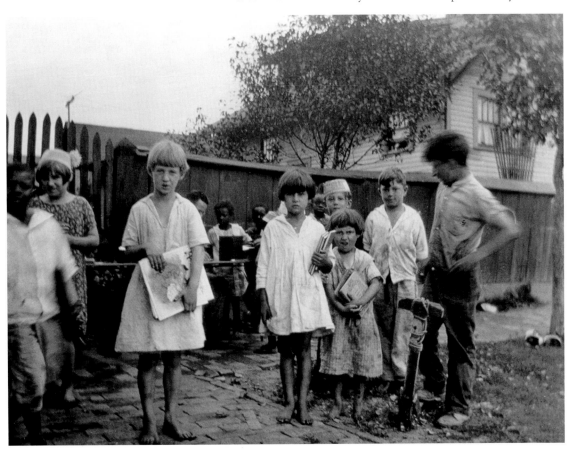

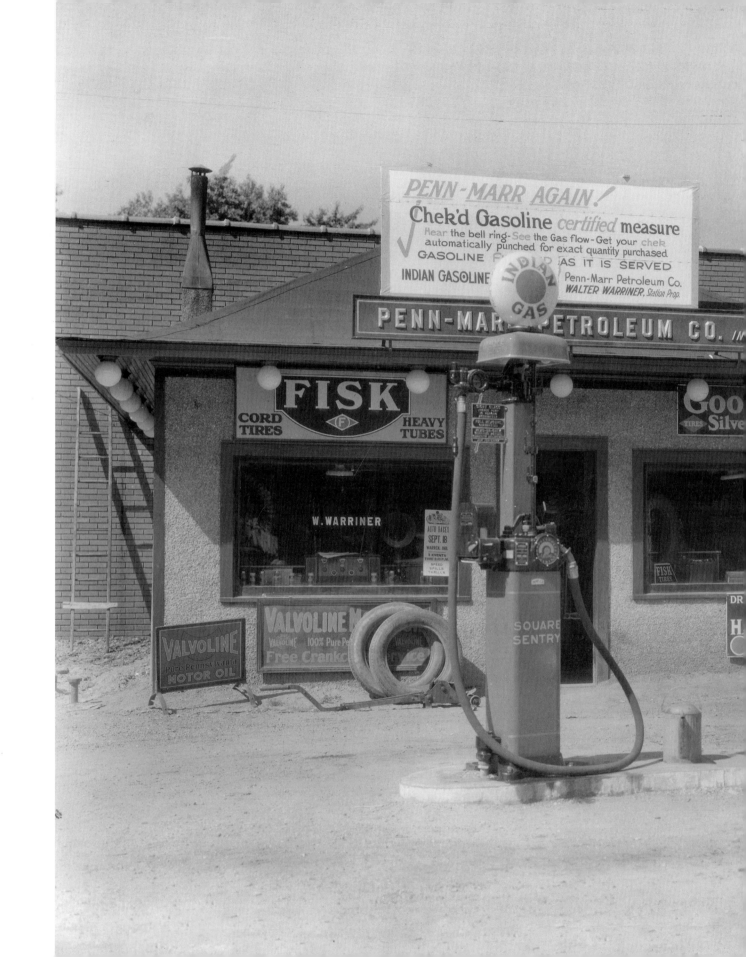

112

The Bowser certified measurable gasoline pumps are prominently displayed at the Penn-Marr Petroleum gas station at Packard and Fairfield in this 1927 photograph. Walter Warriner was the proprietor of this station.

113

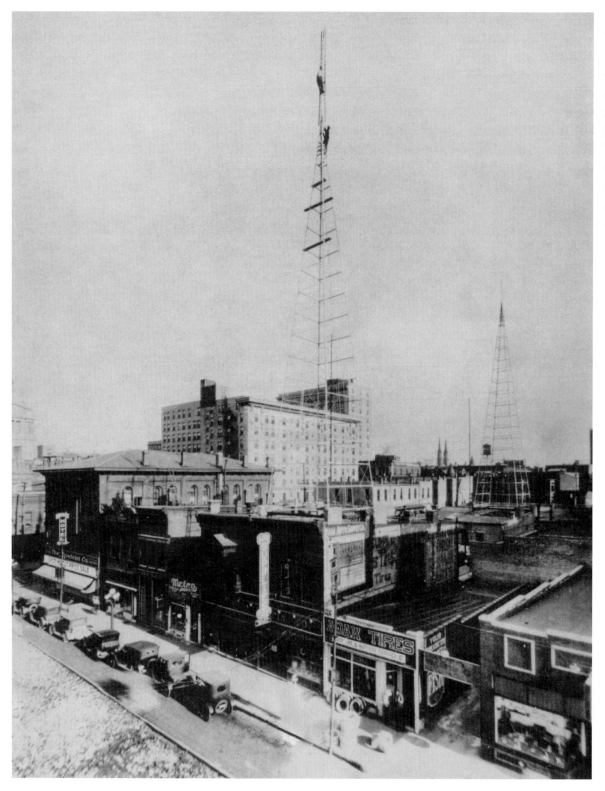

Radio Station WOWO began broadcasting in 1925 and by 1929 was the most powerful station in Indiana. The station's listeners ranged in distance from the Northeast to the upper South and throughout the Midwest, thanks to its antennae towering over downtown Fort Wayne.

Transfer Corner, as the intersection of Main and Calhoun streets was commonly known, was the heart of the city's public transportation system. Here the urban and interurban lines connected until the 1950s.

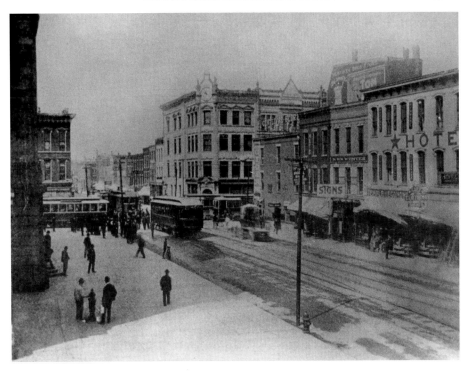

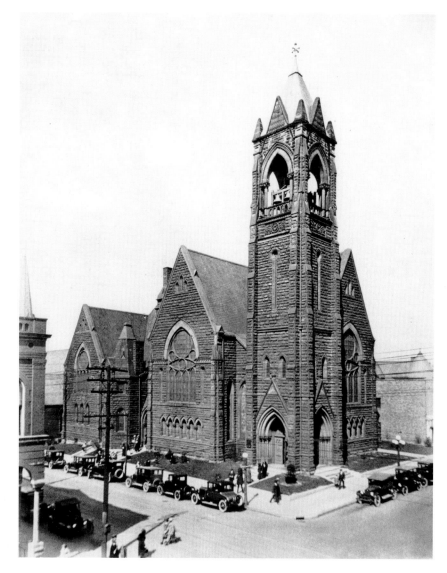

It appears that this 1920s photograph of the First Presbyterian Church located at Clinton and Washington streets was taken on a busy Sunday as parishioners headed to church.

The Fort Wayne Public Library was built in 1904 with the help of a $90,000 grant from the Carnegie Foundation. The Greek Revival structure, built from buff-colored Indiana Bedford limestone, was razed in 1965.

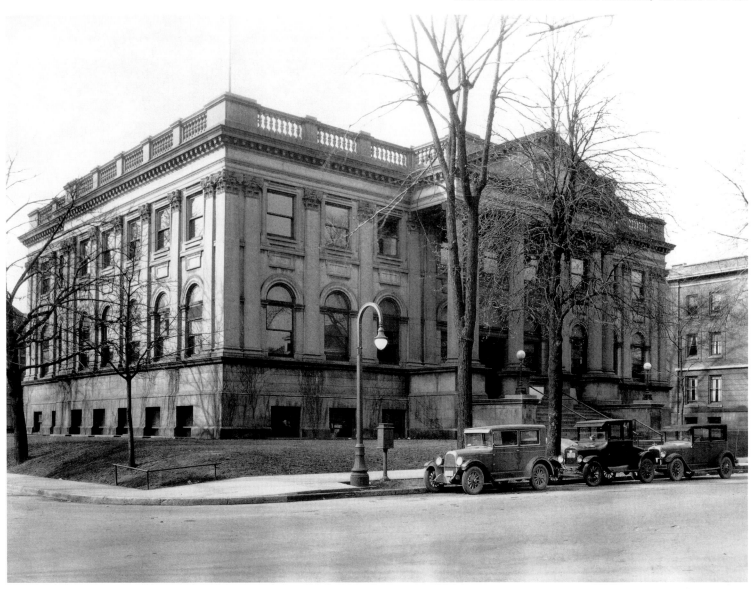

The South Wayne School was built in the 1890s and continued to serve its neighborhood until the 1950s. This image of children in a reading class was recorded around 1928.

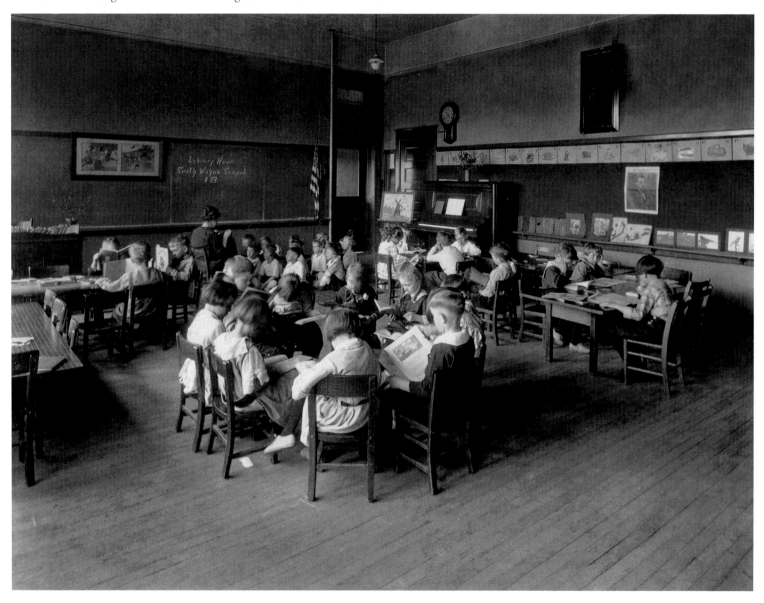

There were plenty of high hopes when Board Chairman Sam Foster broke ground for the Lincoln Bank Tower in August 1929. A little more than a month later, the stock market collapsed. Fort Wayne's first skyscraper was completed in 1930, and Lincoln Bank was one of two banks in the city to survive President Roosevelt's bank holiday without undergoing a reorganization.

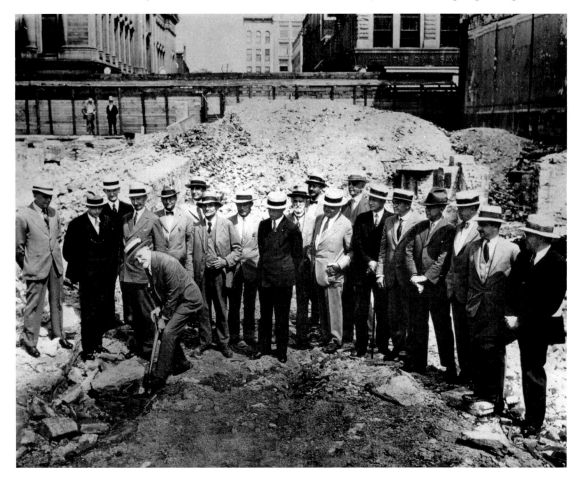

The Achduth Vesholom congregation was formed in 1848, and this synagogue at Wayne and Fairfield streets served as its home from 1916 to 1958.

Fort Wayne was among the many U.S. cities vying for airmail service in 1930 and managed to send more than 45,000 letters the first day of service. George Hill was the pilot in the first flight, shown here in the cockpit of his biplane at Smith Field. In April 1932, Hill was killed when his plane crashed on a Fort Wayne–to–South Bend flight.

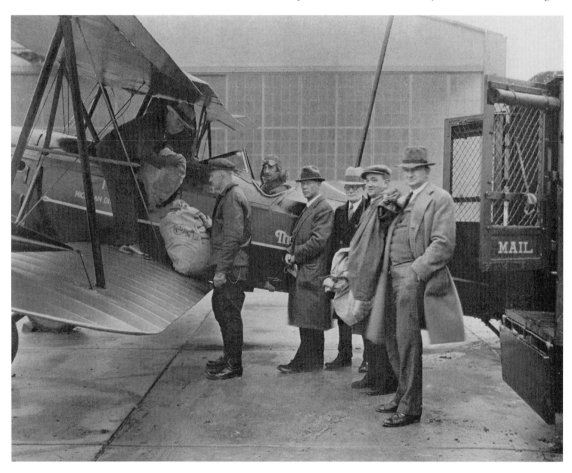

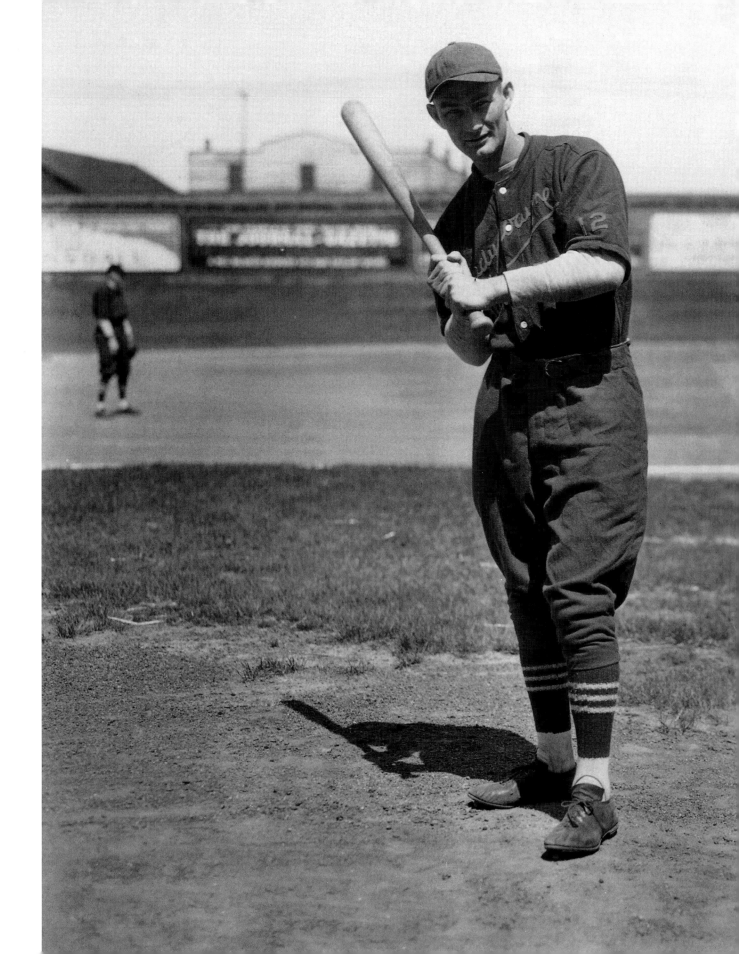

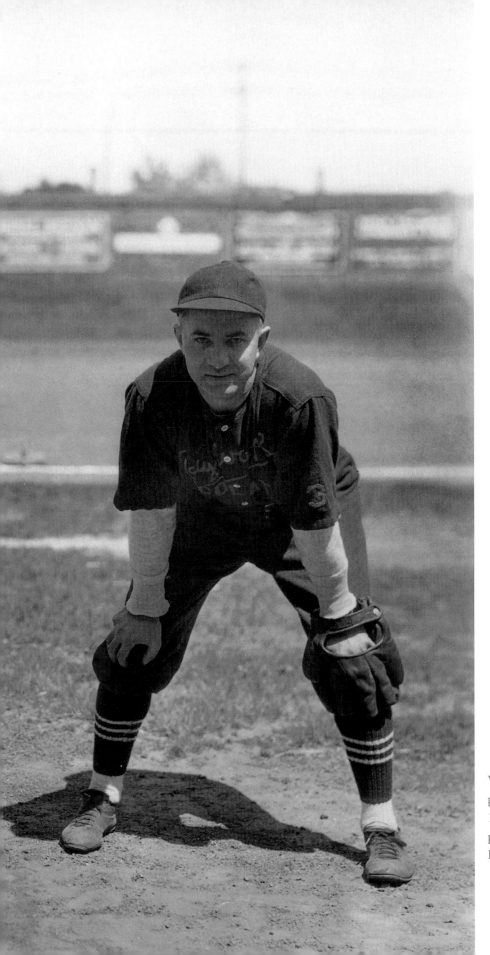

Where do Major League baseball stars go when they are too old to play? Everett Scott, right, played for the Lady Wayne Chocolates, a 1931 industrial league team. Scott was baseball's first "iron man," playing in 1,307 consecutive games from 1916 to 1925 with the Red Sox and the Yankees. The player with the bat is Earl Bolyard.

This 1930s photograph was taken after city firemen had restored the department's 1848 Button Hand Pumper. The pumper, which arrived in the city by way of the Wabash & Erie Canal, required six men on each side to operate it and send water through leather hose, which was riveted together. The Button is now in the Firefighters Museum in Fort Wayne.

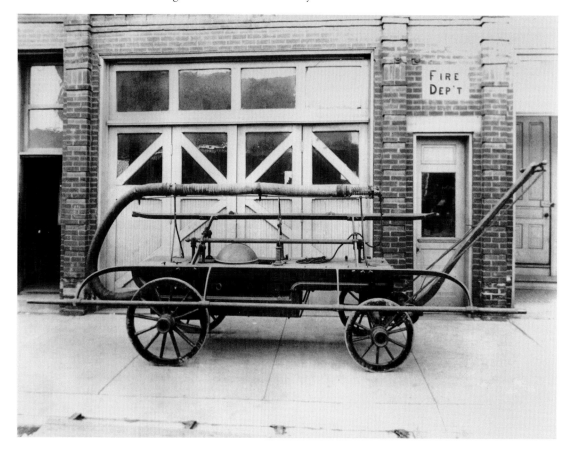

Built in 1893, Fort Wayne's Victorian-era City Hall was beginning to show wear in the 1930s. Its sandstone was beginning to darken from the accumulated soot from coal-fired locomotives and coal-heated homes. Also visible in this image are the Barr Street Market on the right and the City Utilities Building to the left of City Hall.

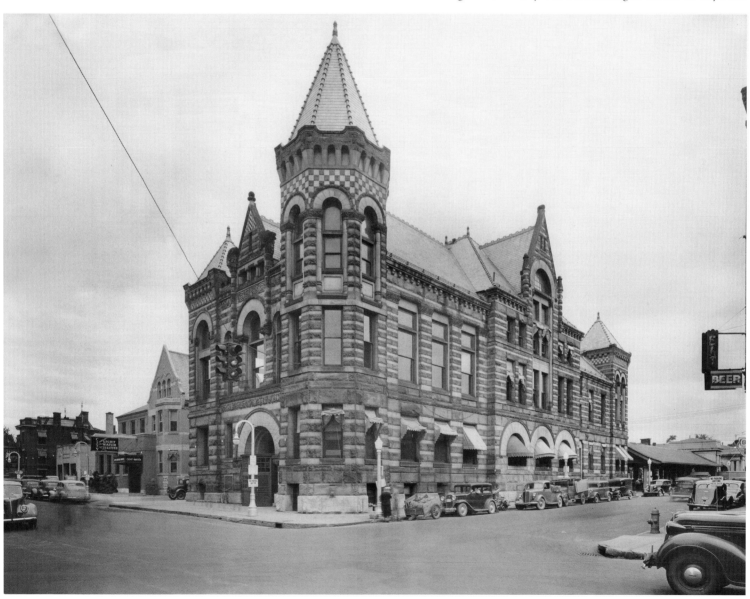

Where once there had been horses and wagons, now there were cars and trucks. Market day on Barr Street was a time of congestion—equally so early in the twentieth century and here, in the 1930s.

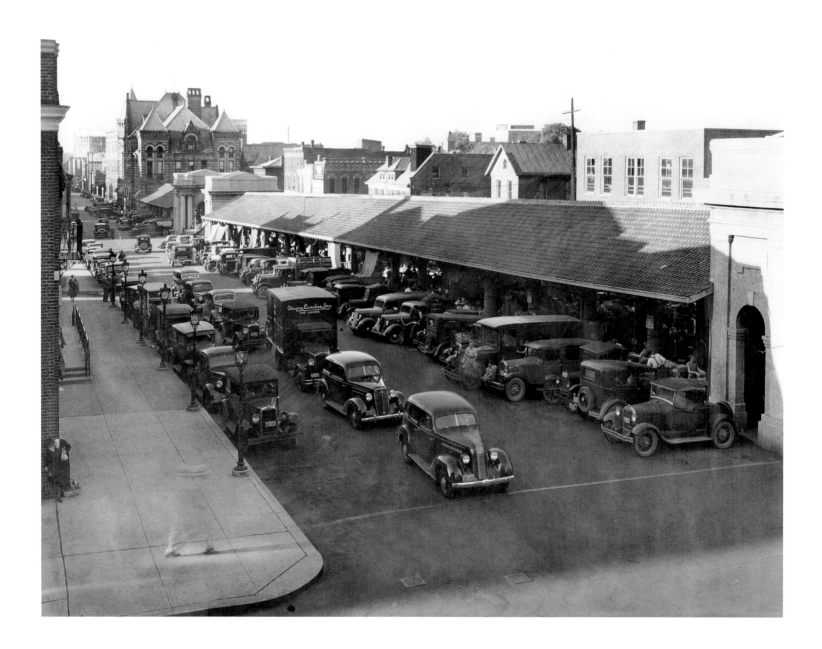

The lobby and main stairs of the Fort Wayne Public Library was the ideal place to assemble if one were a child wanting to attend the Story Hour in the 301 West Wayne St. building.

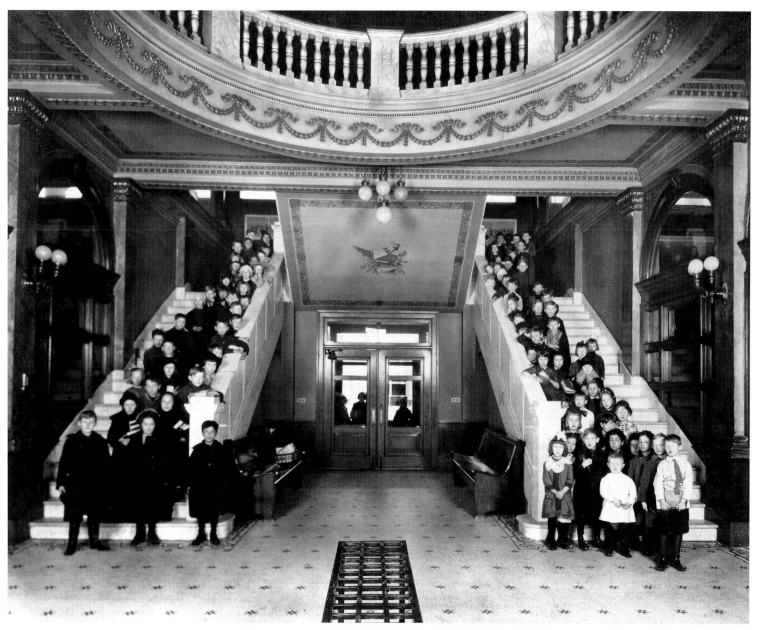

The new Pennsylvania Lines depot—more commonly known as the Baker Street Station—was built in 1914 to serve the growing demand for rail passenger service. Before World War I, Pennsy service through Fort Wayne included ten trains to Chicago and ten more to the East every day.

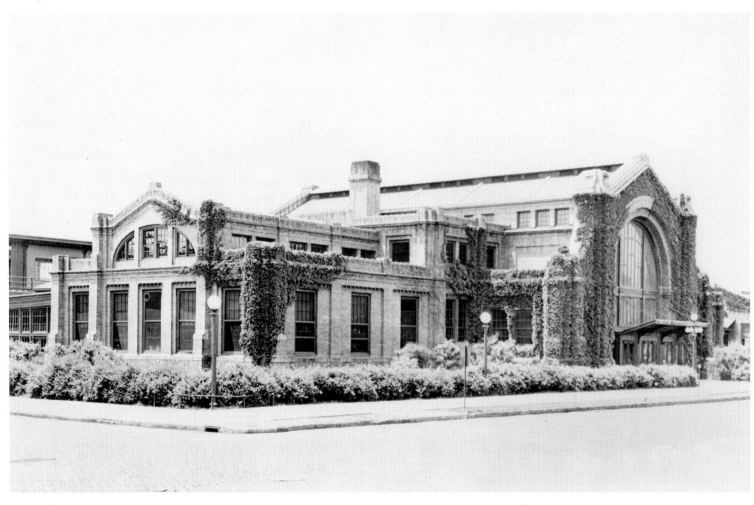

This close-up of the main building of the Three Rivers Filtration and Pumping Station more closely resembles a castle than a public utility. The water treatment facility was part of a $2.5 million project in 1930 that also included a dam on the St. Joseph River and a reservoir.

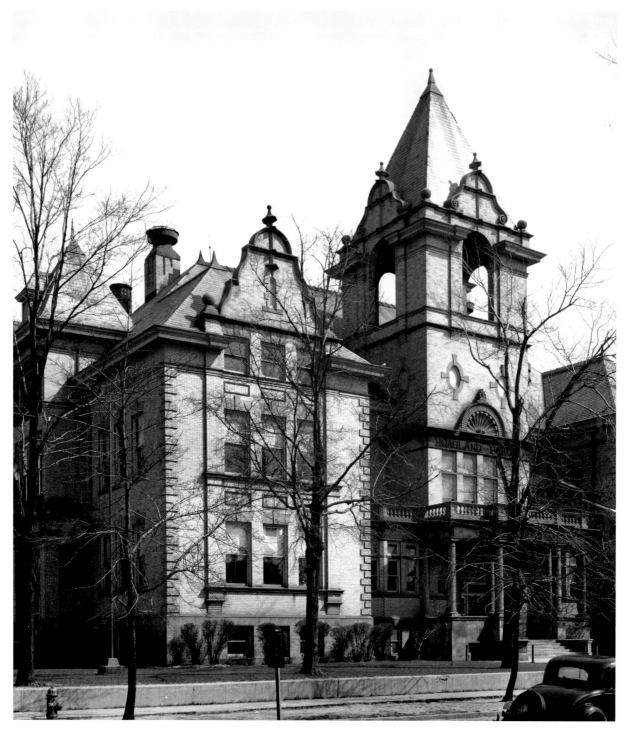

The Hoagland School was opened in the year the Civil War ended, but it was still operating when this 1930s photograph was taken. The school was located on the northeast corner of Hoagland and Butler streets.

The Lincoln Bank Tower changed the Fort Wayne skyline, as this image facing south along Calhoun Street demonstrates. The crossing tower, used to lower and raise gates across the street, was a common sight where busy rails and streets converged.

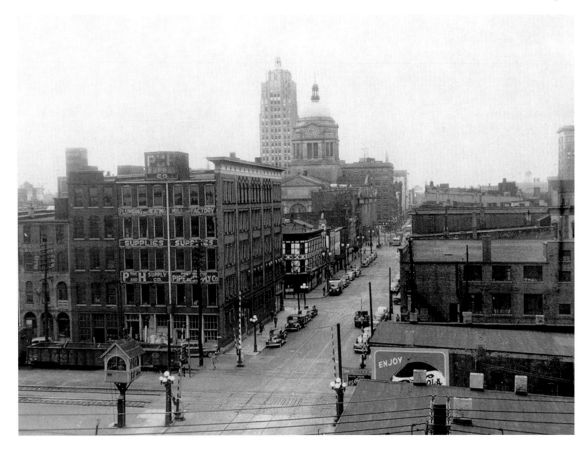

This well-crafted wagon, powered by a real horse, was a rarity on city streets in the late 1920s. As the Great Depression wore on however, scenes like this one became more common.

This Barr Street building was once the bustling home of the Kunkle Valve Works, a company renowned for its critical safety equipment that kept boilers, engines, and pipelines from exploding. When this photograph was taken in January 1939, it housed a far different company—Martin Wrecking.

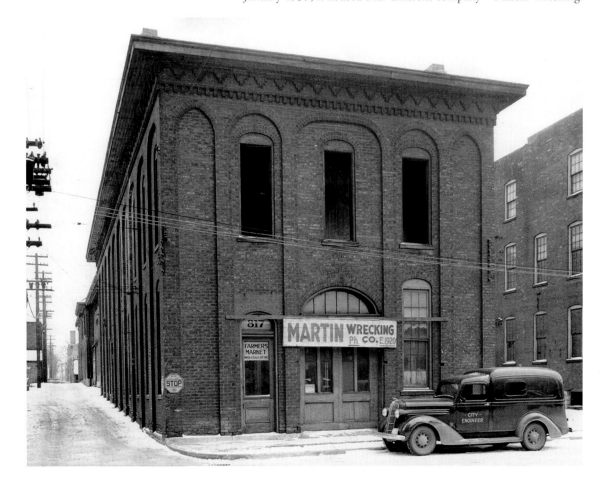

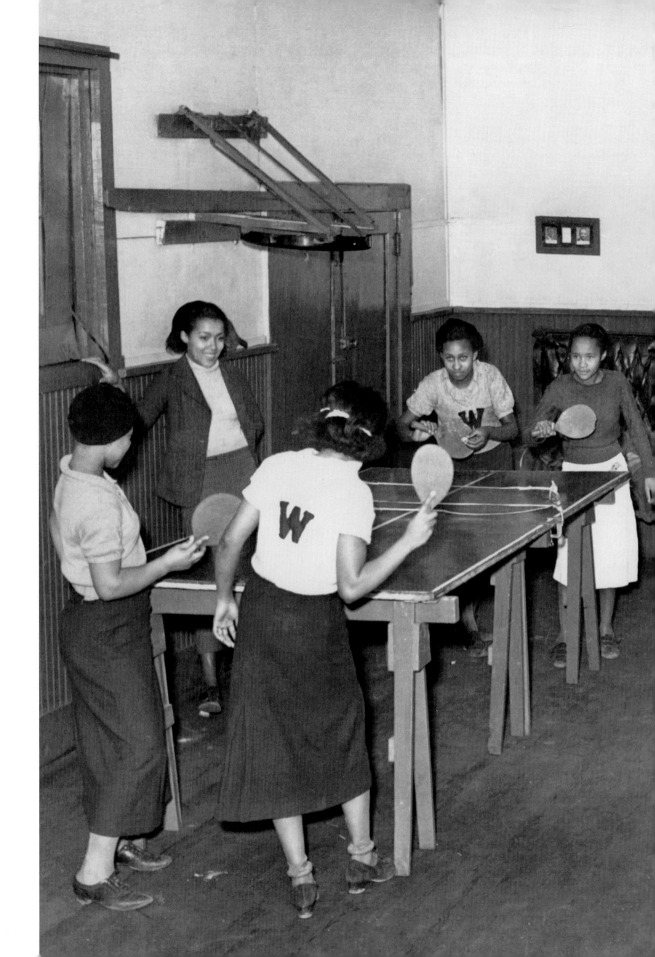

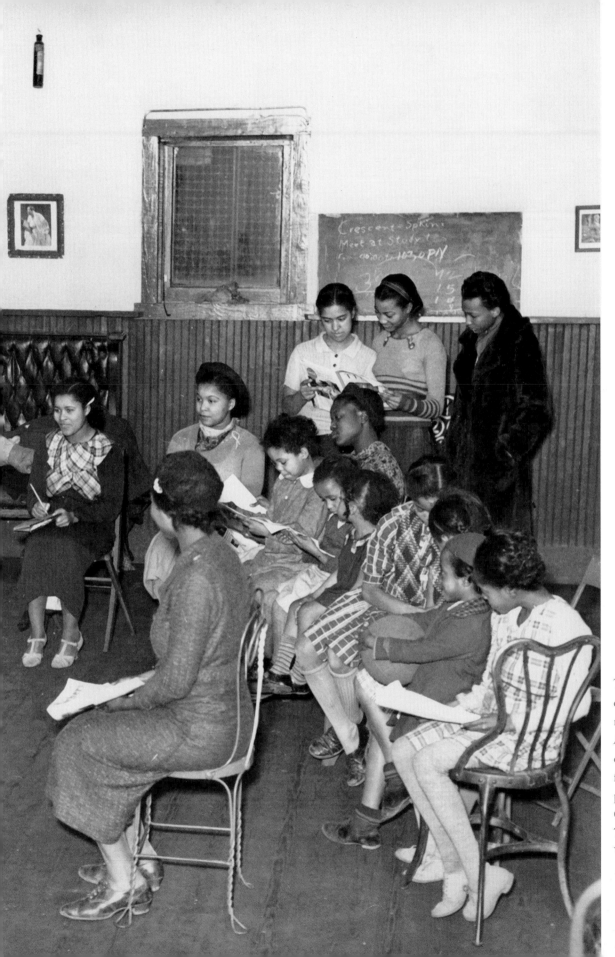

The Phyllis Wheatley Social Center on East Douglas Street became the most important agency for African Americans in Fort Wayne in the 1920s, offering a variety of programs. In 1936, for example, recreation and reading programs were offered at its Westfield Community Center on Taylor Street. The Wheatley Center became Fort Wayne's Urban League a decade later.

Indiana University opened its first Fort Wayne Extension Center in 1917 to offer classes in the community. This Barr Street building served as its home after 1939 until Indiana and Purdue universities combined their local classes.

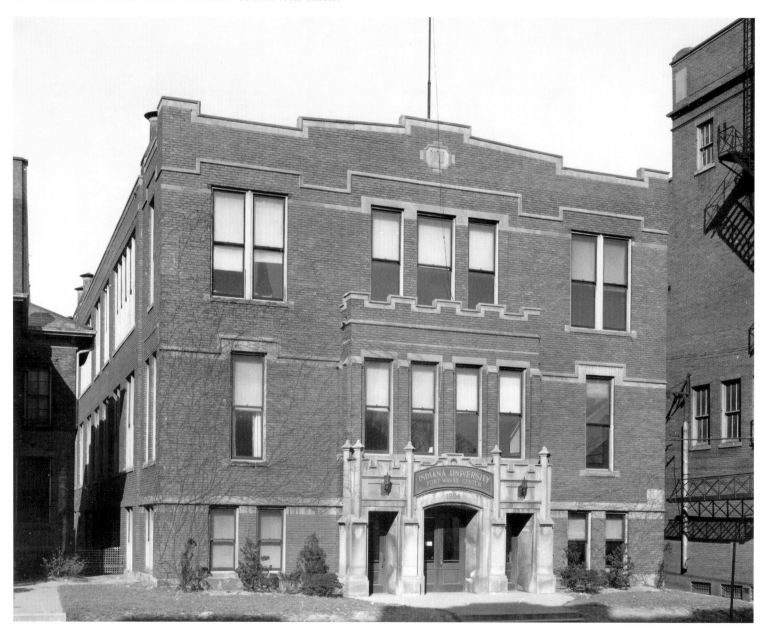

The era of the streetcar began to come to an end in 1939 as the Indiana Service Company brought a Fargo motor bus into operation. The 25-passenger bus replaced the trolley shown here, which served the Jefferson Street line.

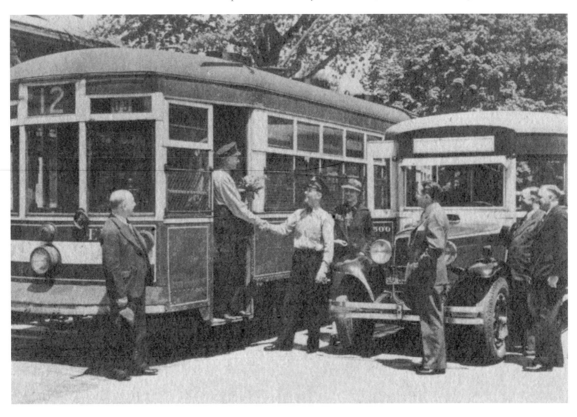

Mayor Harry Baals, center, was on hand to greet orchestra leader Paul Whiteman at the railroad station in February 1939. Whiteman and his renowned jazz orchestra played a three-night stand at the Paramount.

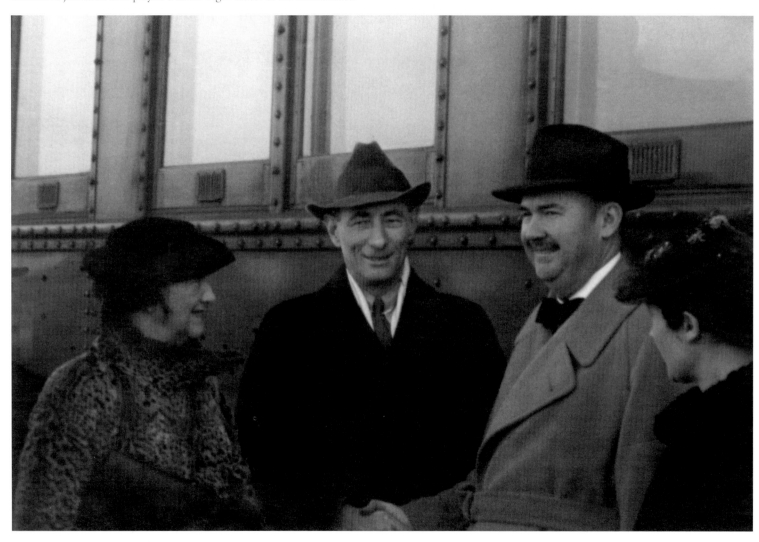

The family-owned Centlivre Brewery was a key part of Fort Wayne from its inception in 1862. It gained renown with its Nickel Plate Beer, the exclusive beer served on the Nickel Plate Railroad. This building on the St. Joseph River was crowned with a statue of the founder, Charles Louis Centlivre.

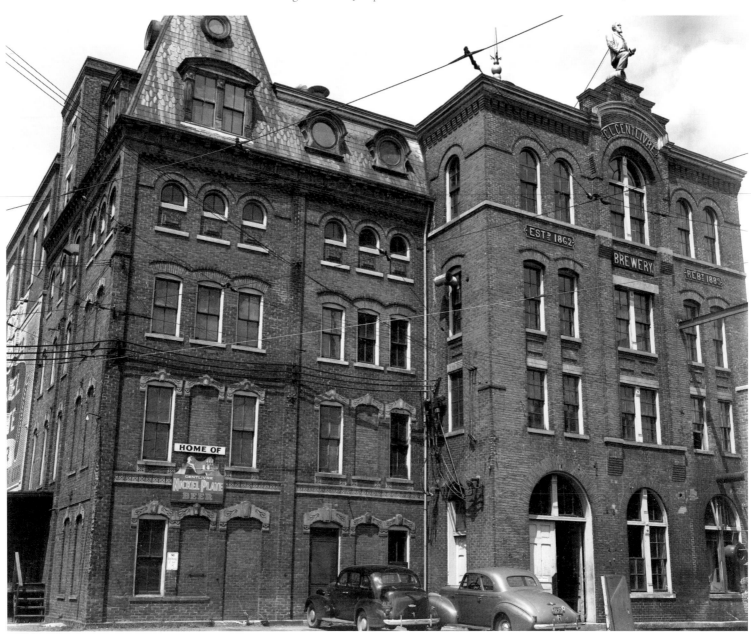

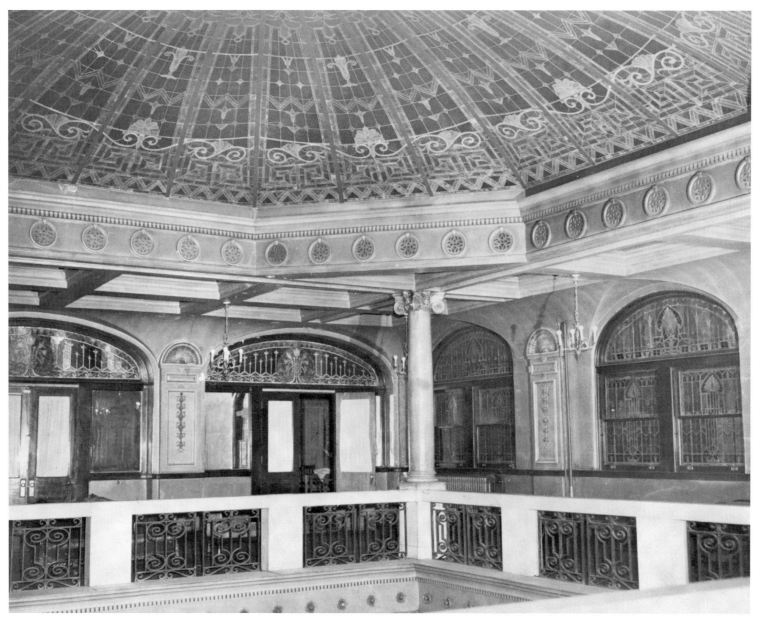

The Anthony Hotel, built in 1908, reigned as the grand hotel in Fort Wayne for decades. The 9-story, 263-room hotel was the city's finest meeting place and convention center as evidenced by this image of its mezzanine and the ballroom entrance.

VICTORY'S ENGINE

(1941–1955)

With the coming of World War II, preparation for war was visible in Fort Wayne. Not only were factories like International Harvester producing military trucks and General Electric building superchargers for aircraft, but also the U.S. Army Air Corps decided to construct an air base south of the city. Named after a Fort Wayne–born ace in World War I, Baer Field became fully operational when a squadron of P-39 Airacobra fighters arrived on December 6, 1941—the day before the Japanese attacked Pearl Harbor. During the war, thousands of American fliers came through Baer Field on their way to overseas assignments. The war added greater numbers of women to the workforce, and churches, schools, and businesses all supported the war effort. The number of servicemen from Allen County killed in the war exceeded 350.

Victory over Germany and Japan in 1945 brought more than dancing in the streets. It also brought a pent-up demand for goods and services denied first by the Depression and then by the war. Shoppers flocked to the retail center in downtown Fort Wayne, and stores, movie houses, and restaurants thrived. Housing construction resumed in the late 1940s to meet the needs of returning GIs. Industry—both traditional and nontraditional—grew. Dana Corporation moved its axle plant to Fort Wayne. Essex Wire relocated its magnet wire manufacturing from Detroit to the city. Bowmar Instrument Corporation was founded on Pennsylvania Street to produce electronic devices for engineering. Later Bowmar became a leading producer of mini-calculators. College enrollments increased with the advent of the GI Bill, and the Veterans' Hospital was built in 1949.

The city overcame a longtime obstacle to its growth in 1955 when the Nickel Plate Railroad completed the elevation of its tracks through the center of the city. Freight trains had been a hazard to pedestrians and drivers for 40 years and had discouraged the economic development of areas north of downtown. While this was a very positive development for Fort Wayne, the increased reliance on private cars over mass transit and the building of small shopping centers on the outskirts of the city were the harbinger of difficult times ahead for the downtown store owners.

The Grand Leader Department Store reigned supreme from its location on the southeast corner of Wayne and Calhoun streets. This had been the scene of one of the great fires in downtown Fort Wayne when a December 1927 blaze gutted the Grand Leader. A year later, the building shown here was erected.

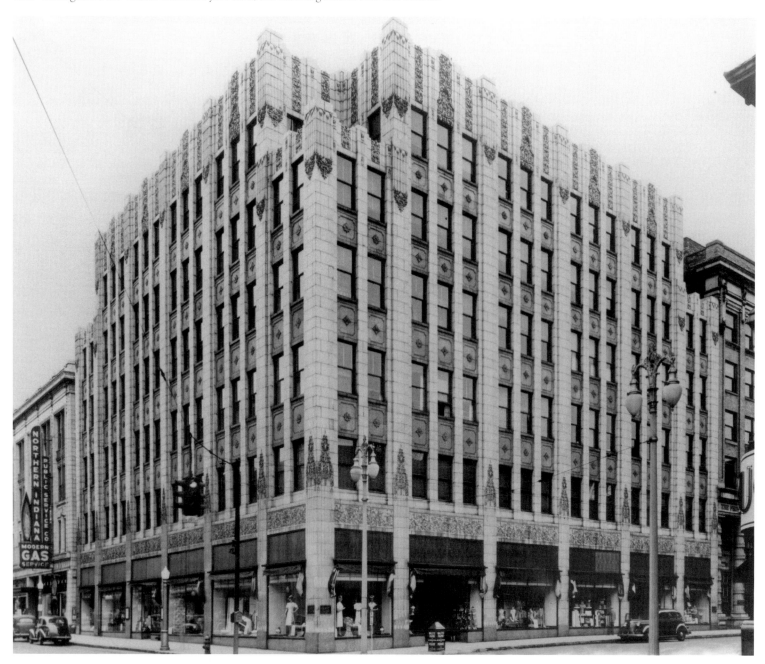

Downtown was a vibrant, competitive shopping area. Passengers boarding this Fort Wayne Transit bus must have been predisposed to shop at Wolf & Dessauer after finding that the store had paid for the day's fares.

The economic recovery is evidenced here by the number of automobiles in the downtown retail area. Another indicator was Wolf & Dessauer, seen on the left in this photograph of Washington and Calhoun, proudly advertising in 1941 that it was fully air-conditioned.

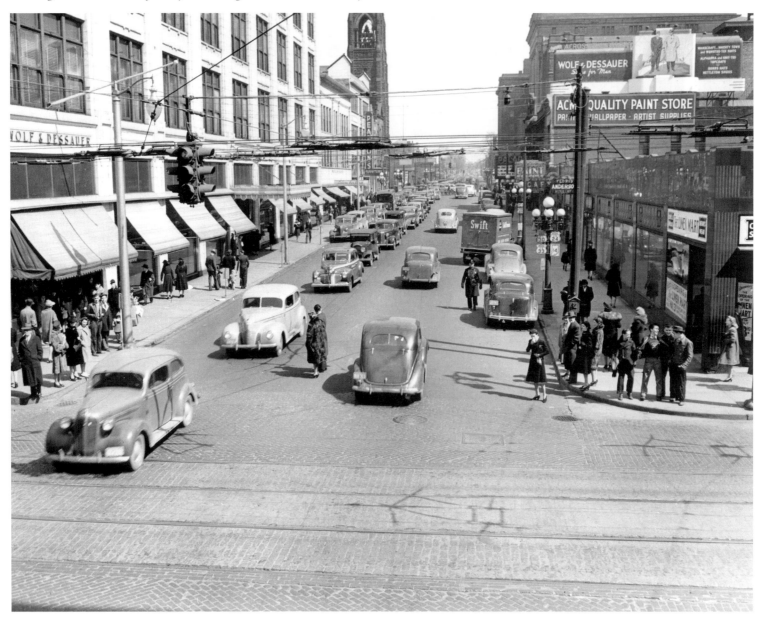

This is a rare view from the roof of City Hall on Berry Street in November 1941. Recorded by Ellsworth Crick, it is the skyline to the west, using infrared film. The blurred figure at right is one of the roof ornaments.

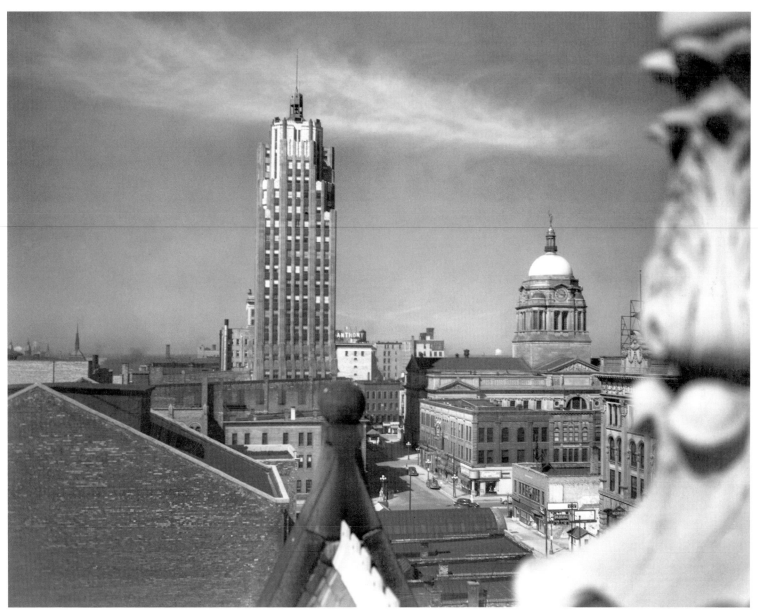

Most Precious Blood Catholic Church opened its school in 1929 at Barthold
and Spring streets. Despite a difficult beginning in the Depression, the school
prospered in the 1940s, as seen here, and into the next century.

Patriotism was evident everywhere at the start of the war. The American Legion Post's 40 & 8 "Black Jack" engine was a frequent parade participant. The 40 & 8 is a fraternal organization honoring U.S. veterans of World War I in France. The Fort Wayne chapter obtained permission from General John Pershing's family to use the general's nickname for their engine.

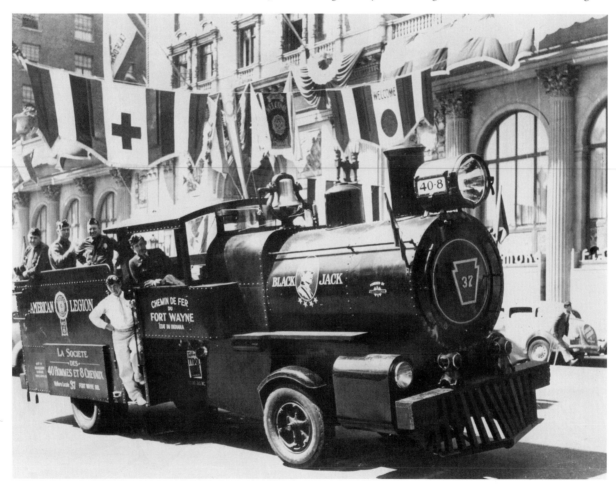

The Auto-Inn Garage on West Washington Boulevard owned by Ambrose Hayes and Raymond Young supported the war effort by gladly taking all donations as the city's "scrap rubber depot" in June 1942.

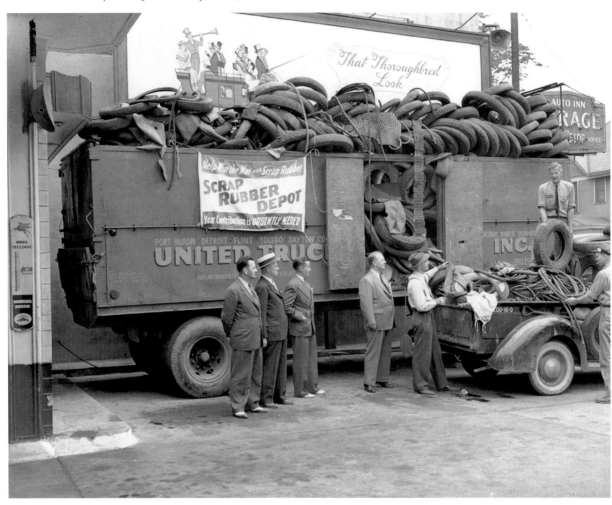

More than $650,000 was raised in the literary bond drive at the public library in October 1943. Lincoln Life paid $20,000 for Carl Van Doren's notated copy of *The Secret History of the American Revolution* and then donated the book to the library.

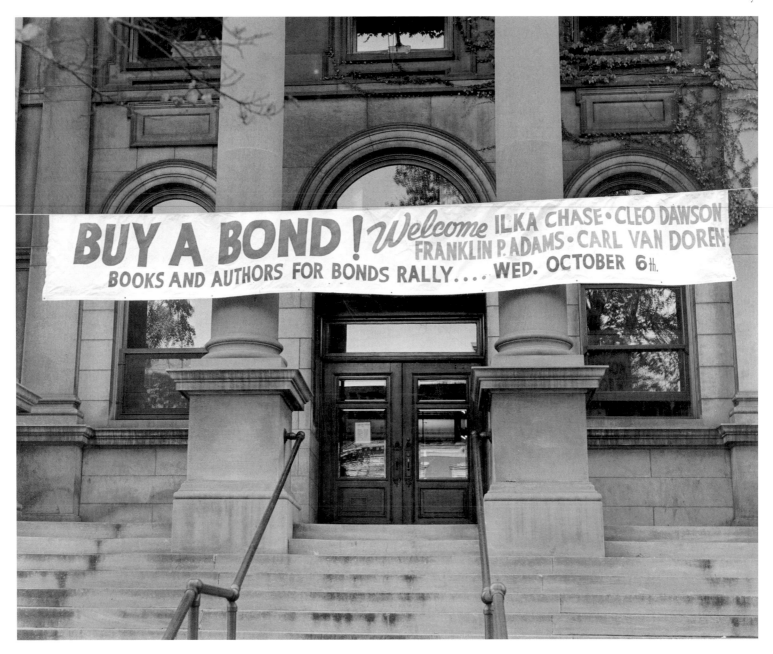

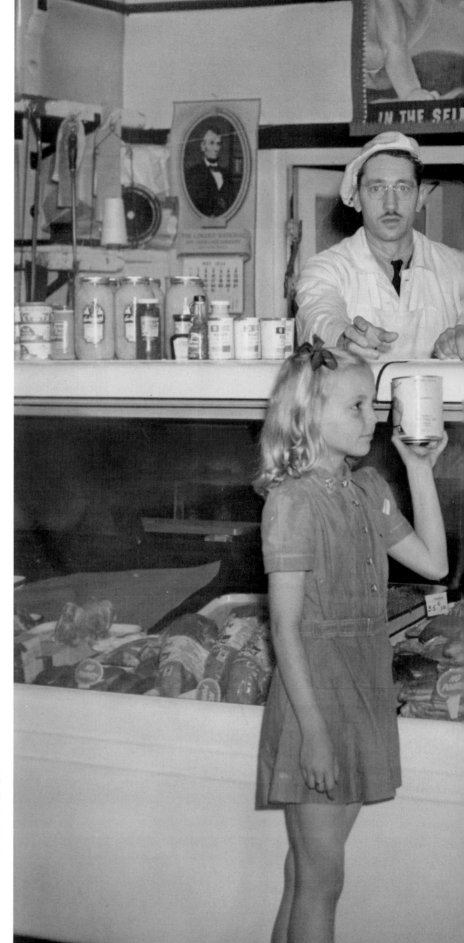

Nothing went to waste in the war effort. Even fat from cooking could be used in making war materiel. Here a Brownie and a Girl Scout bring the waste fats they have collected from homes in their neighborhood and turn them over at Samuel Manning's meat store on West Foster Parkway.

150

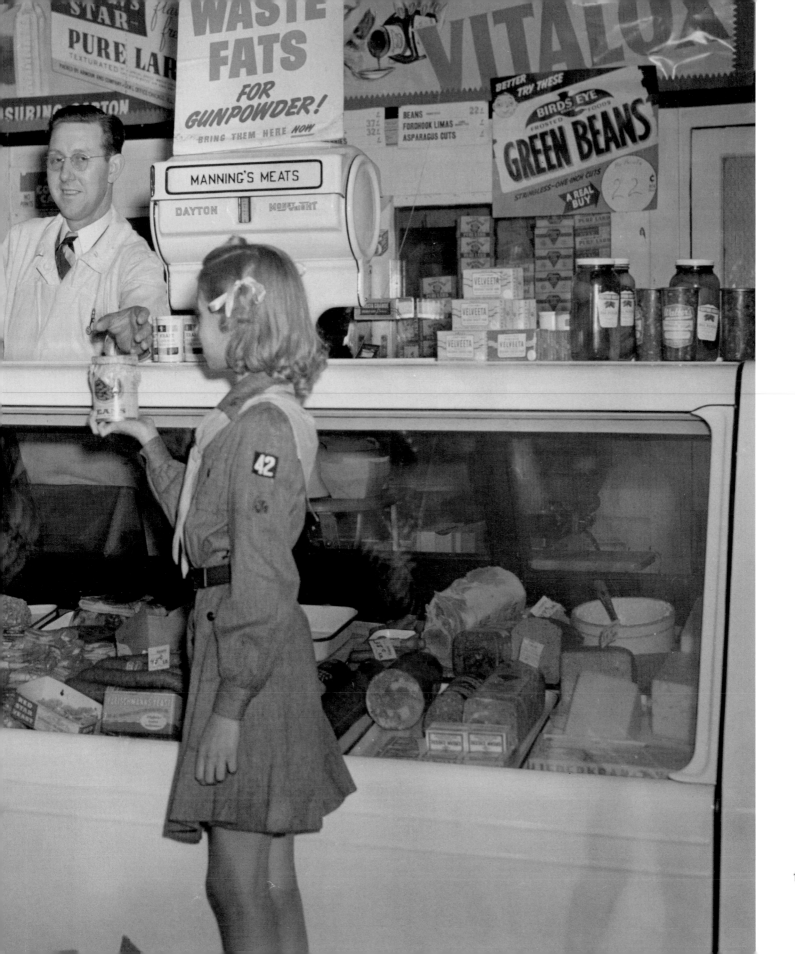

The war sometimes brought extraordinary events to Fort Wayne. In this rare baseball photo, Hall of Fame catcher Mickey Cochrane, manager of the Great Lakes Naval Station team, looks over the field before a 1944 evening game with General Electric team manager John "Red" Braden and umpires Fryback, Lamb, and Ehle.

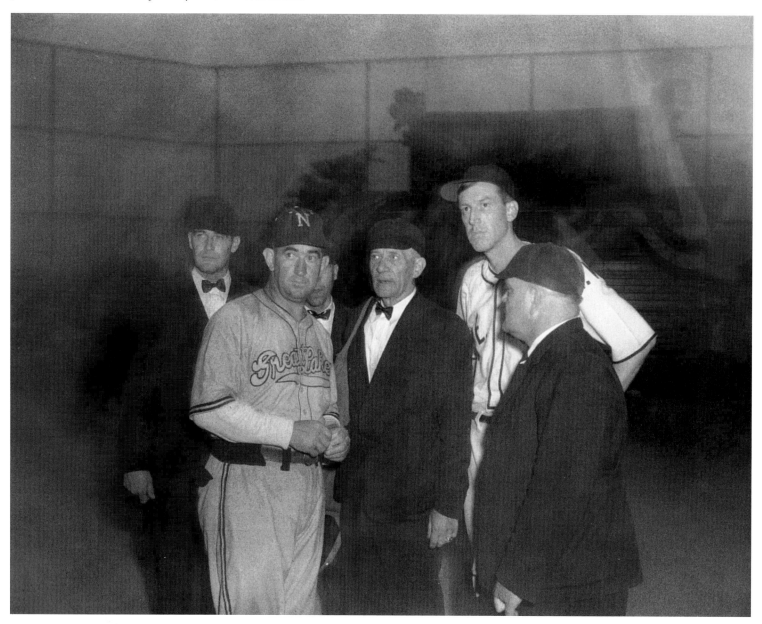

Shoppers standing outside the Morris Lunch Room look for their northbound streetcar on Calhoun Street near Washington in this late February 1945 photograph.

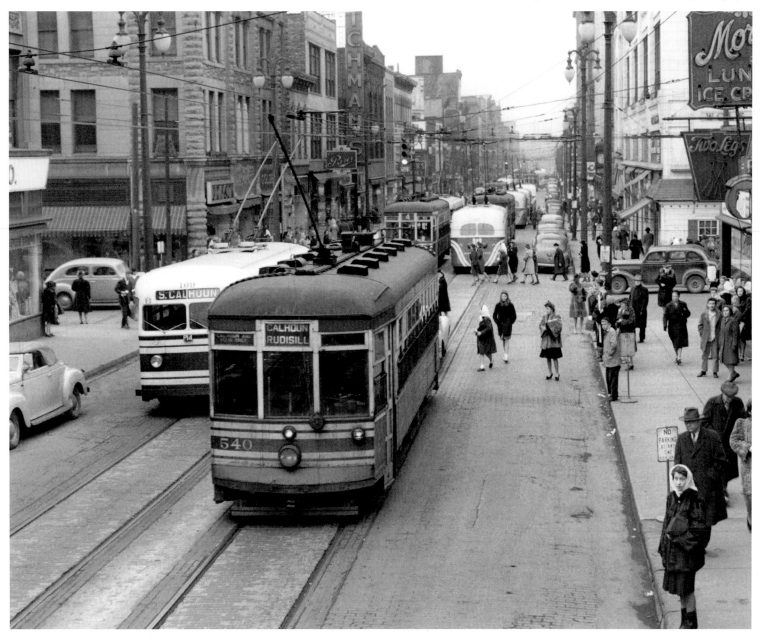

There are more women in the wartime workforce and electric-powered buses are replacing streetcars in this March 1945 image outside the General Electric complex on Broadway. Records show that trolleys and streetcars carried 36.2 million riders in Fort Wayne in 1944.

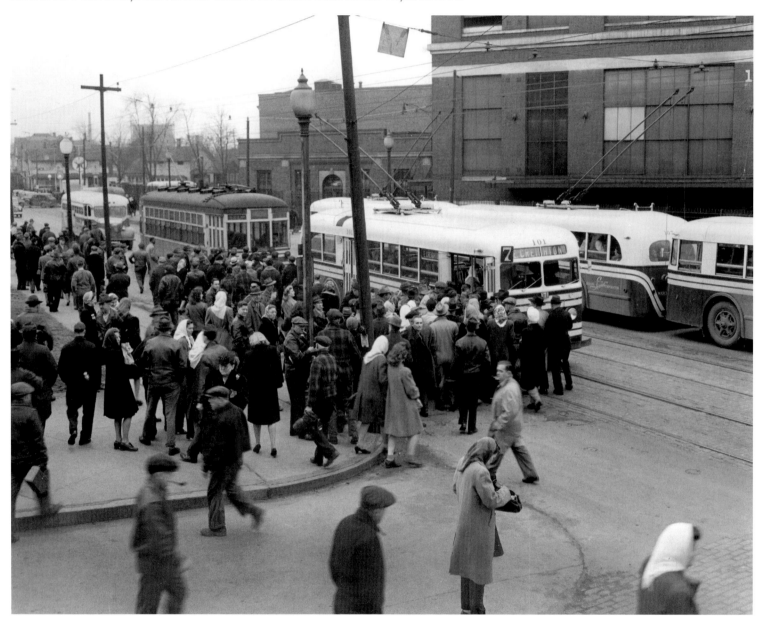

Mayor Harry Baals, center, is obviously pleased that this June 1944 War Bond drive has raised $1 million. Flanking the mayor are Major Walker Bud Mahurin of Fort Wayne, then America's top war ace, and Captain Charles Clark, the first pilot among the Tuskegee Airmen to shoot down three Nazi fighter planes, who was visiting family in Fort Wayne.

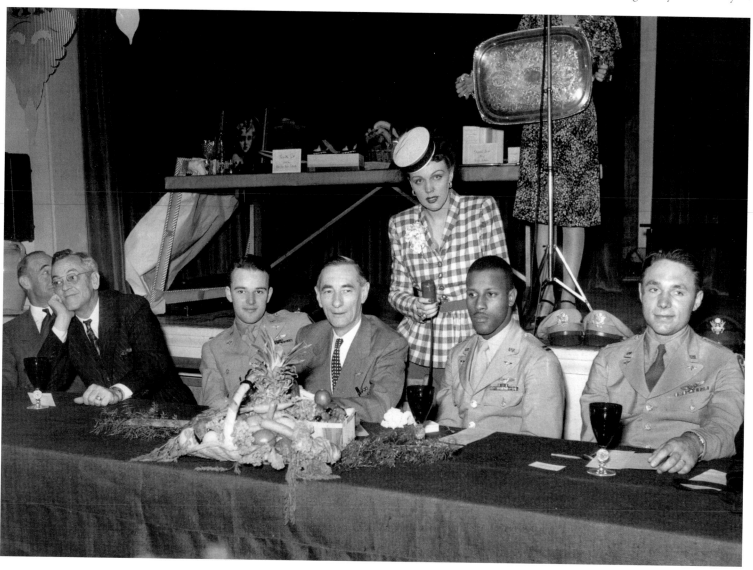

Fort Wayne's dedication to winning the war came at the expense of upkeep to the city's infrastructure. The deterioration in the streets is evident on Anthony Boulevard, looking north at Wayne Trace in 1945.

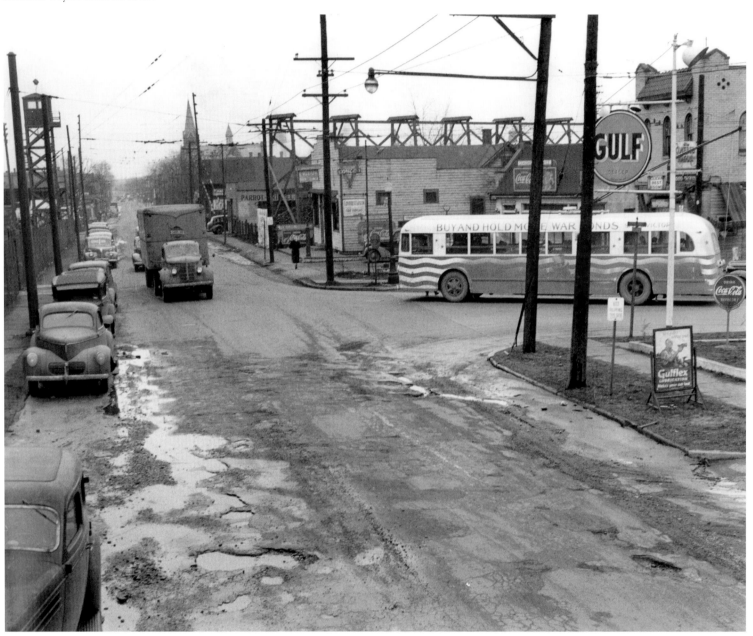

Life began to return to normal in late 1945, even to the extent that the National Peanut Company store on Calhoun Street went to great heights to help promote Fire Prevention Week. Fireman Ralph Fredericks steadies the store's Mr. Peanut on the ladder.

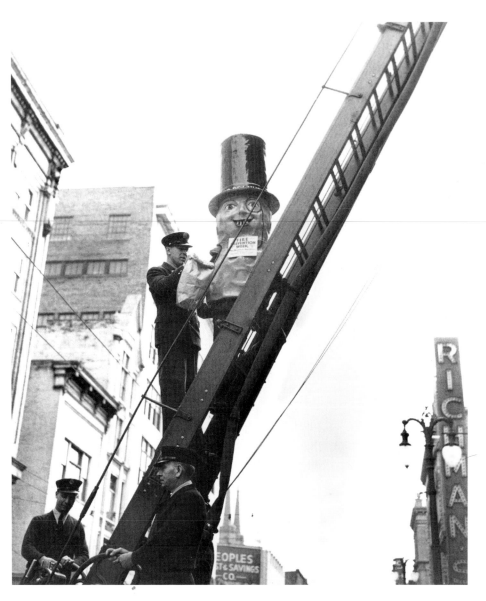

The longest operating hotel in the city's history had seen better days by 1946. Originally known as the Hedekin House and built near the Wabash & Erie Canal in 1843, the Home Hotel on South Barr Street would continue operations until it was demolished in the 1960s.

Robert Gehrig and W. S. Mason prepare to drive their 1904 Brush automobile to Detroit as part of the May 1946 Automotive Industries Golden Jubilee Celebration. Their drive from the Firestone Garage at Fairfield and Jefferson in Fort Wayne to the Detroit city limits took eight hours: the Brush averaged 40 miles per gallon and ran on a one-cylinder engine and wooden axles.

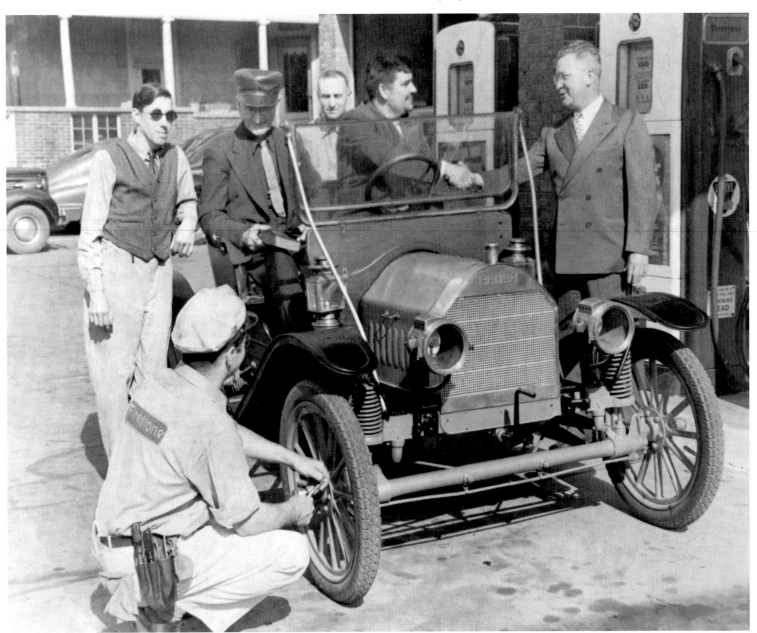

President Harry Truman's whistlestop campaign to win re-election in 1948 included a brief visit to Fort Wayne at the Pennsylvania Railroad station. In this election and those throughout most of the twentieth century, Fort Wayne voters favored the Republican candidate for president.

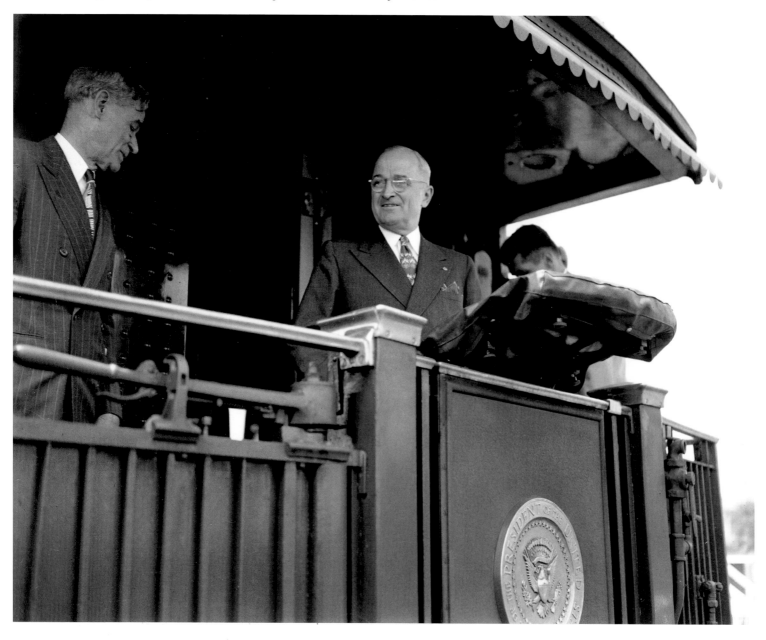

This small stone building was in deteriorating condition on Superior Street as the last remaining structure from the days of the Wabash & Erie Canal. Built in 1852, it had been a warehouse and a home, among other things. It was preserved in 1975 and served as the office of Arts United.

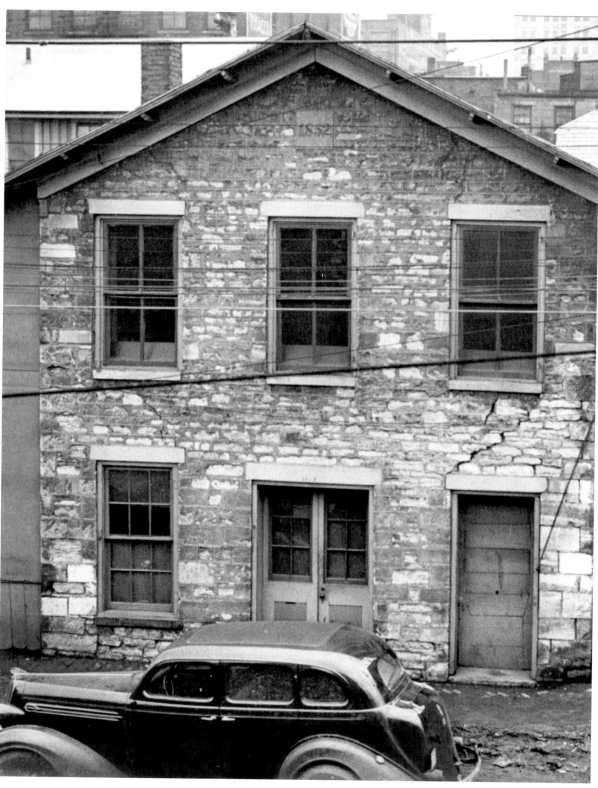

G. C. Murphy's at Wayne and Calhoun was a shining light in the retail sector of downtown Fort Wayne. Its bright limestone structure replaced the heavy brownstone IOOF Building at Wayne and Calhoun in October 1950.

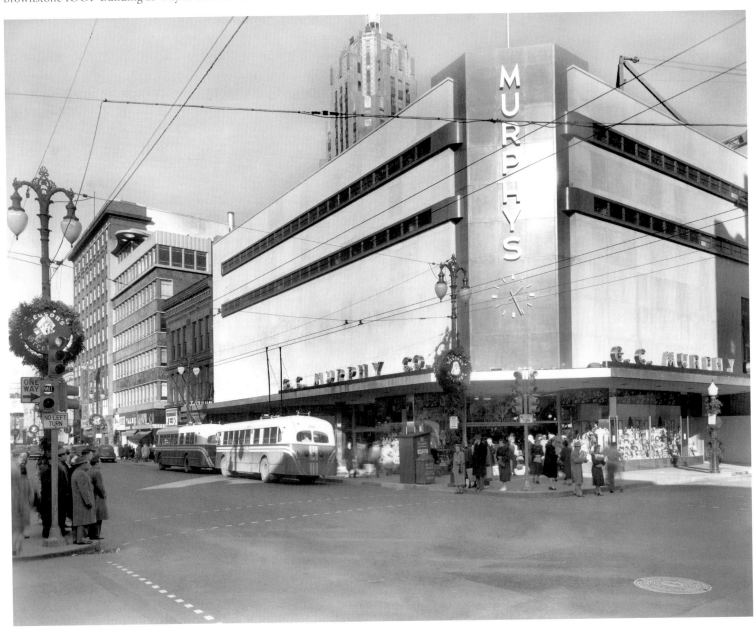

Fort Wayne was among the first cities to implement an emergency fire telephone number. The "119" number was promoted throughout the city in 1950, with members of Junior Chamber of Commerce stenciling reminders on streetcorner sidewalks.

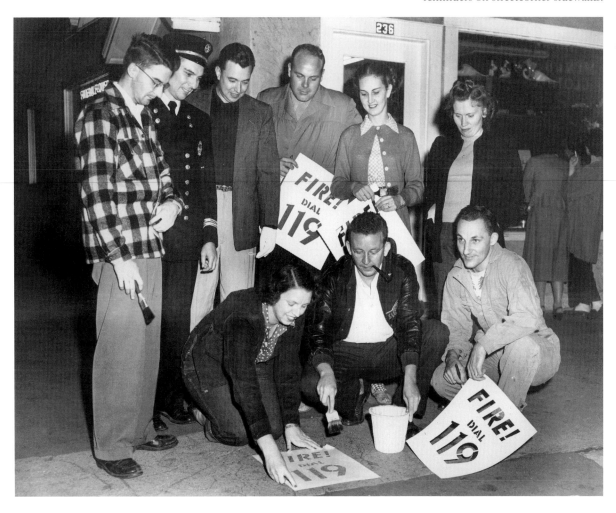

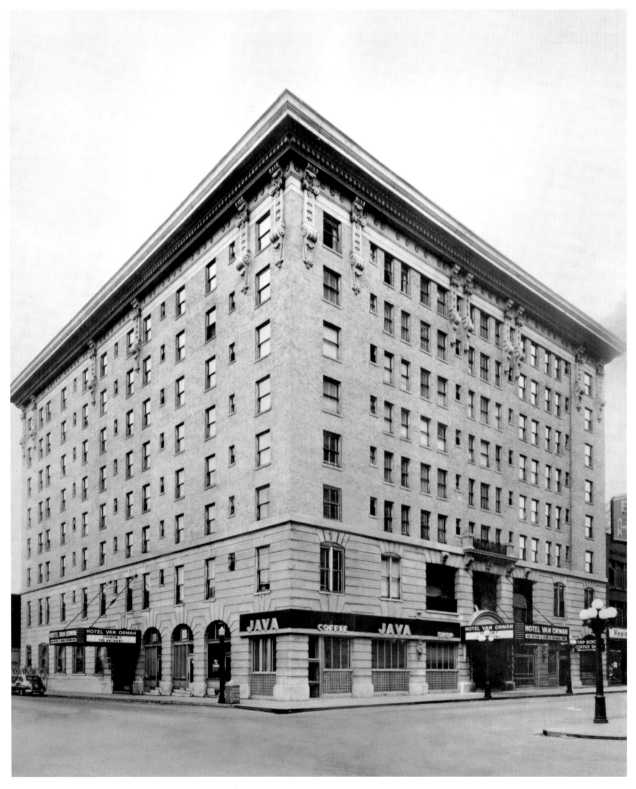

The Van Orman Hotel at Harrison and Berry streets was the new name of the refurbished Anthony Hotel. It was known in the early 1950s for its stylish New Coral Room with nightly dancing, and equally renowned for its 24-hour coffee shop on the corner.

Not so well known as Budweiser's Clydesdales, the show horses used by Berghoff Brewing to pull its beer barrel wagon were very popular in northern Indiana parades. Berghoff was first brewed in Fort Wayne in 1887.

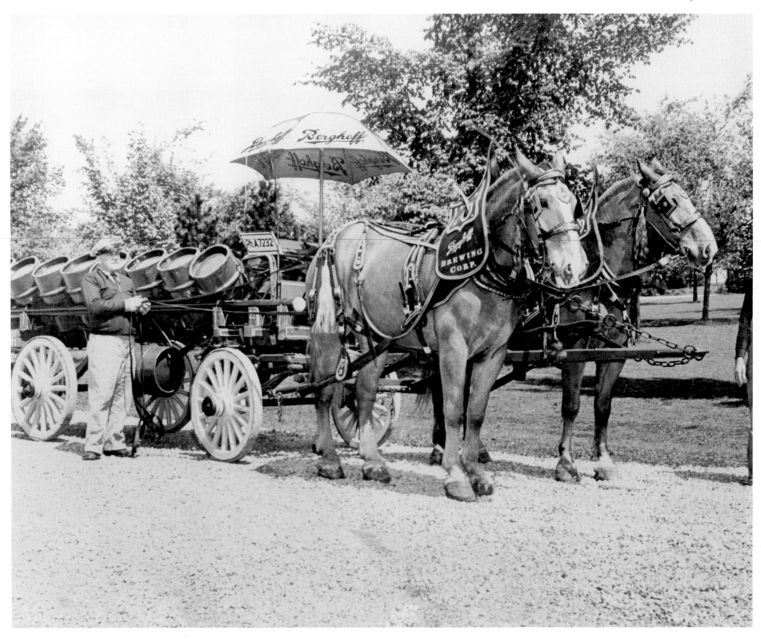

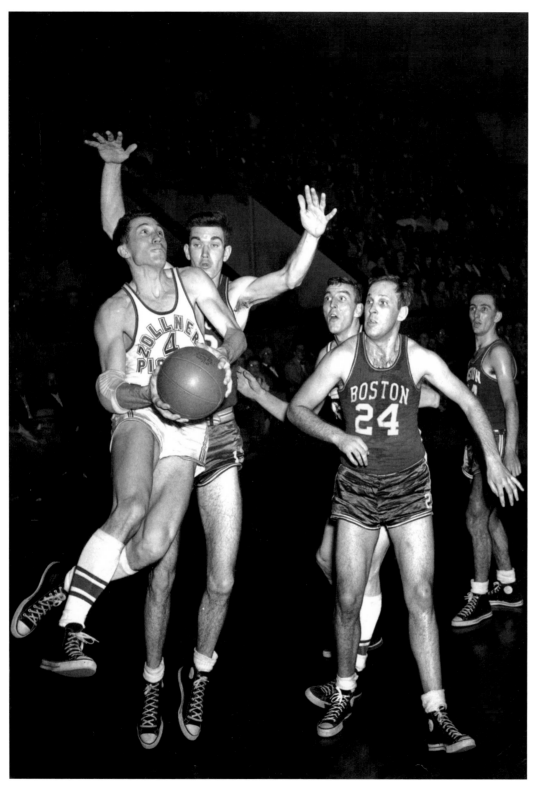

Fort Wayne's John Oldham (4) has already slipped past one future NBA Hall-of-Famer, Ed Macauley, as another at the far right, Bob Cousy, looks stunned in this game with the Boston Celtics during the 1950-51 season. The Zollner Pistons were an integral part of professional basketball before the team moved to Detroit in 1957.

Crossing a street in downtown Fort Wayne in the 1950s meant one had to look in both directions. But this group of pedestrians at Barr and Jefferson streets seems to be more interested in "You can see the difference" in the Arvin "Dual Power" TV advertised on the side of the bus than in oncoming traffic.

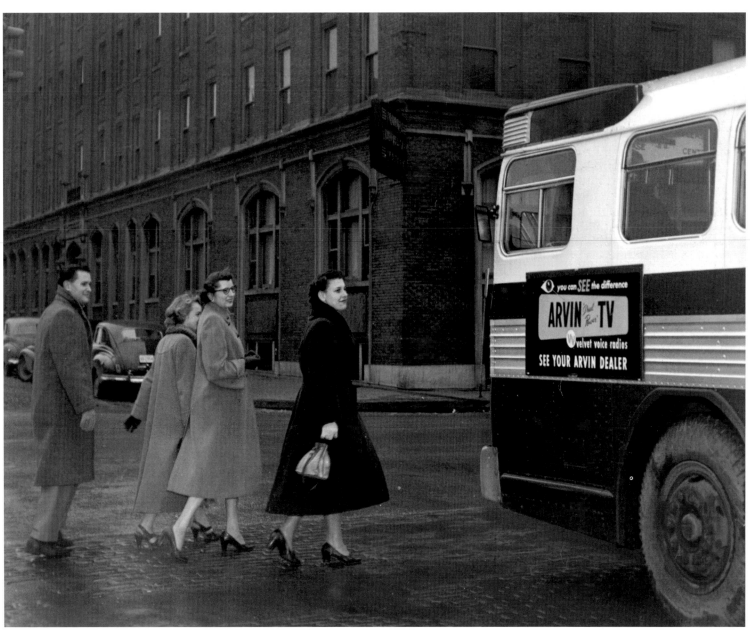

The Foellinger Building at Washington and Barr streets in the 1950s was the home of the *Fort Wayne News-Sentinel,* the city's very popular evening newspaper. This nighttime photograph reveals the silhouette of a man in a trench coat and fedora. Perhaps the visitor was that renowned radio personality of the era, Kent Allard, also known as the Shadow.

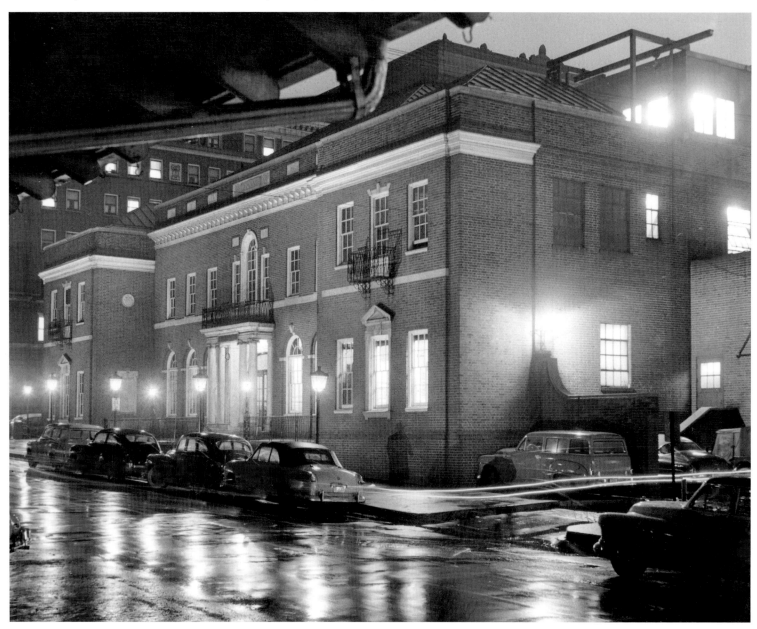

The Rialto Theater on South Calhoun showed more than its share of blockbuster movies, and for a time it had a future star on its staff. Marilyn Maxwell attended Central High School and worked as an usher in the 1930s at the Rialto before going on to a successful acting career.

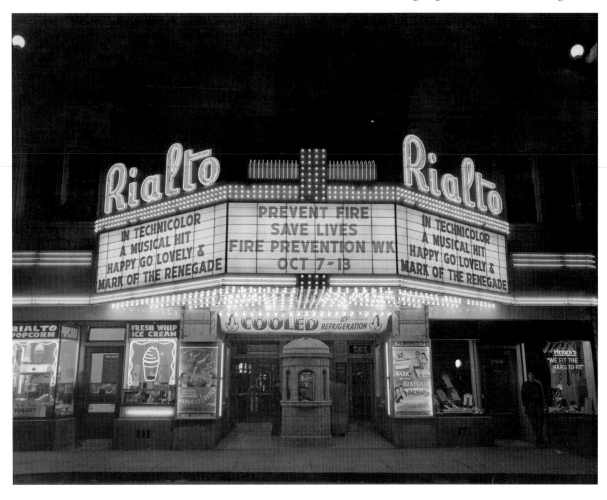

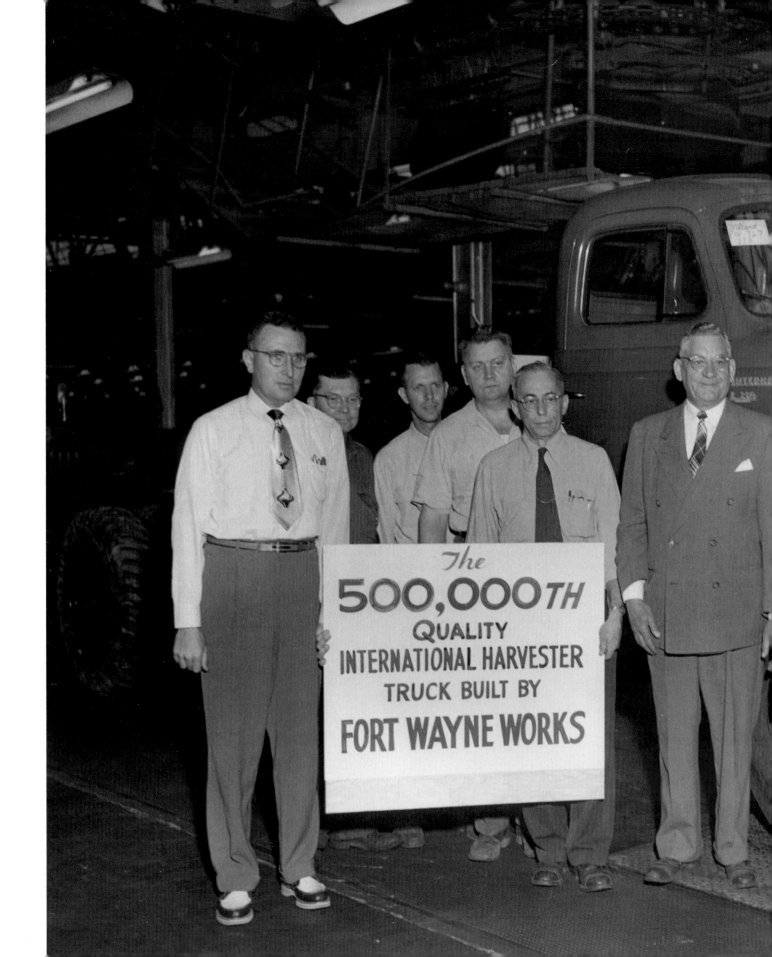

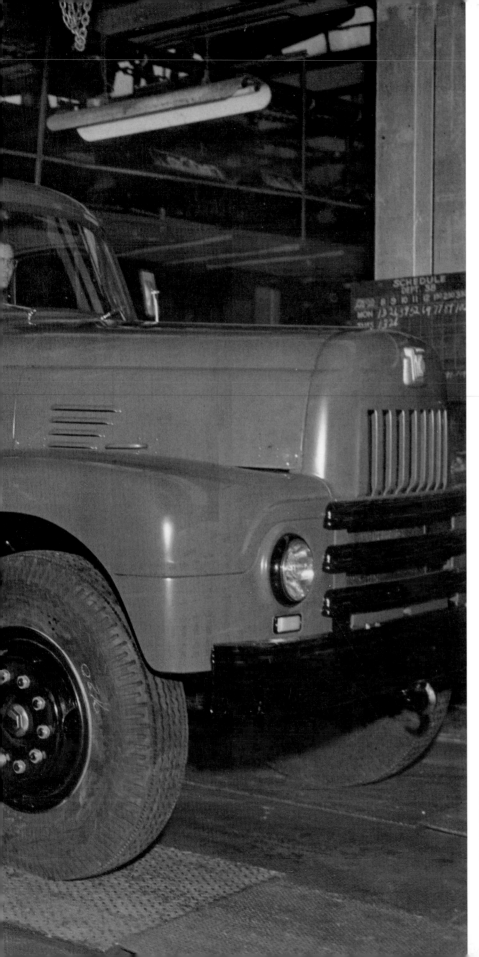

International Harvester's truck manufacturing complex, shown here on June 12, 1951, had come a long way since its 1923 beginning. The company's one-millionth truck would roll off the line in 1973.

It's not a big sale at Wolf & Dessauer Department Store, but a fire drill in 1951. Fort Wayne experienced more than its share of large fires in the downtown area over the years, prompting the Fire Department to conduct extensive safety campaigns.

The Fort Wayne Daisies were in "a league of their own" in 1952 when they were managed by Hall of Fame slugger Jimmy Foxx. The Daisies were the city's most admired sports team in the late 1940s and early 1950s before the All-America Girls Professional Baseball League folded.

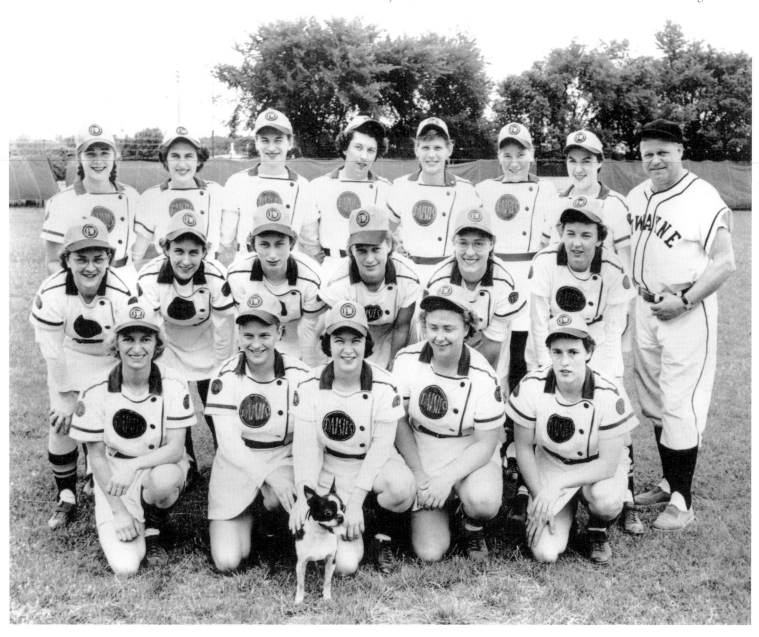

The Allen County War Memorial Coliseum opened in what was then the outskirts of Fort Wayne, as this aerial photograph shows. The coliseum has hosted thousands of sporting events, carnivals, home and garden shows, and rock concerts.

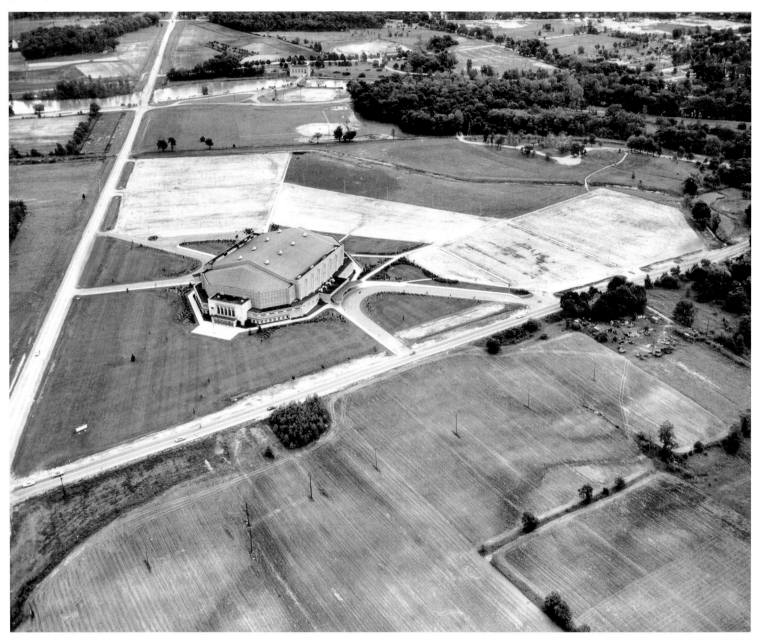

When the Memorial Coliseum was dedicated in 1952, Bob Hope and Marilyn Maxwell were two of the stars saluting the community's newest entertainment facility. Hope was fond of Fort Wayne and remembered performing at the Embassy. Maxwell grew up in the city.

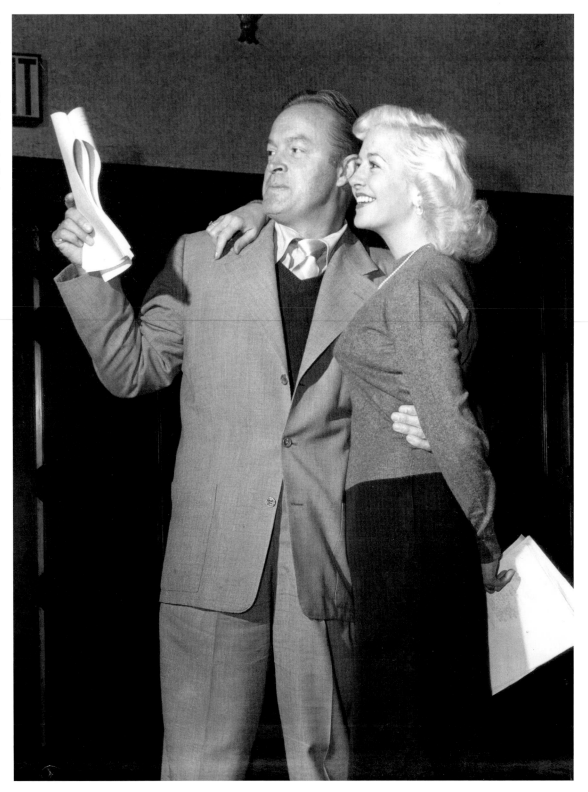

There has always been more than professional sports in Fort Wayne. This ball game at the old Municipal Beach Park is an example of the fun and recreation that has been part of Fort Wayne since its earliest days.

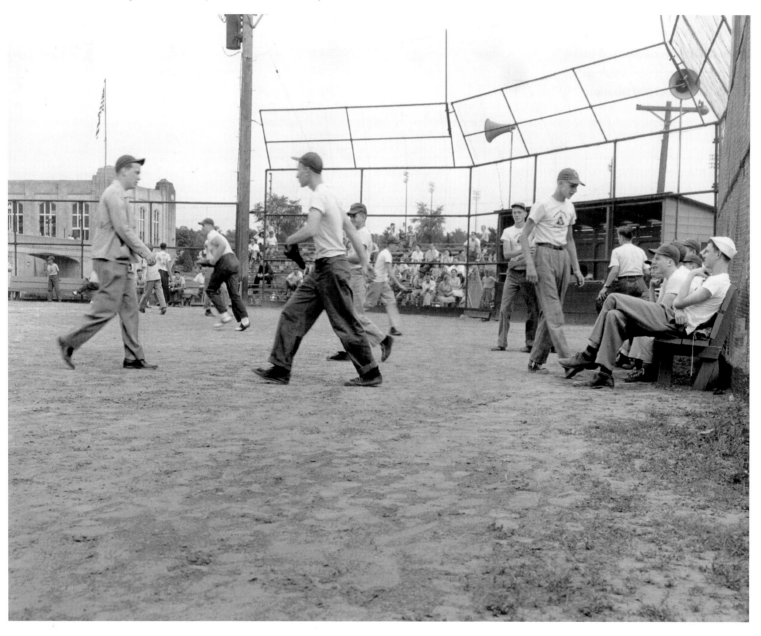

This southeasterly view from the courthouse stretches from the Lincoln Bank in the foreground to the white facade of Wolf & Dessauer's to the prominent steeple of St. Mary's Church and beyond.

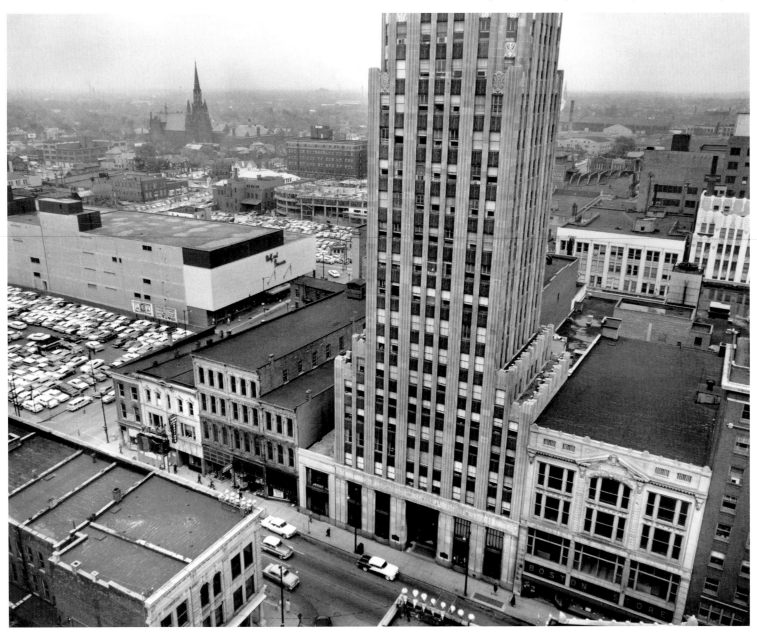

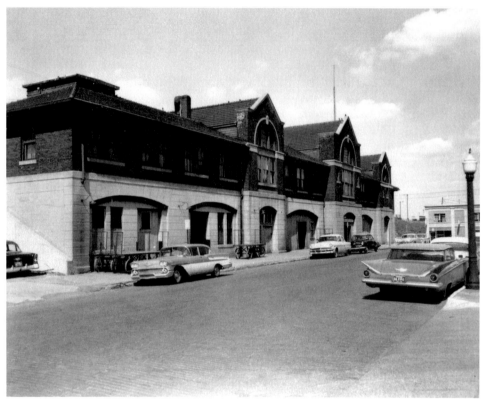

The impact of other forms of transportation on the nation's railroads became
increasingly evident in the 1950s. The old Wabash Railway depot became the
Norfolk & Western Railroad station, but that didn't stop the railroad's legendary
"Wabash Cannonball" from coming to the end of its line in May 1971.

DRIVEN TO CHANGE

(1956–1979)

The Fort Wayne population had grown to 161,000 by 1960; however, Allen County's population was growing much faster. The flight of residents to suburbia fueled the growth of shopping centers far removed from the traditional downtown retail district. Wolf & Dessauer fought the trend by closing its seven-story store at Calhoun Street and Washington Boulevard where it had operated since 1919, and building a gleaming four-story structure at Wayne and Clinton streets in 1959. It was a greatly applauded move, although Wolf & Dessauer also opened a smaller store in a mall south of the city later. At the end of 1969, however, a large chain of department stores bought the business and the name long associated with fine shopping in Fort Wayne disappeared.

Construction began in 1965 on what was then the largest shopping center in Indiana, Glenbrook Mall at Coldwater. Designed by Schenkel & Shultz of Fort Wayne, the mall initially had 70 stores and seemed to grow exponentially over the years. In essence, the success of Glenbrook and other shopping malls meant that the downtown area had to change. Instead of retail merchants, its occupants became professional, legal, and financial firms. Even the presence of the Lincoln National Life Insurance Company's home office and its 2,000 employees was not sufficient to keep small retail stores solvent.

During the 1960s and 1970s, several industries expanded, including International Harvester, General Electric, International Telephone and Telegraph, Phelps Dodge, and Dana Corporation. A new high-tech firm, Magnavox, grew at a remarkable pace. Fort Wayne was proud to be a Midwestern industrial showpiece. It was proud of its accomplishments and its history. Weekend celebrations like the Johnny Appleseed Festival attracted thousands of visitors to the city. There didn't seem to be an inkling of the hardship ahead. The next 20 years, however, would bring a loss of key employers, acquisition of the city's locally owned banks and financial institutions, a sharp regional economic downturn, increased crime, and a disastrous 1982 flood.

Fort Wayne has responded with different initiatives with varying results. As the city uses new approaches and draws on past strengths to confront the future, citizens are employing their own ingenuity to surmount the region's challenges.

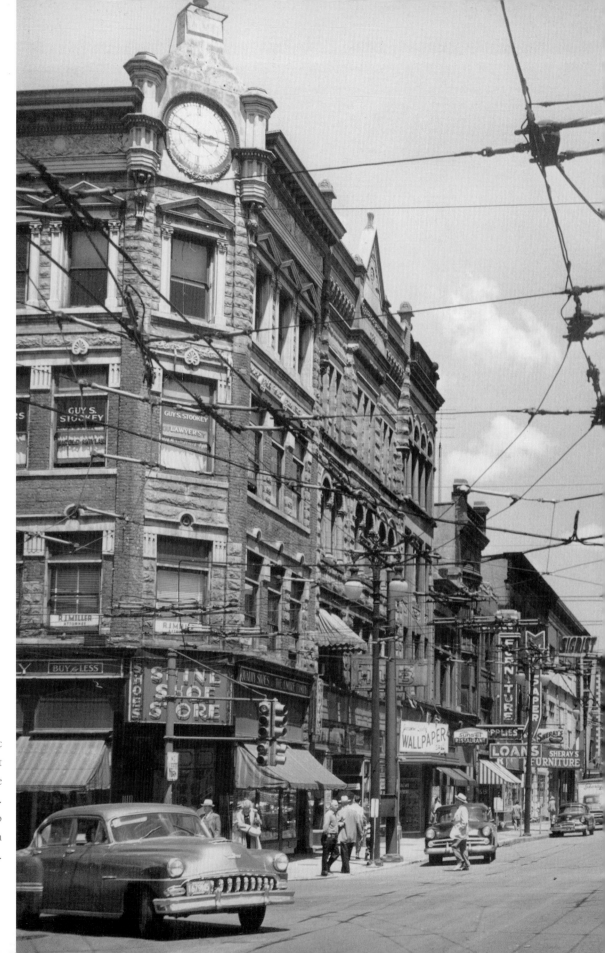

The overhead wires so integral to public transportation were taking on a different dimension in the 1950s, when more people preferred to use their own cars. This photograph shows the electrified web along Calhoun Street from Main Street in the mid 1950s.

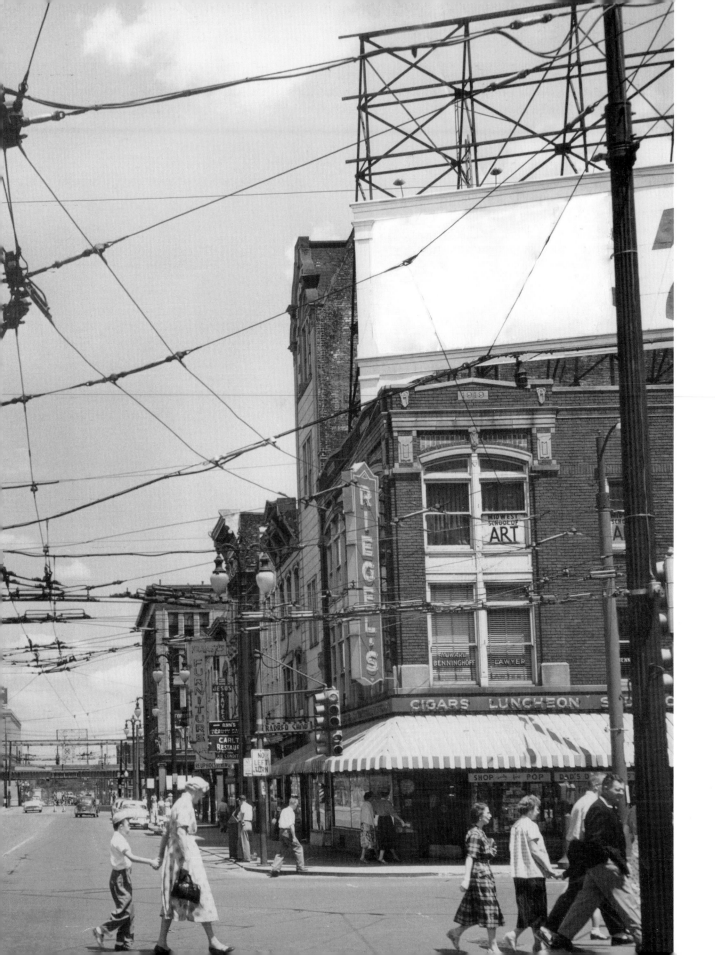

By the late 1950s, the number of passenger cars plying the streets outnumbered the mass transit vehicles in the downtown retail center.

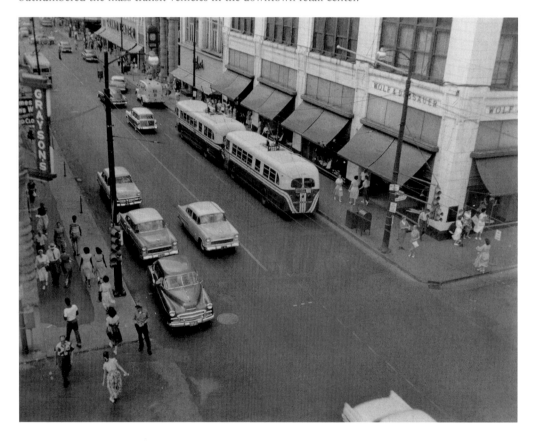

In 1958, the city demolished the Barr Street pavilion to make way for a parking lot. It was a poor ending for what had been the city's open air marketplace from its early days. Fifteen years later, volunteers would try to revive the market in a smaller space.

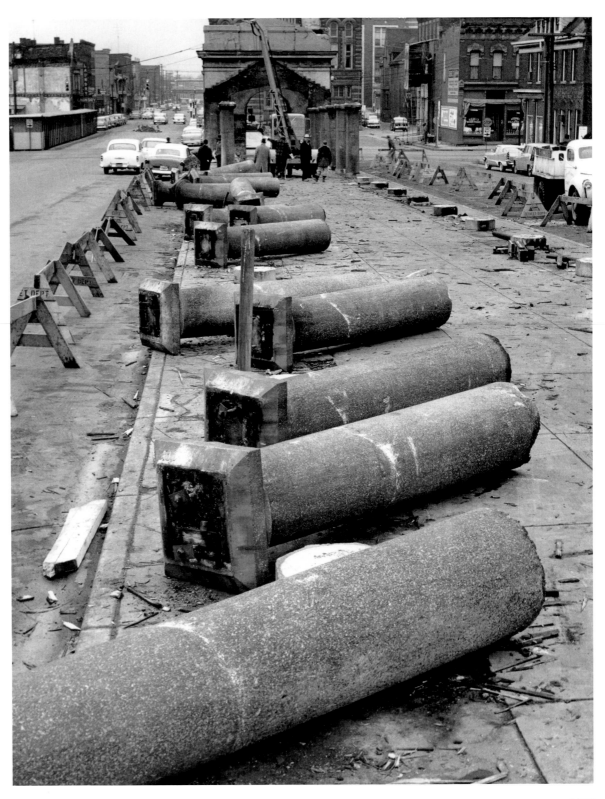

Wolf & Dessauer, which was founded in 1896, operated from this landmark building at Calhoun and Washington streets, on the right, from 1919 until 1959. The firm chose to build a new store downtown—at Wayne and Clinton streets—in the face of a growing trend of retail establishments moving to suburban shopping centers.

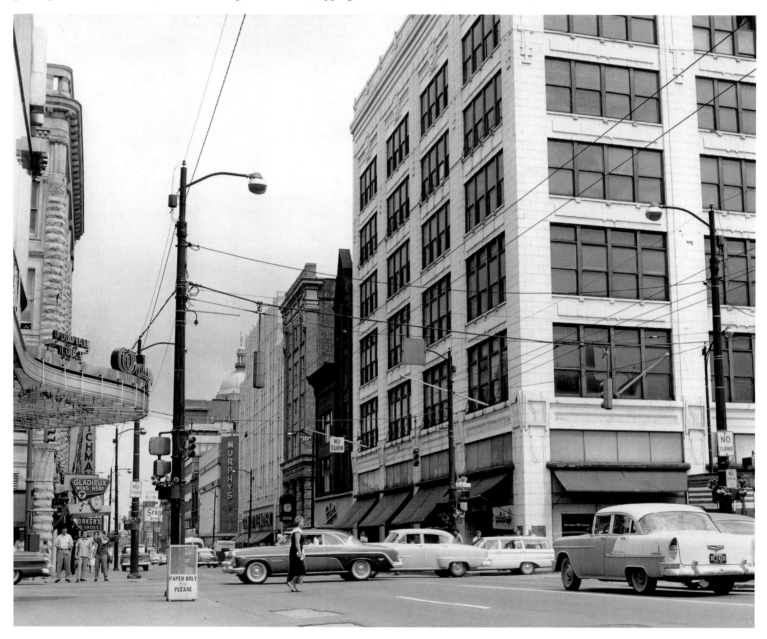

This photograph makes a different kind of statement about the changing nature of American cities, including Fort Wayne. Parked in front of the Allied Loan Co. and the Royal Tavern on East Main Street is a foreign-made car, a Volkswagen "Beetle."

Fort Wayne's profile from the air.

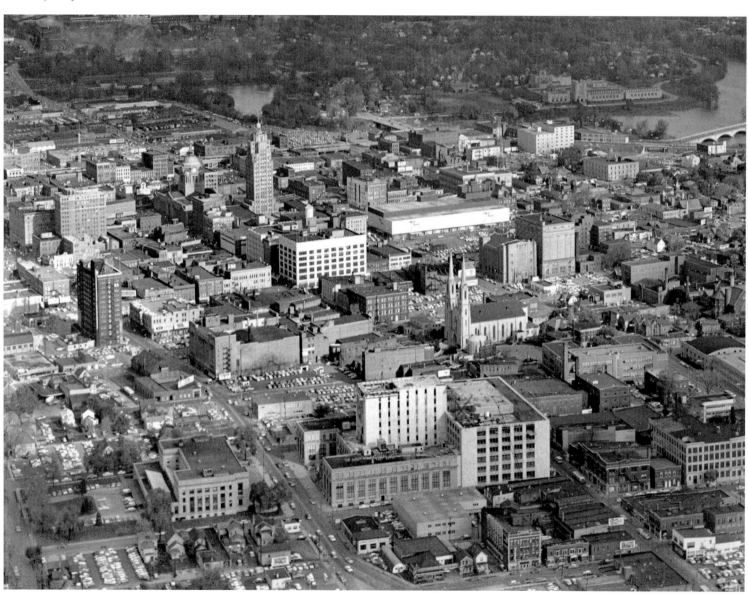

A December 29, 1958, fire in the MacDougal Building caused this tense moment as firemen give oxygen to an overcome colleague. The fire—one of several massive fires that winter—destroyed the 101-year-old building at Calhoun and Berry streets.

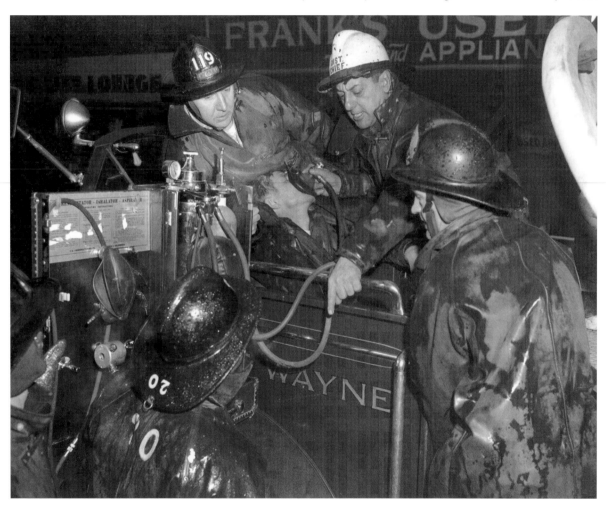

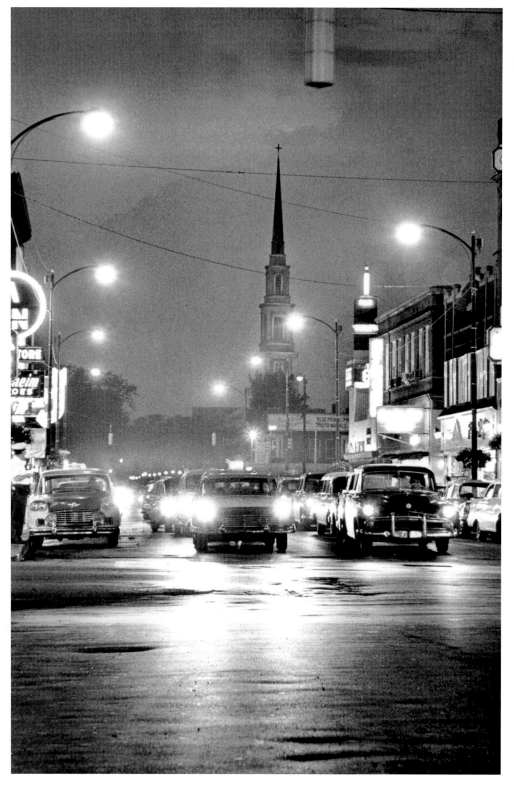

The spire of the First Presbyterian Church rises darkly against illuminated Wayne Street in this 1960 photograph.

A very young lady wields the shovel at the groundbreaking for the Good Shepherd Methodist Church in May 1965. Pastor Floyd Blake, left, and District Superintendent Virgil Bjork lead the ceremony for the church on Vance Avenue.

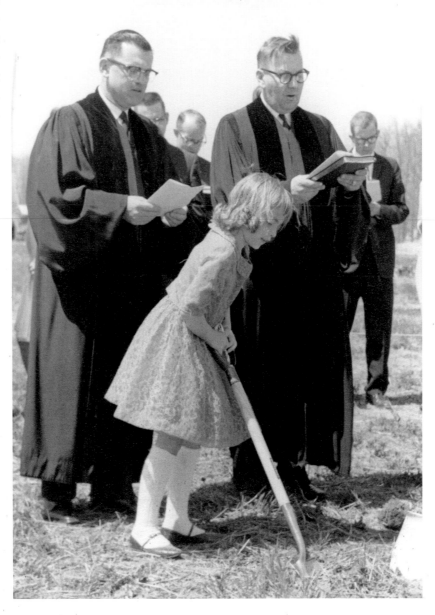

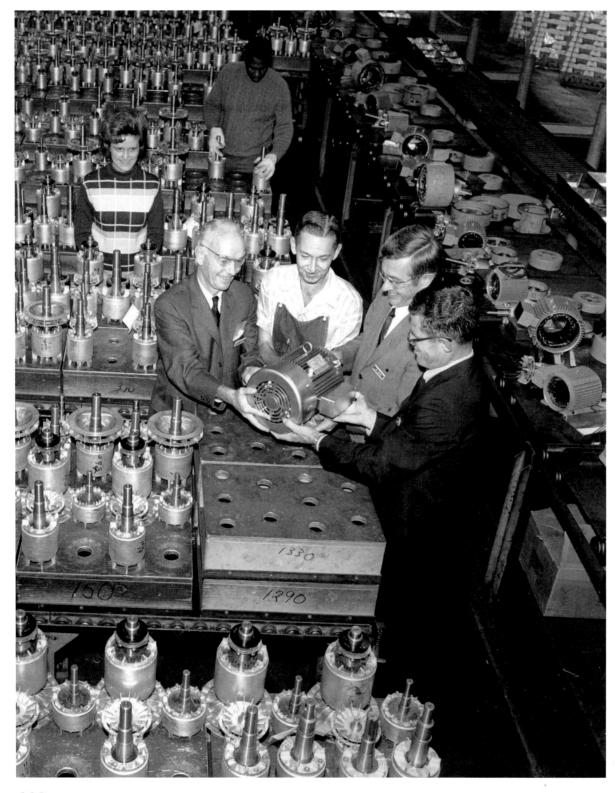

The three-millionth motor produced at General Electric's plant on Winter Street is examined by GE officials and the customer for whom it was made in October 1969. GE began making small motors at its Fort Wayne facilities before World War I.

Purdue University operated its extension program of classes from this building at Barr and Jefferson streets from 1947 until Indiana University and Purdue combined their programs at the IPFW campus in 1964.

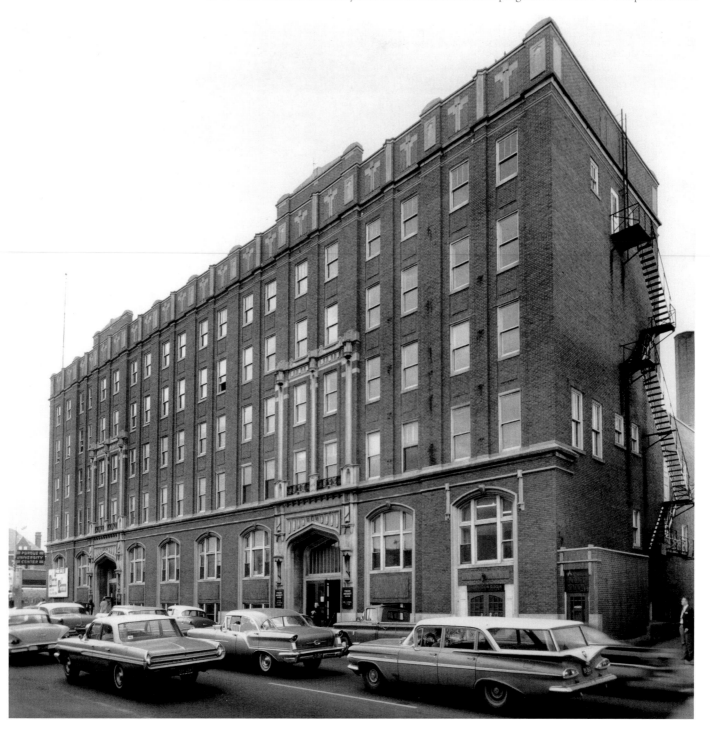

Construction was under way in the winter of 1969 for the new City-County Building on Main Street at Calhoun. In the background is the Allen County Courthouse and the Fort Wayne National Bank Building, also under construction.

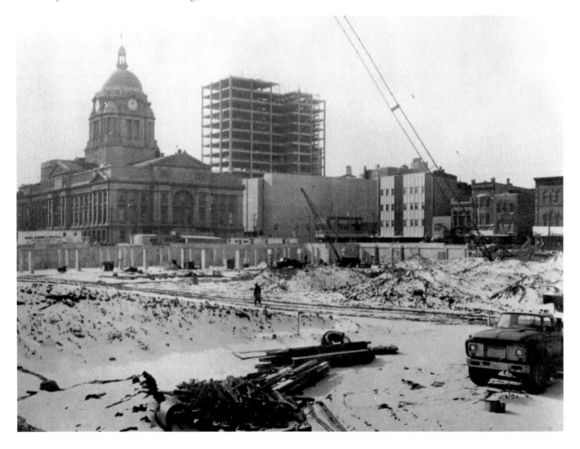

The Fort Wayne Komets skated into the hearts of Fort Wayne fans when the Memorial Coliseum opened in 1952. The Komets were a longtime fixture in the International Hockey League before moving to the United Hockey League.

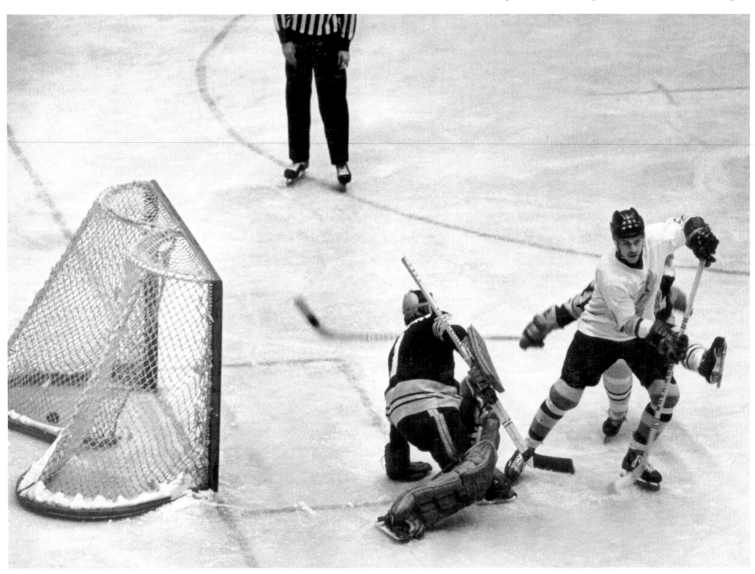

Cathedral Square has been a central part of life in Fort Wayne since a portion of it was purchased in the 1830s. Now housing the primary cathedral of the Roman Catholic Diocese of Fort Wayne–South Bend, Cathedral Square includes the Chancery, MacDougal Chapel, the former Cathedral Boys School, and the Rectory.

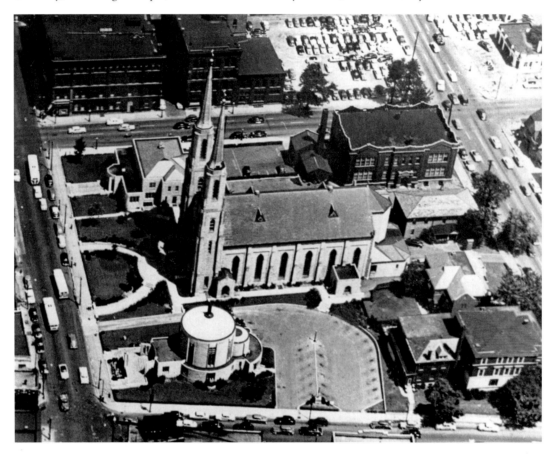

The 200 block of Columbia Street between Main and Barr streets stands forlornly in 1970 after being marked for razing. In its place, the city constructed Freimann Park.

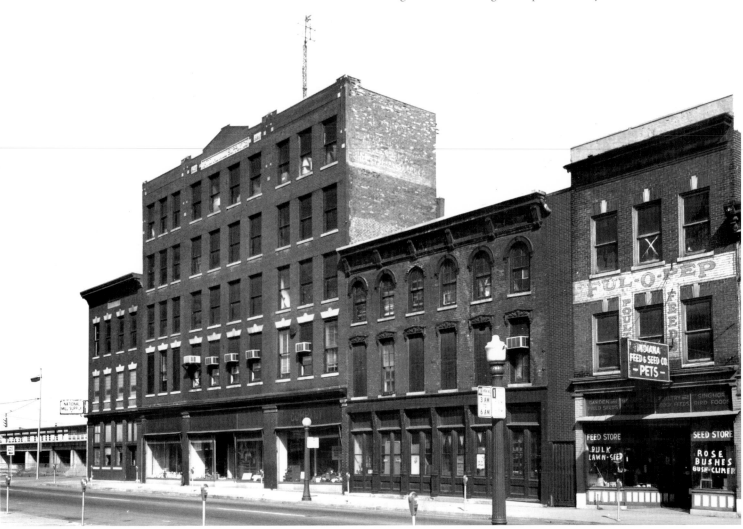

The city and its downtown merchants made numerous efforts to attract shoppers back downtown, including free transportation, but times had changed. Retailers either opened stores in the new suburban shopping centers or went out of business.

Judy Zehner has prepared a pioneer meal for the Johnny Appleseed Festival in 1976, but her son Eric doesn't seem to be sure he wants to taste it. The festival has become one of the region's most successful, featuring crafts and entertainment from the nineteenth century.

In 1977, a star and a cross on West Wayne Street capture the spirit of the season in downtown Fort Wayne.

The Fort Wayne and Allen County flags frame the most recognizable part of the skyline, the Lincoln Bank Tower. Built on the eve of the Great Depression and able to survive sweeping changes in the community's social and economic structure, the art deco tower remains a symbol of Fort Wayne's dreams and determination.

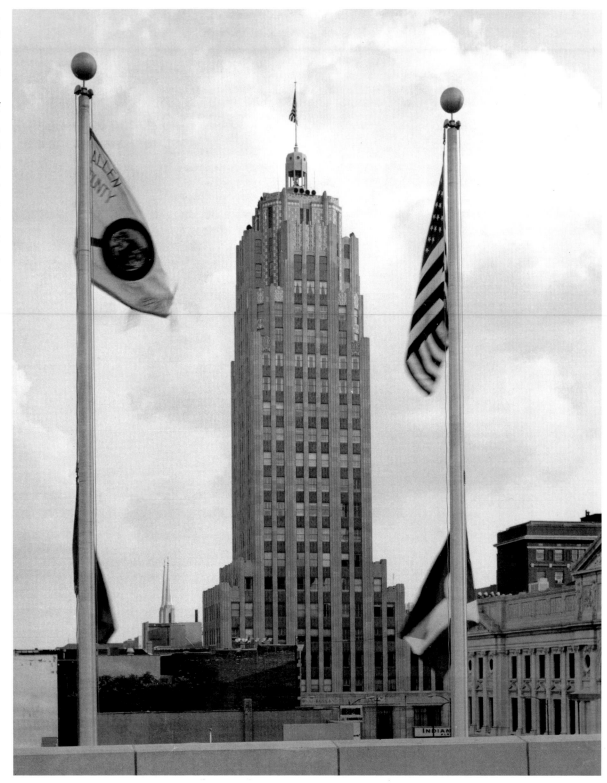

Notes on the Photographs

These notes, listed by page number, attempt to include all aspects known of the photographs. Each of the photographs is identified by the page number, photograph's title or description, photographer and collection, archive, and call or box number when applicable. Although every attempt was made to collect all available data, in some cases complete data was unavailable due to the age and condition of some of the photographs and records.

II Honor Roll
Allen County Public Library
00000785

VI Firemen
Allen County Public Library
ff03870

X Vigilant Engine
Allen County Public Library
00008631

2 Reservoir
Allen County Public Library
00001519

3 City of Churches
Allen County Public Library
00001094

4 Fire Department
Allen County Public Library
00008632

5 Evangelical Lutheran
Allen County Public Library
00001103

6 St. Paul's
Allen County Public Library
00001063

7 Columbia Street
Allen County Public Library
00000067

8 Randall Hotel
Allen County Public Library
00000041

9 Orphans Home
Fort Wayne Historical Society
reformedchurchorphans

10 Frankenstein Building
Fort Wayne Historical Society
Frankensteinbldg

11 Calhoun Street
Fort Wayne Historical Society
00003257z

12 Aveline House
Fort Wayne Historical Society
00003973

13 West Main Street
Allen County Public Library
00000135

14 Allen County Courthouse
Allen County Public Library
00000769

15 Meat Market
Allen County Public Library
00000714

16 Berry Street
Allen County Public Library
0000054

17 Cigar City
Allen County Public Library
00000702

18 Trackbed
Fort Wayne Historical Society
canalscene

20 Paving Streets
Allen County Public Library
00000107

22 Berry Street
Allen County Public Library
00003244

23 Calhoun Street
Allen County Public Library
00000233

24 Commercial Activity
Allen County Public Library
00000208

25 Retail Clothing
Allen County Public Library
00000264

26 Clinton Street
Allen County Public Library
00000051

27 Harrison Street
Allen County Public Library
00001074

28 Lake Shore Hotel
Fort Wayne Historical Society
lakesshorehotel

29 City Hall
Allen County Public Library
FF02719

30 Barr Street Market
Fort Wayne Historical Society
market

32 Cowcatcher
Allen County Public Library
00006480

33 Mayflower Mills
Fort Wayne Historical Society
mayflowermills1895

34 SYLVANUS BOWSER
Fort Wayne Historical Society
bowserplant

36 100TH ANNIVERSARY
Allen County Public Library
00001654

37 RAILROAD STATION
Allen County Public Library
00003315

38 THE PEOPLE'S STORE
Fort Wayne Historical Society
peoplesstore

40 ELECTRIC PLANT
Allen County Public Library
00008549

41 TROLLEY LINE CREW
Allen County Public Library
00000876

42 VILBERG & CO.
Allen County Public Library
00003234

43 WAYNE AND BROADWAY
Allen County Public Library
00001158

44 CALHOUN STREET
Allen County Public Library
00000206

45 LAKESIDE SCHOOL
Allen County Public Library
00000304

46 WHITE NATIONAL BANK
Allen County Public Library
00004647

47 SWINNEY PARK
Allen County Public Library
00001608

48 VICTROLA
Fort Wayne Historical Society
victrola

49 McCULLOCH HOME
Allen County Public Library
00004316

50 REITER'S STORE
Allen County Public Library
00003284

51 ST. PAUL'S FIRE
Allen County Public Library
00001093

52 YOUNG GERMAN BOYS
Fort Wayne Historical Society
germanboys

53 LEAGUE PARK
Fort Wayne Historical Society
floodballpark

54 COMMERCIAL CLUB
Fort Wayne Historical Society
oddfellows

55 FEDERAL BUILDING
Allen County Public Library
00003589

56 POSTMEN
Fort Wayne Historical Society
postofficewrks

57 COURTHOUSE
Allen County Public Library
00000242

58 VETERANS PARADE
Fort Wayne Historical Society
GARparade

59 157TH INFANTRY
Allen County Public Library
00004686

60 AVELINE HOTEL FIRE
Allen County Public Library
00003629

61 AFTERMATH
Fort Wayne Historical Society
avelinefire

62 CRAWFORD FAMILY
Allen County Public Library
00006462

63 MAJESTIC THEATRE
Allen County Public Library
00002746

64 ALLEN COUNTY COURTHOUSE
Fort Wayne Historical Society
Allencourthouse

66 OLD HEIDELBERG
Fort Wayne Historical Society
altheidelberg

67 BARR STREET MARKET
Allen County Public Library
00003709

68 ST. MARY'S CHURCH
Allen County Public Library
00001050

69 CATHEDRAL SQUARE
Allen County Public Library
00001070

70 WAYNE STREET
Allen County Public Library
00008578

71 RAILROAD STATION
Fort Wayne Historical Society
cwstation

72 MAYFLOWER MILLS FIRE
Allen County Public Library
00003638

73 TRAIN WRECK
Allen County Public Library
00003402

74 CAROLE LOMBARD
Fort Wayne Historical Society
mccullochbday

76 ELEVATING RAIL LINES
Fort Wayne Historical Society
weberhotelrr

77 WIGWAM SALOON
Fort Wayne Historical Society
wigwamsaloon

78 GE EMPLOYEES
Library of Congress
LOT 12353-7

80 MASSIVE FLOOD
Fort Wayne Historical Society
JGflood1913

81 ART SMITH
Allen County Public Library
00004429

82 HENRY HILBRECHT
Allen County Public Library
00008660

83 ROLLING MILL TEAM
Allen County Public Library
00001792

84 LIBERTY BELL
Fort Wayne Historical Society
libertybell

86 LINCOLN CABIN
Allen County Public Library
00001516

87 APPLESEED MONUMENT
Allen County Public Library
00002925

88 **YWCA FOUNDERS**
Fort Wayne Historical Society
ywcamembers1916

90 **E. C. RURODE**
Allen County Public Library
00004828

91 **AUTOBUSES**
Allen County Public Library
00003378

92 **FUNERAL PROCESSION**
Allen County Public Library
FF00119

93 **OFFLOADING SUGAR**
Allen County Public Library
00000879

94 **CRAFTING PROPELLERS**
Fort Wayne Historical Society
packard1

95 **50-50 RULE**
Allen County Public Library
00000878

96 **RED CROSS FUNDRAISING**
Allen County Public Library
00000901

97 **SCHOOL CANNING CLUB**
Allen County Public Library
00000355

98 **ARMISTICE DECLARED**
Fort Wayne Historical Society
WWIwomen

100 **WWI MEMORIAL**
Allen County Public Library
00002942

101 **REPAVING CALHOUN STREET**
Allen County Public Library
00000226

102 **THEODORE THIEME**
Fort Wayne Historical Society
thiemegarden

104 **WABASH RAILWAY DEPOT**
Allen County Public Library
00008456

105 **WAYNE HOTEL**
Allen County Public Library
00003977

106 **S. SIDE HIGH SCHOOL**
Allen County Public Library
00000481

108 **N. SIDE HIGH SCHOOL**
Allen County Public Library
00000489

109 **INTERNATIONAL HARVESTER**
Fort Wayne Historical Society
ihctruck1923

110 **EMBOYD**
Embasssy Theater Foundation
emb1

111 **BOOK WAGON**
Allen County Public Library
00001683

112 **GAS STATION**
Fort Wayne Historical Society
pennmargasstation

114 **RADIO STATION WOWO**
Allen County Public Library
00002774

115 **TRANSFER CORNER**
Allen County Public Library
00006463

116 **CLINTON STREET**
Allen County Public Library
00001138

117 **FORT WAYNE PUBLIC LIBRARY**
Allen County Public Library
00003471

118 **SOUTH WAYNE SCHOOL**
Allen County Public Library
00000349

119 **TOWER GROUNDBREAKING**
Allen County Public Library
00004632

120 **SYNAGOGUE**
Allen County Public Library
00001080

121 **AIR MAIL SERVICE**
Allen County Public Library
00004414

122 **LADY WAYNE CHOCOLATES**
Fort Wayne Historical Society
Ladywaynechocolates

124 **BUTTON HAND PUMPER**
Allen County Public Library
FF02741

125 **CITY HALL**
Allen County Public Library
00008701

126 **BARR STREET**
Allen County Public Library
00008657

127 **STORY HOUR**
Allen County Public Library
00003477

128 **BAKER STREET STATION**
Allen County Public Library
00003360

129 **PUMPING STATION**
Allen County Public Library
00004057

130 **HOAGLAND SCHOOL**
Allen County Public Library
00000271

131 **LINCOLN BANK TOWER**
Allen County Public Library
00000257

132 **WELL-CRAFTED WAGON**
Allen County Public Library
00006449

133 **KUNKLE VALVE WORKS**
Allen County Public Library
00000683

134 **RECREATION AND READING**
Allen County Public Library
00005058

136 **EXTENSION CENTER**
Allen County Public Library
00004343

137 **FARGO MOTOR BUS**
Allen County Public Library
00003382

138 **MAYOR BAALS**
Fort Wayne Historical Society
mayorballs&oc

139 **CENTLIVRE BREWERY**
Fort Wayne Historical Society
centlivrebldg1940

140 **ANTHONY HOTEL**
Allen County Public Library
00003541

142 **DEPARTMENT STORE**
Fort Wayne Historical Society
grandleader1940

143 **TRANSIT BUS**
Allen County Public Library
00005989

196 FREE BUSING
Allen County Public Library
00006035

197 JUDY ZEHNER
Allen County Public Library
00006295

198 WEST WAYNE STREET
Allen County Public Library
00001142

199 FLAGS
Allen County Public Library
00004657